FERNAND LEGER

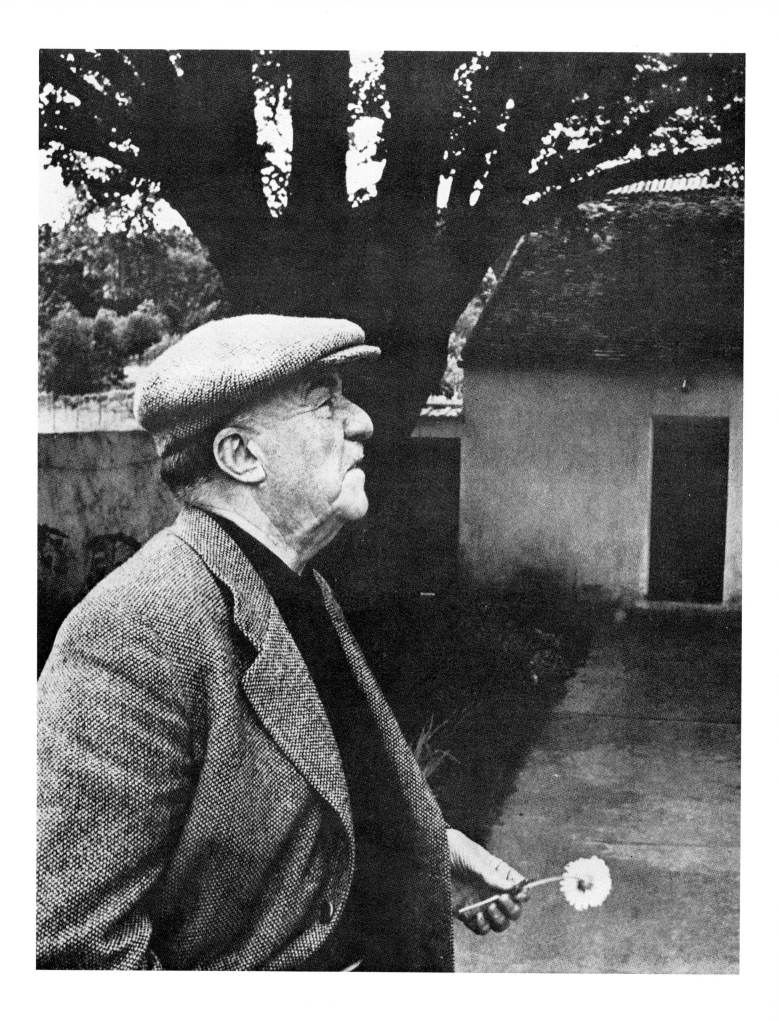

FERNAND LEGER

ESSAYS BY

ROBERT T. BUCK

EDWARD F. FRY

CHARLOTTA KOTIK

ALBRIGHT-KNOX ART GALLERY

ABBEVILLE PRESS • PUBLISHERS • NEW YORK

COVER:
Cat. 29. *Reading (La Lecture),* 1924
Musée National d'Art Moderne, Paris

FRONTISPIECE:
Léger at his home at Gif-sur-Yvette.

This publication has been prepared in conjunction with the exhibition organized by Robert T. Buck and Charlotta Kotik for the Albright-Knox Art Gallery, Buffalo, New York.

ALBRIGHT-KNOX ART GALLERY, BUFFALO, NEW YORK
January 15 – February 28, 1982

MUSEE DES BEAUX-ARTS DE MONTREAL/THE MONTREAL MUSEUM OF FINE ARTS, MONTREAL, CANADA
March 11 – April 18, 1982

DALLAS MUSEUM OF FINE ARTS, DALLAS, TEXAS
May 12 – June 27, 1982

The exhibition, *Fernand Léger,* is supported by grants from the National Endowment for the Arts, Washington, D.C., a federal agency. The Albright-Knox Art Gallery receives funding from the New York State Council on the Arts.

Library of Congress Cataloging in Publication Data
Main entry under title:

Fernand Léger, an exhibition.

 Bibliography: p.
 1. Léger, Fernand, 1881–1955 — Exhibitions. I. Léger, Fernand, 1881–1955. II. Kotik, Charlotta, 1940– III. Buck, Robert T. IV. Fry, Edward F. V. Albright-Knox Art Gallery.
ND553.L58A4 1981 759.4 81-12869
ISBN 0-89659-256-1 AACR2
ISBN 0-89659-254-5 (pbk.)

CONTENTS

FOREWORD

"People live in a continually poetic atmosphere. They live in the middle of modern objects that they judge beautiful, pretty, magnificent: cars, airplanes, machines . . . Why couldn't they be qualified one day to understand modern art?"[1]

"A beautiful work of art does not explain itself. It does not want to prove anything; it appeals to the sensibility, not to the intellect. Above all, it is a matter of loving art, not of understanding it."[2]

With these two seemingly paradoxical yet lucid statements on the part of Léger, a dichotomy within the man himself is revealed. His life-long goal was to bring art at its finest into the existence of the ordinary man through the embellishment of architecture and objects. The task was, in any case, too great for one man and judgment of his success or failure in this regard proves nothing.

What is striking is that his own sort of home-spun philosophy, shaped early in his life by his humble origins, led him to inject his populist ideas into the rarified and insular world of high art more consistently than any other major art figure of our century. Furthermore, this consistent stance led to an art in his hands that has had a profound impact on succeeding generations of artists in Europe and especially in the United States.

Léger's creative triumphs came early in his career. His Cubist works dating from the decade beginning in 1911 are among the most beautiful and noble creations of that watershed movement and culminate in the series, *The City* and *Disks,* both of 1918. His populist ethic shortly afterward took solid hold in the choice of his subject matter and his work became increasingly figurative as a result. But even within the narrow confines of this exploration limited by his particular purposes, he invented a new vernacular in art, so that others who have approached similar problems could not help but refer to his achievement.

America, notably New York City, where he lived as a wartime refugee, was enormously attractive to Léger. The truth was that the activity, commercialism, and uninhibited nature of the people were for him as much a living proof of his theories as were the planning and architecture of the new world for Mondrian. It is highly appropriate, therefore, that we celebrate the centennial of his birth with this major exhibition of his work, the first such effort in America in twenty years.

I am grateful for the support and encouragement which many have extended to make this project a reality. The National Endowment for the Arts has granted major support to this project, as has The Members' Council of the Albright-Knox Art Gallery. Seymour H. Knox, Chairman of

The Buffalo Fine Arts Academy, has given enthusiastic encouragement from the start.

I wish to extend my thanks to Edward F. Fry for his incisive and original essay on the nature of Léger's work and to Charlotta Kotik, not only for her excellent essay contribution but for her able organization of practically all the details of the exhibition.

Finally, the exhibition could not have taken place without the support of Mme. Nadia Léger, and Mr. Georges Bauquier, Director of the Musée National Fernand Léger in Biot, France and I am most grateful to them for their cooperation.

ROBERT T. BUCK
Director
Albright-Knox Art Gallery

(1) Fernand Léger, "Color in the World," in *Functions of Painting* (New York: The Documents of 20th-Century Art, The Viking Press, 1973), p. 125.
(2) Ibid. p. 130.

ACKNOWLEDGMENTS

An exhibition of this magnitude takes place only due to the dedicated cooperation of many individuals. I would like to express special gratitude for the extraordinary help provided by those whose names are listed below:

Daniel Abadie, Curator, Musée National d'Art Moderne, Paris; Celia Ascher, Curator, McCrory Corporation, New York, New York; Georges Bauquier, Director, Musée National Fernand Léger, Biot, France; Ernst Beyeler, Galerie Beyeler, Basel, Switzerland; Irene Bizot, Curator, Réunion des Musées Nationaux, Paris; Dr. Jean S. Boggs, Director, Philadelphia Museum of Art, Philadelphia, Pennsylvania; Gerald Bolas, Director, Gallery of Art, Washington University, St. Louis, Missouri; Patrick Bongers, Galerie Louis Carré et Cie, Paris; Alan Bowness, Director, The Tate Gallery, London, England; Dominique Bozo, Director, Musée National d'Art Moderne, Paris; Bernadette Coutensou, Director, Musée d'Art Moderne de la Ville de Paris, Paris; Rini Dippel, Department of Painting and Sculpture, Stedelijk Museum, Amsterdam, The Netherlands; Bernd Dütting, Galerie Beyeler, Basel, Switzerland; Richard L. Feigen, Richard Feigen and Co., Inc., New York, New York; Dr. Rudolph H. Fuchs, Director, Stedelijk van Abbemuseum, Eindhoven, The Netherlands; Daryl Y. Harnisch, Sidney Janis Gallery, New York, New York; Anne d'Harnoncourt, Curator of 20th Century Art, Philadelphia Museum of Art, Philadelphia, Pennsylvania; Nelly Iampolski, Musée National Fernand Léger, Biot, France; Sidney Janis, Sidney Janis Gallery, New York, New York; Maurice Jardot, Galerie Louise Leiris, Paris; Hubert Landais, Director, Réunion des Musées Nationaux, Paris; Jeanne Laurent, Paris; Abram Lerner, Director, Hirshhorn Museum and Sculpture Garden, Smithsonian Institution, Washington, D.C.; Dr. Peter Krieger, Curator, Staatliche Museen Preussischer Kulturbesitz, Nationalgalerie, Berlin, West Germany; Richard A. Madigan, Director, Norton Gallery and School of Art, West Palm Beach, Florida; Jonathan Mason, Assistant Registrar, The Tate Gallery, London, England; Thomas M. Messer, Director, The Solomon R. Guggenheim Museum, New York, New York; Gerald Nordland, Director, Milwaukee Art Museum, Milwaukee, Wisconsin; Klaus Perls, Perls Galleries, New York, New York; Dr. Earl A. Powell III, Director, Los Angeles County Museum of Art, Los Angeles, California; Simon de Pury, Curator, Thyssen-Bornemisza Collection, Castagnola-Lugano, Switzerland; Michèle Richet, Curator, Réunion des Musées Nationaux, Paris; Anne Rorimer, Associate Curator, 20th Century Painting and Sculpture, The Art Institute of Chicago, Chicago, Illinois; Cora Rosavear, Assistant Curator, Department of Painting and Sculpture, The Museum of Modern Art, New York, New York; Phyllis Rosenzweig, Associate Curator, Hirshhorn Museum and Sculpture Garden, Smithsonian Institution, Washington, D.C.; William Rubin, Director, Painting and Sculpture, The Museum of Modern Art, New York, New York; Dieter Ruckhaberle, Director, Staatliche Kunsthalle, Berlin, West Germany; Thomas T. Solley, Director, Indiana University Art Museum, Blooming-ton, Indiana; James Speyer, Curator, 20th Century Painting and Sculpture, The Art Institute of Chicago, Chicago, Illinois; Mrs. Louise Averill Svendsen, Senior Curator, The Solomon R. Guggenheim Museum, New York, New York; Michèle Venard, Galerie Maeght, Paris; Germain Viatte, Curator, Musée National d'Art Moderne, Paris; Aline Vidal, Curator, Musée d'Art Moderne de la Ville de Paris, Paris; Dr. Stephen Waetzoldt, Director, Staatliche Museen Preussischer Kulturbesitz, Nationalgalerie, Berlin, West Germany; Edouard L. L. de Wilde, Director, Stedelijk Museum, Amsterdam, The Netherlands; James N. Wood, Director, The Art Institute of Chicago, Chicago, Illinois.

I have especially to acknowledge the cooperation of Jean Trudel, Director, and Janet M. Brooke, Curator of European Arts, of the Museum of Fine Arts in Montreal, and Harry S. Parker, Director, and Dr. Steven A. Nash, Assistant Director/Chief Curator, of the Museum of Fine Arts, Dallas, Texas, who supported this project from its inception.

Mr. Sidney Janis generously shared his time, discussing his personal recollections of Léger.

I would like to cite the members of our own staff for their efforts in bringing the exhibition into being:

Norma A. Bardo, formerly Curatorial Secretary; Elizabeth A. Burney, Administrative Assistant to the Director; Margaret Cantrick, Library Assistant; Anita Gilden, formerly Assistant Librarian; John J. Kushner, Building Superintendent and the Installers; Annette Masling, Librarian; Jane Nitterauer, Registrar; Josephine Novak, Editor of Publications; Alba Priore, Assistant Registrar; Serena Rattazzi, Coordinator of Public Relations; Marianne D. Spencer, Curatorial Secretary; Leta K. Stathacos, Coordinator of Marketing Services.

Sandra T. Ticen designed the catalogue with remarkable sensitivity and skill. Karen Lee Spaulding prepared and edited the Bibliography, Chronology and Exhibition Lists, and also generously shared her expertise in the initial stages of preparation of this publication.

To conclude, I would like to express my gratitude to Robert T. Buck, Director of the Albright-Knox Art Gallery and coorganizer of this exhibition for his sustained enthusiasm and expert advice.

CHARLOTTA KOTIK
Curator
Albright-Knox Art Gallery

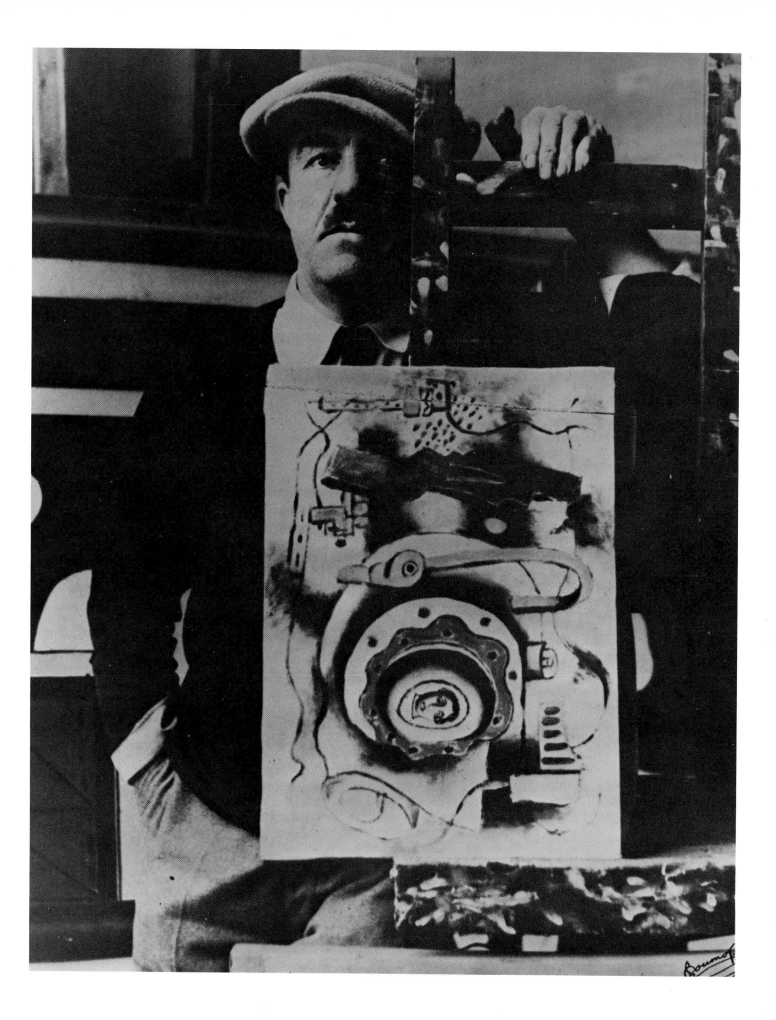

LÉGER AND THE FRENCH TRADITION

BY EDWARD F. FRY

Just as no other artist of the heroic period of twentieth-century European art better demonstrates the remarkable achievements of French modernism than does Fernand Léger, so does the work of Léger in its totality reveal the dimensions of the pre-World War II School of Paris. Léger's career exemplifies the consequences of this tradition, the roots of which extend backward at least as far as Chardin and the brothers Le Nain. The locus of this tradition may best be situated in the consciousness of the intelligent peasant or petit-bourgeois artisan: honest craftsmanship; "plastic values;" attentions to the surface manifestation of things and events rather than to their intangible significations; an honest, stubborn solidity; in all, the recording and reordering of the tangible appearances and objects of the world as ends in themselves, with less regard for the mental structures, interrelationships and ultimate implications of such appearances and objects. Such an approach, with its implicit nonintellectualism, compounded in Léger's case by his enormous physical vitality, places a premium on the effects of experience on the observer, who reacts to, and reorders this world of experiences rather than interrogating it with a countervailing intellect. It is a stance of vigorous receptivity which accepts the world as it is, along with the experiences it provides, be they traditional or "modern," as givens – *faits accomplis* – to which the only imaginable response is a more or less active, more or less stylized reordering and rearranging. The achievement of Léger is thus the full and dynamic realization of a pragmatic intelligence in which the inward and subjective being is not so much suppressed as simply merged with an external world of objects and events. That the ultimate political consequences of this viewpoint are populist, syndicalist and working-class communist, in contrast to the intellectual/technocratic operations of a ruling class, should come as no surprise, as they are evidenced by Léger's own political beliefs and lifelong identification with working-class attitudes, interests and activities.

Léger's direction of inward mind into external objecthood, and the persistent focus of his consciousness upon the life-world of the artisan and petit-bourgeois, are nevertheless only two of the underlying elements of his work, predominant and perhaps fundamental as they may be. A more complete inventory, leading to a more precise situating of his life and work, would necessarily include certain biographical and historical factors: his rural Norman background; his entry into the cultural life of Paris early in the twentieth century; and the essentially nineteenth-century quality of Parisian life before 1914, with the still lingering traditions of an almost village existence in many neighborhoods. This inventory would also have to include the ambiguous acceptance of an industrial society by a France that had remained until recently an essentially agrarian culture, as well as the curiously filtered and unbalanced acceptance of industrial life after World War I on the part of the cultural elite. Also of importance are the consequences, for French political rhetoric and practice, of that selectively accepted industrialism, in company with a nevertheless naive enthusiasm for the extreme exemplars of industrialism — above all, America and the spectacle of New York. To these, one must finally add the deep-seated French desire, persistent to this day, to absorb the modes and artifacts of industrial modernism into nostalgic traditions of craftsmanship.

These cultural elements have a direct effect on many aspects of Léger's paintings, often to a degree that is self-evident. But Léger's work may be situated on a more general historical level that is more closely allied to the visual arts. For Léger and the Cubist generation demonstrate the ambivalent relationship of French modernism to its nineteenth-century roots, as well as the even more problematic relationship of

Fig. 2. Léger in his studio, c. 1930.

9

French traditions in art and thought to the classical humanism of the Renaissance. In a very fundamental sense, the fusion of medieval spirituality with classical form that became the veritable incarnation of the Renaissance never took root in France; for the simulacrum of that fusion, French classicism, turns out upon close examination to be very different from its Italian exemplar. The word is rarely, if ever, made flesh in French classicism: instead, a secularized Gothic scholasticism reappears in Cartesian dress, whether as pure verbal discourse or as academic rules and structural norms in architecture and the plastic arts. The superimposition of imported Renaissance classical forms upon indigenous French Gothic styles in both the art and architecture of the sixteenth and early seventeenth centuries was destined not to transform, but only to redirect, the essentially pictorial and linear traditions of Paris and the Ile de France. This passage from late Gothic to a formal simulacrum of the classical, without an intervening moment of the truly classic, is an exact parallel to the secularized scholasticism of Cartesianism, in which words and concepts are used to operate on other words and concepts. In both cases what is absent is that classical dialogue of mind with nature which leads directly to the condition of incarnation: the word made flesh. What happens instead within the French tradition of Cartesian academicism in art and literature is that a priori rules or structures are imposed on secularized but preclassical traditions for the apprehension of nature and experience. The result for French painting of this epistemological mismatch is that the human figure is less common than landscape and still life; that figurative painting is primarily portraiture; and that figurative compositions, from Poussin through David, Géricault, Bouguereau and even Gauguin, tend toward moralistic or political rather than humanist content. Similarly, in landscape and still life, the classical dialogue with the world is supplanted either by, rarely, a passive and almost "primitive" apprehension of visual experience or, more usually, by the imposition of a priori styles, logic, and linear or geometrical structures.

Thus, despite the richness and apparent variability of the French pictorial tradition, a few common denominators emerge as virtual iconologic constants, foremost of which is intellectual and stylistic formalism. What seems to be outside the paradigmatic limits of French art is the possibility that there exists in nature, and in human behavior itself, an order or rationale that is distinct from the a priori categories of logical analysis and manipulation. In this sense the French moralistic approach to humanistic themes is itself as much a

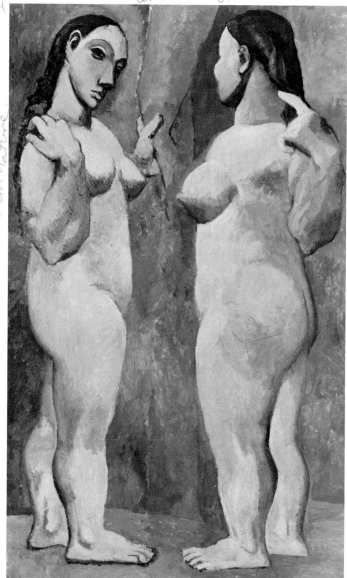

Fig. 3. Pablo Picasso. *Two Nudes,* 1906, late oil on canvas, 59⅝ x 36⅝ (151.5 x 93) The Museum of Modern Art, New York, New York, gift of G. David Thompson in honor of Alfred H. Barr, Jr.

species of logical formalism imposed upon subjective experience as are the stylistic or geometric norms imposed upon a still life, the human body itself used as a compositional motif rather than a symbol, or the design of gardens for a chateau.

Léger, with Braque and Matisse, is a principal exemplar of this French tradition in its twentieth-century guise, to which he brings the almost tangible variant of his own vigorous, direct and physical sensibility: he is the very type of intuitive mesomorph as avant-gardist plastician. Léger's overall career has nevertheless remained somewhat obscure in comparison to his contemporaries; recent scholarly treatment of his work has fastened on the Cubist and immediately post-Cubist period, and assessments of his work as a whole have been marginal, premature or eulogistic.

He emerges as a distinct artistic personality by around 1908-09, much of his earlier work having been lost or destroyed. Such paintings as *The Seamstress* of 1909 and *The Bridge* of approximately the same time, provide the only important surviving indications of Léger's response to the Parisian situation of early Cubism. Both works display an extreme, block-like formal reductiveness of volumes within conventionally illusionistic space. This volumetric reductiveness, which

was also the approach of Gleizes, Metzinger and Le Fauconnier around 1909-10, and which is equally evident in the 1908 L'Estaque paintings of Braque, coexists in Léger at this moment not only with a normative spatial illusionism but also with a relatively neutral iconography. These stylistic traits may reflect the transitory influence of Le Douanier Rousseau, as may be seen also in aspects of Picasso's works during the second half of 1908. In general, however, this combination of neutral motifs and volumetric reductiveness in Léger and his French contemporaries marks a response to Cézanne on the part of a French Cartesian stance which, with respect to its links to the Italian classical tradition by way of French academic art, may best be called sub-classic. That the Cézanne retrospective at the 1907 Salon d'Automne should have evoked this response is not surprising in view of the radical challenge presented by Cézanne's art to the classical tradition itself. For, in his mature works, whether bathers, landscapes with houses or still lifes, Cézanne struggled against any a priori principles of structure or order and sought instead an unmediated approach to visual experience in all its variety. Cézanne, in remaining faithful to experience itself, in what Adorno so eloquently called the "force-field" between nature and the mind, thus passed almost beyond the limits of the classic altogether, save for a residual dualism. He thereby paradoxically revived the classical impulse by rejecting all academic tenets; in so doing, however, he also stepped outside the limits defined by Cartesian epistemology.

But the consequences of this extraordinary achievement — Cézanne's art itself — would inspire French artists of Léger's generation to retrieve that same freedom for Cartesianism through their imposition of a new, nontraditional set of a priori structures upon the external stylistic appearance of Cézanne's vision. In so doing, Léger and his generation would by the 1920s, if not before, have established a neo-academic Cartesian orthodoxy as the basis for the twentieth-century School of Paris that would become the direct modern equivalent of the old French academic classicism.

With Léger this process is already underway in *Nudes*

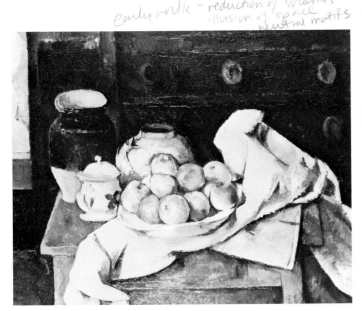

Fig. 4. Paul Cézanne. *Still Life With Dresser (Nature morte à la commode)*, c. 1885
oil on canvas, 25½ x 32 (71 x 90)
Fogg Art Museum, Harvard University, Cambridge, Massachusetts

11

in the Forest of 1909-10, with its multiple references backward to Cézanne's landscapes with figures and its imposition of geometrical volumes on natural forms. At the same time the artist's palette, diminished to tans, greens and silvery greys, reflects the Cubist tonality by later 1909. Contact with Picasso and Braque at this moment on Léger's part is most likely, if not directly, then at least through their works as included in group showings at Kahnweiler's gallery. Léger's still life *The Fruit Bowl,* 1909, reveals multiple points of similarity and divergence if juxtaposed both with Picasso's still lifes of later 1909, such as *Le Bock,* and with characteristic still lifes of the mature Cézanne of the mid-1880s. These confrontations reveal that by 1909 neither Picasso nor Léger had penetrated to an understanding of Cézanne's epistemologically radical "force-field" but that both had become obsessed with the challenge offered by Cézanne to the academic/classical tradition. If Picasso's response was to pursue a new mental draughtsmanship that would invert classical norms and lead to the invention of a new language of representational signs, Léger's was in many ways simpler and more literal. In *The Fruit Bowl* it included the influence of Cézanne's high vantage point, *passage,* and apparently discontinuous composition, and — undoubtedly as a result of his exposure to works of Picasso and Braque — the imposition of curved and rectilinear planes upon the ambient surround of his motif. These planar impositions nevertheless differ from those of Picasso and Braque in that they do not directly derive from, nor do they act as signs for visual experience to the degree that they would in Léger's work by 1911-12.

The immediate consequences of Léger's responses to Cézanne, as well as to Picasso and Braque, become apparent in an important group of paintings done between 1910 and 1912, of which the first was probably *Study for Three Portraits* of late 1910/early 1911. This large painting (77 x 46") is one of the least known of Léger's early works but, historically at least, it is among the most important. It was shown in the 1911 Paris Salon d'Automne, after which it was in the early 1912 Knave of Diamonds exhibition in Moscow; Apollinaire also reproduced it in his 1913 *Les Peintres Cubistes,*

by which time it was already on its way to America for the Armory Show. The presence of this work in Moscow in early 1912 exerted a momentarily decisive role upon Malevich's development, notably in such works as his 1912 *Woman With Water Pails: Dynamic Arrangement* (Fig. No. 5), *Head of a Peasant Girl* and possibly also *The Knife-Grinder.* Malevich's debt to Léger depends in fact on *Study for Three Portraits* rather than on the better known *Nudes in the Forest,* which was never shown in Russia and, was known there only through reproductions, if at all.

With *Study for Three Portraits,* Léger extended and intensified the volumetric reductiveness and the imposition of a priori planes that he had explored in works of 1909-10. But he went beyond his earlier efforts by strengthening the bond between surface and image through the combined results of a bird's eye viewpoint, the multiplication of reductive volumes and the resulting breakdown of these volumes into surface-related planar facets; it is a depictive strategy which, along with an accompanying anatomical disjointedness, reflects

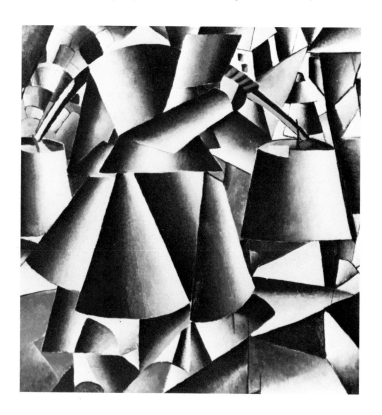

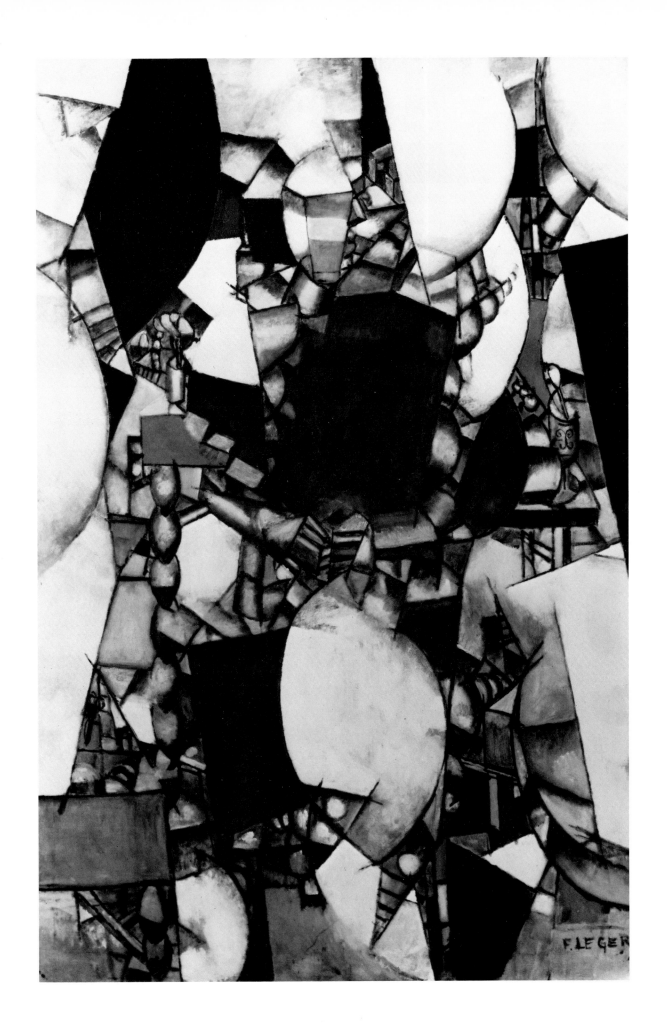

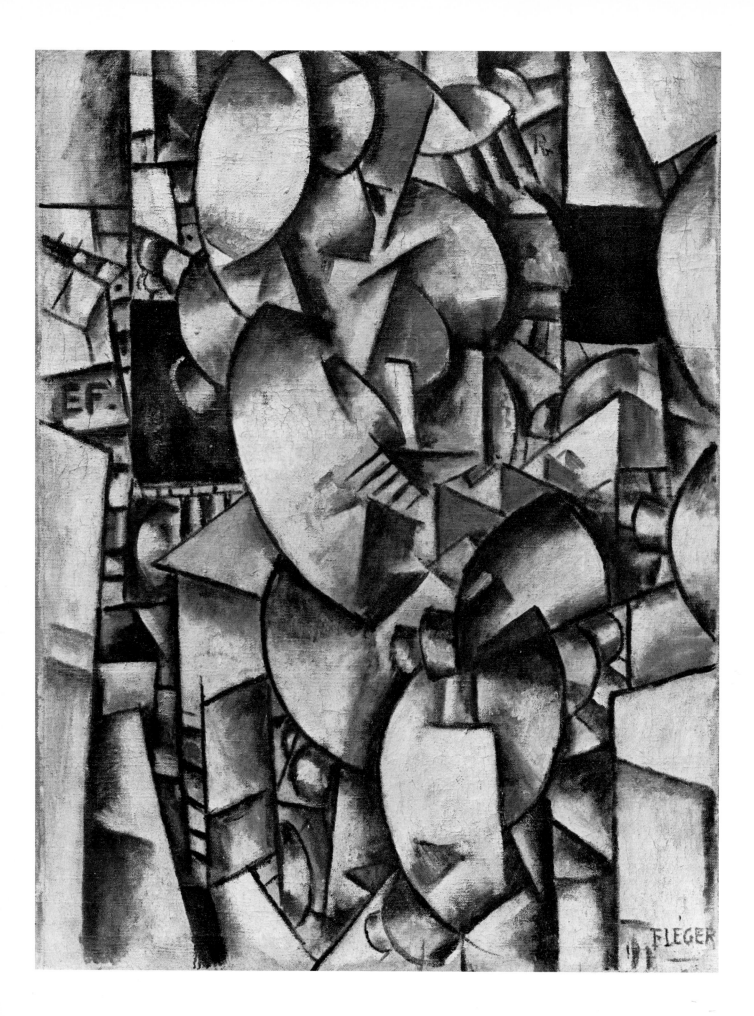

Léger's growing awareness of Picasso's experiments during later 1909 and early 1910. Like Picasso (and Braque), at this moment Léger also remained faithful to an Aristotelian unity of time and place: the subject is three figures, at least two of whom are recognizably female, seated in a surrounding of potted plants, tables and other Victorian paraphernalia, against an architectural backdrop that probably included a window.

During 1910-11, Léger was also working on his largest painting to date, *The Wedding,* which was probably exhibited in the Salon des Indépendants in the spring of 1912. It is a problematic work which, in its partial absorption of diverse and often conflicting ideas, reveals the incipient dilemmas posed by Léger's approach to art and experience. In contrast to the proto-analytical Cubism of *Study for Three Portraits* and its Aristotelian unities, *The Wedding* contains a priori planar elements like those in the 1909 *Still Life* but now intensified, perhaps through his growing friendship with Robert Delaunay and the influence of Delaunay's exactly contemporary *Eiffel Tower* series. In these paintings Delaunay, with his Neo-Impressionist roots, absorbed Picasso's 1910 Cubist planar vocabulary and applied it not to solid objects or the human figure but to the optical flux of color and light, notably in his treatment of clouds and sky. Léger's use of this opticalized sub-Cubism emerged in later 1911 with works such as *The Smokers* (Cat. No. 4), in which the evanescence of smoke puffs is captured by surface-bound planes within a scene that otherwise continues his prior use of a bird's eye view and undefined horizon. *The Wedding* continues this high vantage point landscape perspective and the arbitrary use of surface-bound planes, while the overall surface pattern of light and dark, as well as the group of figures in the center of the composition, is clearly an extension of his composition for the *Study for Three Portraits.* But in *The Wedding* Léger has juxtaposed his figures with the disjunctive details of landscape motifs, in complete disregard of classical unities. This break with space/time continuities, in which the details of distant trees and houses intrude upon a foreground crowd scene, was almost surely a last-minute addition as the result of Léger's response to the Italian Futurist ideas and paintings that

descended on Paris with the February 1912 Futurist exhibition at the Galerie Bernheim-Jeune.

The Léger-Futurist interaction at this moment is ironic, historically and culturally; for the break with space/time continuities in Futurist doctrine and to a lesser extent in Futurist paintings, notably in those of Boccioni, was primarily the result of the ideas of the Frenchman Henri Bergson. So far as the visual arts are concerned, the principal issue at stake in Bergsonian thought is a revolt against the established categories, whether derived directly from Descartes or by way of Kant, of objective space and time: a revolt which in pictorial terms implies a rejection of the fundamental tenets of Renaissance classical art. As used by the Futurists, Bergsonism amounted to little more than an imposition of the interactive flux of memory and perception upon an otherwise normative academic style, with a resulting interpenetration of near and far imagery and a juxtaposition of images otherwise separated by the passage of the time during which they are experienced.

In *The Wedding* it is precisely this non-Aristotelian merging of space/time flux which Léger repatriated to France, juxtaposing Bergsonian ideas with his own proximate, formalist misreadings of both Cézanne and analytical Cubism. The result is one of the more unusual, and revealingly unusual, monuments of the early twentieth-century School of Paris; for the real historical irony is that Bergsonism, as a negation of normative Cartesian thought as well as of most aspects of nineteenth-century scientific positivism, was given full and virtually definitive pictorial realization by Cézanne himself before the end of the 1880s, in isolated independence of Bergson. Cézanne's equivalent to Bergsonism, however, is different from that of Léger's generation, since in Cézanne the flux of the authentic visual experience of the world was recorded more or less directly, with the minimum of intervening conceptualization beyond what was necessary to satisfy the demands of the medium of painting. For Léger and his contemporaries, however, the simultaneous depiction of images experientially separated in space/time was self-conscious: a willed act of thought and decision rather than a direct record of experience.

Fig. 7. Fernand Léger. *Nude Model in the Studio (Le Modèle nu dans l'atelier).* 1912 oil on burlap, 50¼ x 38⅜ (127.6 x 97.5) The Solomon R. Guggenheim Museum, New York, New York

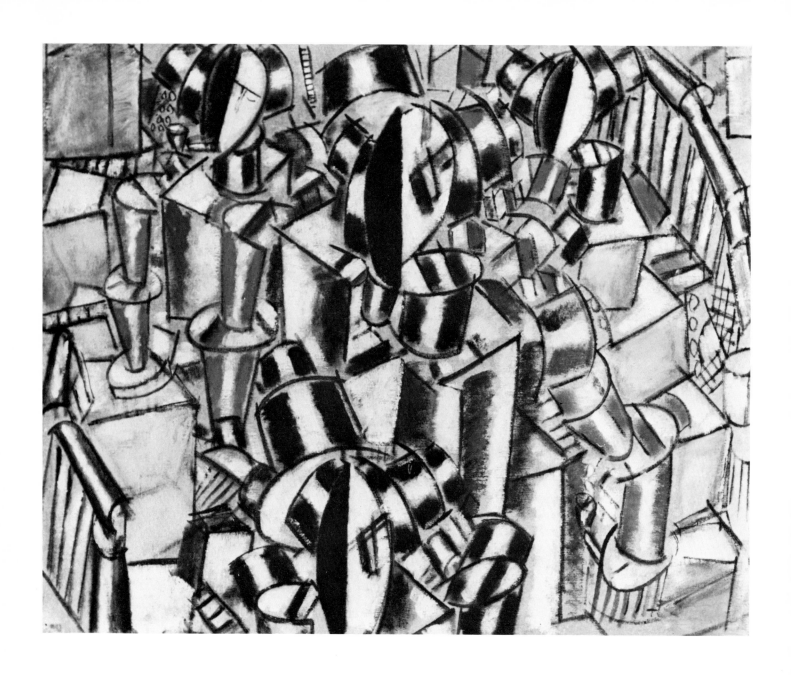

Fig. 8. Fernand Léger. *The Staircase (L'Escalier)*, 1914
oil on canvas
Kunstmuseum, Basel, Switzerland

Simultaneity reappears later in Léger's career, but the issue confronting him along with the entire early twentieth-century Cubist and Futurist avant-garde was more fundamental. For, given that Bergsonism offered an alternative to the nineteenth-century vestiges of classical idealism, just as Cézanne's art created the first truly post-classical/academic representational mode for painting, the challenge facing French artists of the generation which, like Léger, came to maturity in the first decade of the twentieth century, was not simply that of coming to terms with Cézanne and Bergson. It was, in fact, the more difficult task of translating their nineteenth-century anti-idealist and anti-academic achievements into a universally applicable mode for the representation of modern life, while remaining within the inescapable confines of French cultural and intellectual traditions. The choices available were limited: A continuation of Cézannian style, with the infusion of modern, urban subject-matter; the added reimposition of Cartesian a priori forms and categories upon the freedom of the Cézannian/Bergsonian world view; the acceptance of Cézanne as an endpoint in himself, whose approach could be only emulated rather than extended and codified, in consequence of which a neo-idealist representation of the world must be invented that would rival Cézanne in its freedom from academicism even as it provided a new universal language of representation and remained within the French Cartesian version of the classical tradition.

These three alternatives to tradition established a spectrum of possibilities for the Cubist generation. The first category corresponds to the host of Cézanne-inspired artists who emerged around 1905-07, to many of the Fauves and to the early work of such Cubists as Braque, Delaunay, and to an even greater extent Léger, was most closely allied with the second category, as were Gleizes, Metzinger and, in their diverse manners, the brothers Duchamp. Braque and Gris, each in accordance with his respectively intuitive and conceptual sensibilities, partially realized the third category. Picasso alone, and only after years of struggle culminating in his invention of Cubism in late 1912, was able fully to transcend both nineteenth-century idealism and its Cézannian/Bergsonian alternative. But even Picasso, functioning within a French context, yet also, with his strong ties to a pre-industrial Spanish heritage, as an outsider, achieved the most complete response to the logic of the historical moment without fully embracing or, indeed, acknowledging the new realities of the modern urban and industrial world. Conversely Léger, despite his only partial resolution of the historical situation, nevertheless succeeded during the course of his career in incorporating the modern world into his art to a greater degree than any other member of his generation, save perhaps for the transient efforts of Boccioni and Severini to devise an iconography that would acknowledge the existence of the modern industrial city.

These theoretical issues concerning Léger's role within the Cubist generation are clearly demonstrable in his works of 1912-14. Two paintings of 1912, *Smoke* (Cat. No. 6) and the *Woman in Blue* (Fig. No. 6), reveal his oscillation between the formalized neo-Bergsonism of *The Wedding* in the first work, while *Woman in Blue* derives more directly from the proto-Cubism of *Study for Three Portraits,* with the addition of a generalized set of red, white and blue surface-bound planes. These planes, which function almost but not quite as representational signs in the full Cubist sense, are superimposed upon an otherwise normative illusionistic scene, in bird's eye perspective, of a figure seated with hands clasped in a Victorian lathe-turned chair, beside which are two side tables, on one of which sits a goblet. The scene, and its depiction, are superficially comparable to the 1911 café scenes of Picasso and Braque; and the work as a whole is virtually as close as Léger comes to being a Cubist, with the possible exception of his 1912-13 *Nude Model in the Studio* (Fig. No. 7). In this latter work Léger evidently drew upon his efforts with *Woman in Blue* as well as upon his growing awareness of Picasso and Braque in their incipiently synthetic Cubism of 1912.

Having reached this point, however, Léger turned away from the fundamentally cognitive intentions of Cubism, and in his *Contrast of Forms* series of 1913 (Cat. No. 7) he devised his most successful personal version of what might be called neo-Bergsonism. In

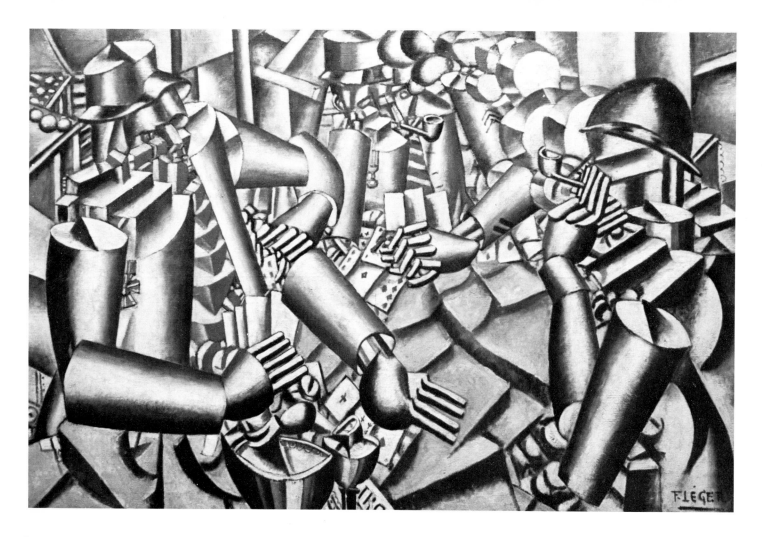

these paintings, which are nonrepresentational yet spatially illusionistic, Léger depicted carefully juxtaposed concatenations of cylindrical and cubic volumes, using primary colors and a restricted vocabulary of curved and straight lines. The resulting effect upon the viewer is that of dynamic intensity restrained by a counterbalancing of forces; and this emphasis upon sheer visual experience for its own sake was apparently Léger's conscious intention, if one judges by his statements in his 1913 and 1914 lectures at the Académie Wassiliev. Such dynamic intensity as an end in itself has obvious parallels with Futurist aims, but both Léger and the Futurists in this respect were redeploying the nineteenth-century symbolist strategy of indirect expression through correspondences: the invention of

forms or motifs that would reconstitute in the mind of the viewer the artist's original, often pre-verbal, state of mind or being. With Léger's *Contrast of Forms* that original state of mind would seem to have been attuned to an identifiably Bergsonian awareness of energy, intensity and the inner sense of the life force itself, here revived in a formal context that is the result of the imposition of a priori categories (Euclidean volumes and primary colors) upon illusionistic pictorial space. By 1914 he began to fuse the dynamic structures of his *Contrasts* with recognizable and often Cézannian motifs of houses among trees, still lifes and portraits. In other instances the iconographic themes were themselves incipiently dynamic, notably his groups of figures perched on balconies or con-

Fig. 9. Fernand Léger. *Soldiers Playing Cards (La Partie de cartes)*, 1917
oil on canvas, 50¾ x 76 (129 x 193)
Rijksmuseum Kröller-Müller, Otterlo, The Netherlands

certedly descending staircases, as in the 1914 *Stair-case* (Fig. No. 8) in Basel. By the beginning of World War I, Léger had thus reached a partially resolved, if composite, stance from which to respond to the problematic heritage of the nineteenth century. The varied components of his art — its normative if often disguised spatial illusionism, his conscious restatement of Bergsonian attitudes, his recourse to planes and forms superimposed upon his motifs, and his partial absorption and ultimate rejection of Picasso's Cubism — would all remain with him well into the 1920s. But before then he would also shift his attention to the city, the modern urban experience and the world of machines, factories and workers as the new focus of his art.

Much has been made of Léger's war experiences and of their role in his subsequent artistic and social attitudes. His well-known fascination with artillery, airplanes and the other imposing hardware of mechanized warfare has superficial parallels with Futurist rhetoric. But Léger, far from adopting the proto-fascist elements implicit in certain aspects of Futurism, developed a growing sense of camaraderie with the ordinary foot soldiers rather than with the officer corps, and he became aware of his solidarity with the uncommon abilities and force of character of the so-called common man. This affective shift to a sense of solidarity with the new urban and industrial underclass should not be confused with the traditional French veneration for village life and the supposedly noble simplicity of agrarian life, which Léger knew at first hand in his youth. It is rather a clue to his fundamental approach to knowledge and experience, which was latent during his prewar life in the midst of the rarified aesthetic atmosphere of Cubism, but which emerged with increasing clarity after 1918.

Léger's preoccupation with military hardware and the ordinary soldier and later, with industrial artifacts and the urban working class, is the external manifestation of a kind of consciousness that seizes upon effects instead of causes or processes; upon the external character of objects and people, rather than upon theoretical or structural principles or subjective thoughts and emotions: upon the surface of experience rather than upon the inner dynamics of either natural law or human logic. It is a kind of consciousness that was ordained not to penetrate to the level of invisible mental processes underlying Picasso's prewar Cubism, but instead to impose neo-Cartesian structures upon experience so that experience itself might remain safely within the limits of the physical and the objective. The resulting components of experience, once objectified, were then available to Léger for whatever representational or stylistic schema he wished to pursue. There are unavoidable parallels with French political traditions given the difficulties of changing deep-seated social structures by any means short of disruptive revolution; all other conceivable arrangements and accommodations at secondary levels are therefore preferable to cataclysmic change.

These issues surfaced in such wartime paintings as the 1916 *Smoking Soldier* and the important *Soldiers Playing Cards* of 1917 (Fig. No. 9), in both of which the immediately prewar cylindrical style was applied to the iconography of the anonymous *poilu*. Upon his return to Paris in 1918, Léger soon embraced modern urban life in a prolific outpouring of works which nevertheless incorporated his prewar stylistic discoveries even as he updated them in the light of the intervening wartime evolution of synthetic Cubism. At first, in works of 1918 such as *The Acrobats* and *The Médrano Circus,* he returned to the picturesque Parisian vignettes favored by the prewar avant-garde; but even here his stylistic methods reveal an intensification of his use of the formal elements of synthetic Cubism in combination with a conceptual extension of simultaneity. In 1918 also, Léger recapitulated a crucial aspect of Delaunay's prewar approach to modern themes via the use of colored disks. But the various versions of Léger's *Disks* during 1918 and 1919 display his growing preoccupation with formal structures and their association with the modern cityscape as opposed to Delaunay's original, optically derived use of chromatic circles. In the short period between 1918 and 1920 Léger in fact achieved a high degree of Cubist-derived formalism, even as he turned to compositional motifs which, as in the *Mechanical Elements*, 1918-23, would be con-

gruent with and absolutely suggestive of the dynamics of the industrial world. These Cubist-formalist, simultaneist and neo-symbolist approaches to the evocation of the modern city reached their fullest expression in the culminating works of this period, *The City,* 1919 and *Disks in the City,* 1919-20 (Cat. No. 16). In both paintings his calculated dismemberment and reassemblage of Cubist-derived motifs brought Léger closer to the goal of expressing modern life, through means stylistically independent of academic classicism, than almost any other works of his entire career.

Two seemingly disparate new elements appeared at about the same moment in the artist's development during the first half of the 1920s. The first was his turn to the human figure as a predominant motif in his compositions; it was heralded by his manifesto-like declaration of solidarity with the working class, *The Mechanic,* 1920, and developed in numerous portrayals of women in interior settings, notably *Three Women, (Le Grand Déjeuner),* 1921 (Fig. No. 11) and *Reading,* 1924 (Cat. No. 29). The second development stemmed from his exposure to, and increasing involvement with, Ozenfant and Le Corbusier and their activities, foremost among which was the Purist movement in painting and the publication between 1920 and 1925 of their magazine, *L'Esprit Nouveau.*

But these two new tendencies, in Léger specifically and among the postwar Parisian avant-garde generally, were not so unrelated as they might at first appear to be. Aside from such programmatic symptoms as Cocteau's book *Call to Order,* the signs of a realignment with classical or classicizing traditions surfaced as early as 1912 in Derain, following his turning away from the challenge and opportunity of Cubism. Classicism reappeared in Picasso himself in his 1914 Avignon sketches and continued through his involvement with ballet in 1917-18 to the emergence of his grandiose neo-Hellenistic figural works of the early 1920s. A similar resurgence of post-Cubist classicizing figuration emerged in artists as diverse as Severini, by 1916-17, and Braque and Gris by the early 1920s. The sculptor Henri Laurens turned gradually from his remarkable Cubist constructions of the war years to a subclassical portrayal of the female nude during the early and mid-1920s.

This resurfacing of a classicizing figuration was almost universal in the early 1920s among the artists of the prewar Cubist milieu. In almost all cases, save perhaps Picasso, it was prompted not by iconographic needs but by formal and stylistic impulses and by the cultural values associated with pre-Cubist French classicism. Picasso, the outsider, alone had reached the extreme limits of the classical tradition in his Cubist invention of a classically anti-classical style. The other members of the original Cubist generation, including Léger, thereby remained within the psychic confines of the old French Cartesian simulacrum of classicism, no matter how new and radical their latter-day versions of it might seem. Thus arose the varieties of updated academic formalism after World War I and the curious apotheosis of *valeurs plastiques* in French aesthetics. These "plastic values" in twentieth-century France, as much as in *fin-de-siècle* Anglo-American approaches to Renaissance art, were the result of sleight-of-hand compromise with academic classicism, by which Christian/humanist values were minimized and the residue of classical form was either preserved in primitive or archaic figure style or was distilled into the aesthetic imperatives of formal purity and compositional unity.

Thus it was that Léger, in works of the 1920s such as *Reading,* could reintroduce the human figure from its academic hibernation by subjecting it to consciously archaic simplifications, including Cubist-derived reductions of poses to front and side profiles, while at the same time subjecting this figure style itself to the regularities of machine forms. Similarly, the Purist stress on reductive volumes and structures — admittedly inspired by modern mechanical and engineering forms, as Ozenfant and others amply demonstrated in the pages of *L'Esprit Nouveau* — presented Léger with a readily available and almost irresistible visual syntax for his figural compositions, possibly in conjunction with the even more stringent compositional methods of Mondrian.

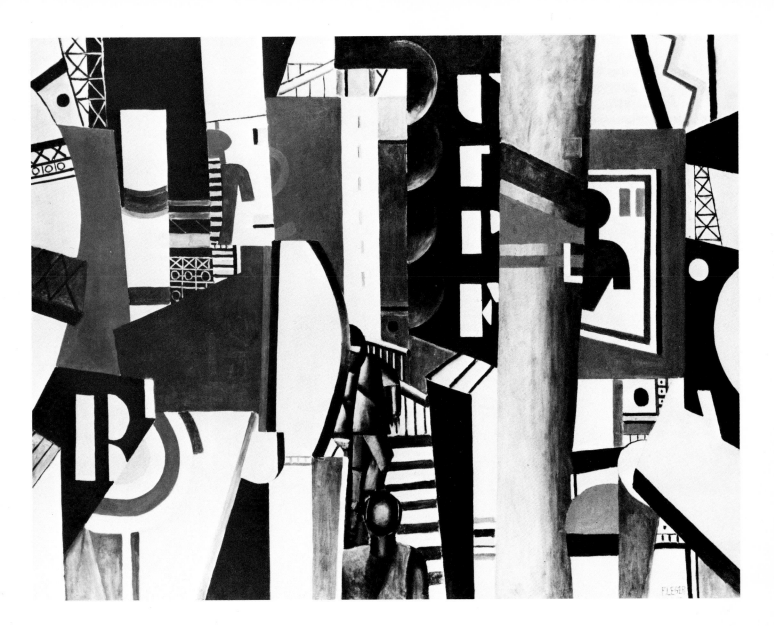

The compositional methodologies practiced by Léger during the 1920s, and the neo-archaic figuration which often accompanied these methodologies, were thus the probable and indeed almost unavoidable consequences of the incomplete transformation of classicism on the part of Léger and his Cubist contemporaries in the School of Paris. It therefore became almost inevitable, following this unrealized response to a crucial historical challenge and opportunity, that French artists would subsequently return to a neo-Cartesian imposition of identifiable structures upon experience, accompanied at best with a comparable formalized and distilled approximation of synthetic Cubist syntax. In Léger's works of the early and middle 1920s these converging formalist, post- and sub-Cubist elements reached their furthest development in a small group of paintings in which the formalist reduction has left a few recognizable motifs intact, as in *The Baluster,* 1925 (Cat. No. 33), where representational imagery has reached a quasi-mechanical regularity. In yet other

Fig. 10. Fernand Léger. *The City (La Ville),* 1919
oil on canvas, 90¾ x 117¼ (230.5 x 297.8)
Philadelphia Museum of Art, The A. E. Gallatin Collection

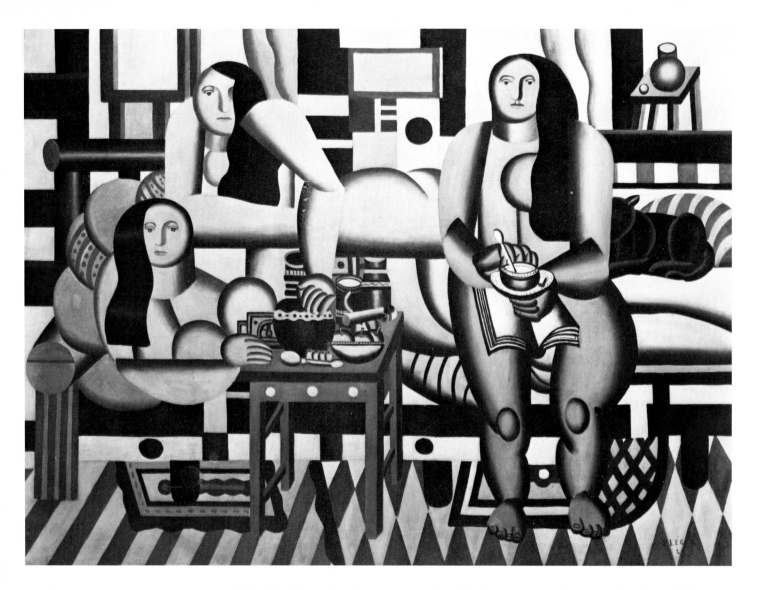

works of the period, notably his 1924-25 *Mural Painting* (Cat. No. 32), the reductive/formalist process has reached a point of apparent abstraction, with only Cubist-derived planes remaining to suggest the possibility of an original motif.

During the later 1920s Léger broadened the application of his formalist/Purist/Cubist approach so as to deal with a wider range of motifs and common objects. In such works as *Still Life With Plaster Mask* of 1927 (Cat. No. 43), much of the immediately previous style is retained, and the objects depicted are not only more recognizable than was often true in the 1920s but also comprise a believable if arbitrary studio grouping. The same cannot be said of other paintings of this period; for, beginning with such works as the 1927 *Composition With a Leaf* (Cat. No. 40) it is no longer possible to associate either the scale or the choice of juxtaposed images with the Aristotelian unities. The predominant criterion has instead become formal structure. This new tendency is even more pronounced *in Composition With Hand and Hats,* 1927 (Fig. No. 19) and in *Two Profiles,* 1928 (Cat. No. 45), in both of which the reference is to classicizing silhouettes

Fig. 11. Fernand Léger. *Three Women (Le Grand Déjeuner),* 1921
oil on canvas, 72¼ x 99 (183.5 x 251.5)
The Museum of Modern Art, New York, New York.
Mrs. Simon Guggenheim Fund

perhaps not accidentally similar to Picasso's motif in his *Painter and Model* of 1928. Far more significant is the reordered assemblage of images and motifs in these and other works of the late 1920s; for this pictorial strategy amounts to a renewed version of Léger's pre-World War I Bergsonian simultaneity, now codified and crystallized as the result of his own intervening versions of both synthetic Cubism and Purism — the latter being in itself a codified and crystallized version of Cubism.

Thus, during the middle and later 1920s, Léger's art reintroduced the issues he confronted before 1914 in an increasingly astringent and graphic manner that reflected his growing interest in popular imagery and modern advertising. But just as Léger stopped short of creating a fully Cubist art before 1914, so now at the end of the 1920s he turned away from the new Surrealist exploration of consciousness itself. Particularly revealing in this context are the works he completed at the beginning of the 1930s in which keys figure prominently, accompanied by a heterogeneous assemblage of images, ranging from leaves and open circles to the *Mona Lisa.* This new mode, while obviously derived from formal experiments of the later 1920s, was Léger's version of Surrealism. But the Freudian symbols for male and female that he employed in paintings such as *Mona Lisa With Keys,* 1930 or *Composition With Umbrella,* 1932 (Cat. No. 48), while orthodox in their references to subconscious erotic dramas, hardly achieve a Surrealist dislocation of reason but remain at best associative in psychic effect. Occasionally, as in *Composition I* of 1930 (Cat. No. 46), Léger resorted to sheer formal and stylistic means to communicate a dream-like contrast between organic female and geometric male principles, in a quasi-surrealist updating of the symbolist theory of correspondences.

Another way by which Léger responded to the Surrealist campaign against Cartesian rationality was to depict images and objects that in themselves are amorphous and thus resistant to comprehension by formal categories. His 1930 *Leaves* and his variations on the motif of a comet's tail as in *Comet's Tail on Brown Background* also of 1930 (Cat. No. 47), are two of the most characteristic examples of this object-linked surrogate of Surrealism. Léger's version of Surrealism was thus not in any truly Surrealist sense fetichistic, hallucinatory or even provocative of new psychic states that might arise from inexplicable juxtapositions. Even when he cast his heterogeneous imagery into an indefinite, dream-like space, as in the 1932 *Composition With Three Figures* (Fig. No. 12), the result is not Surrealist but formal and plastic; the Cubist heritage of blocking out and filling pictorial surface with rhythmically and spatially interlocking motifs.

Léger's chunky, pseudo-archaic figure style of the early 1920s reappeared in the mid-1930s in a more overtly schematized and primitive mode that, in the *Two Sisters* of 1935 (Cat. No. 49) and the directly resulting *Two Women and Three Objects* of 1936, was almost surely inspired by the Iberian primitivism of Picasso's late 1906 *Two Women.* Once again Léger revealed his formalist and by now modernist/academic approach in this use of a figure type; for while he acknowledged even the absence of a breast in one of Picasso's original nudes, he chose to ignore all the psychic and iconographic forces that led Picasso to the creation of this immediately pre-*Demoiselles d'Avignon* composition.

This 1930s phase of Léger's figural style culminated in the various versions of his 1935-39 *Adam and Eve* (see Cat. No. 53 for another version), in which Adam appears as a tattooed proletarian and, again, in the important and monumental *Composition With Two Parrots* of the same period (Fig. No. 14). In this latter work are summed up most of the artist's preoccupations since the early 1920s: chunky archaic figures of proletarians and circus performers; the juxtaposition of heterogeneous images; and a Cubist interweaving of bodies and objects into a surface-bound pictorial block set in ambiguous yet illusionistic space. It is a style of painting which has its roots in the similarly surface-bound yet illusionistic representations of the 1914 *Contrasts of Forms.* It is, moreover a moment in Léger's evolution which, particularly with respect to the archaic/frontal presentation of intertwined figures, contains the seeds of his principal figural compositions of the later

1940s and early 1950s.

As early as the beginning of the 1940s, during Léger's wartime exile in America, the formalist equivalence of objects and bodies had become an unbroken rule. His spatial interweave of forms into a rectangular block set in indefinite space is no less evident in the 1942-44 *Grey Acrobats* (Cat. No. 62) than in *503,* 1943-44, or *Tree in the Ladder,* 1943 (Cat. No. 63). The *Acrobats and Musicians,* 1945 (Cat. No. 68), is instructive for the way in which Léger continued his proto-academic recycling of earlier compositions, as was already evident in the 1930s. But *Acrobats and Musicians* not only incorporates the earlier versions of the three musicians theme; as a composition, it is also a free variant on the key work of the later 1930s, *Composition With Two Parrots,* and thus must be seen as a crucial intermediate prototype for the late figure compositions. It also raises a set of questions concerning Léger's working methods: there is a drawing in the Musée Léger at Biot almost identical to *Acrobats and Musicians,* although laterally reversed (see *Fernand Léger,* Berlin, Staatliche Kunsthalle, 1980-81, p. 440, Cat. No. 190). This drawing, recently dated to 1930, was clearly the source for a gouache, *The Parade,* dated 1936, and the drawing itself is squared off, indicating that it was to be used for a large-scale composition. Certain motifs in this drawing, especially a curled length of rope, do not appear elsewhere in Léger's work until about 1932. But an early version of the *Three Musicians,* dated 1930, itself based on a possibly even earlier drawing of the same theme, is also incorporated into the Biot drawing, laterally reversed. Thus, if the Biot drawing can be securely dated to around 1930-32, the genesis of much of Léger's later style, and certainly the source of many of his later motifs, may be situated in the early 1930s. We may therefore conclude that intermittently during the following two decades, Léger reemployed partial segments of his original conception. Such a working method is, of course, academic and even mannerist, especially in view of Léger's aversion to genuinely iconographic functions for his motifs and his preference for their value as formal units, to be combined or recombined toward the goal of achieving the requisite "plastic values."

A significant new element that Léger added to his stylistic repertoire during his wartime years in America was the superimposition of wide and usually curved transparent swathes of primary colors upon his motifs. An early example is *The Dance,* 1942, but Léger used this inherently surface-bound pictorial device in many of his late works, where it was especially suitable for the large mural scale and decorative character of compositions like *The Great Parade* of 1954 (Fig. No. 13). The immediate source of this stylistic device was his experience in Times Square of seeing the play of colored light from outdoor advertising projectors upon people and objects at night. But these swathes are also the formal and literalized descendants of synthetic Cubism, where color planes linked together otherwise disparate compositional elements.

The late work of Léger is problematic and it exemplifies the impasse reached by the School of Paris before World War II. Of the surviving members of early twentieth-century modernism in France only Matisse and Picasso would develop anything resembling a distinct late style in the traditional sense. Léger is a characteristic figure within the French modern tradition in that he extended and elaborated upon long-established aesthetic positions. His postwar style is a continuation of approaches that he had for the most part formulated earlier. His preference for formally interchangeable motifs superceded the need for thematic invention, with the one exception of his *Constructors* series of the early 1950s. Here, he updated his earlier sympathies for the urban/industrial milieu and the proletarian worker. His most celebrated late paintings— themes such as *The Country Outing* and *The Great Parade,* along with their many close variants—are essentially free versions of a single formal idea, the original statement of which appeared as early as 1930. It is this interchangeability of a given formal configuration in Léger's late work that underscores his preference for style and composition at the expense of iconography. Léger's late work is thus an accomplished if predictable continuation of attitudes, forms and styles which he had already developed to a virtually definitive point in such works as his *Composition With Two Parrots* of the late 1930s. There he also reached his formal mastery of large scale, along with the mural-

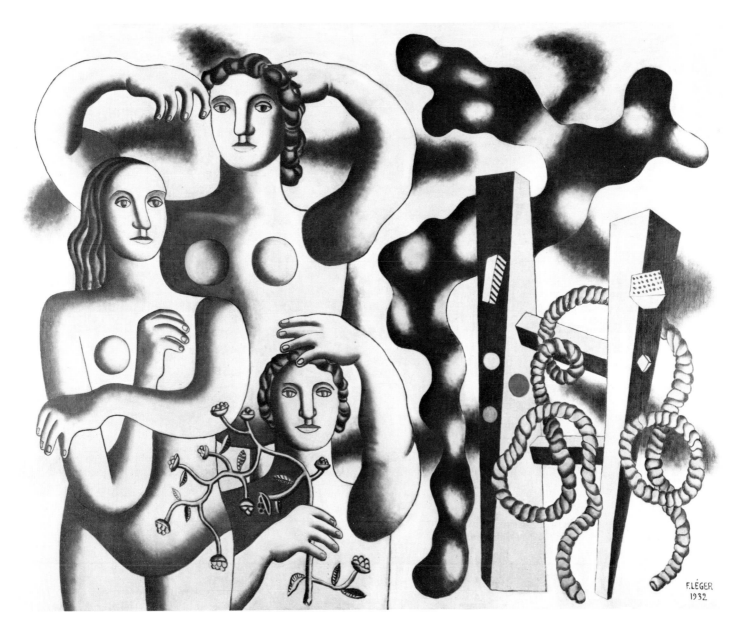

like clarity and simplicity that, together with his color swathes of the early 1940s, are the most prominent and successful aspects of the late paintings.

The central issue presented by Léger's work as a whole is the adequacy of style and formal values as a basis for modern painting. It is an issue which emerges only gradually in his development, being partially obscured before 1914 by his exploration of Cubism, during the 1920s by his engagement with urban/proletarian ico-

nography, and in the early 1930s by his version of surrealism. Léger's formal gifts were considerable, and they increased with the scale and simplicity of his later work. The subtlety and finesse of his 1910-14 accomplishments were transformed into a schematic generalization of the Cubist planar grid, of which the late *Constructors* series is the final perfected version. It is ironic that Léger, who was never a truly Cubist artist, would later reach a large public with a nominally representational style based on Cubist-derived formal ele-

Fig. 12. Fernand Léger. *Composition With Three Figures*
(Composition aux trois figures) 1932
oil on canvas, 71 11/16 x 91 5/16 (128 x 232)
Musée National d'Art Moderne, Paris

25

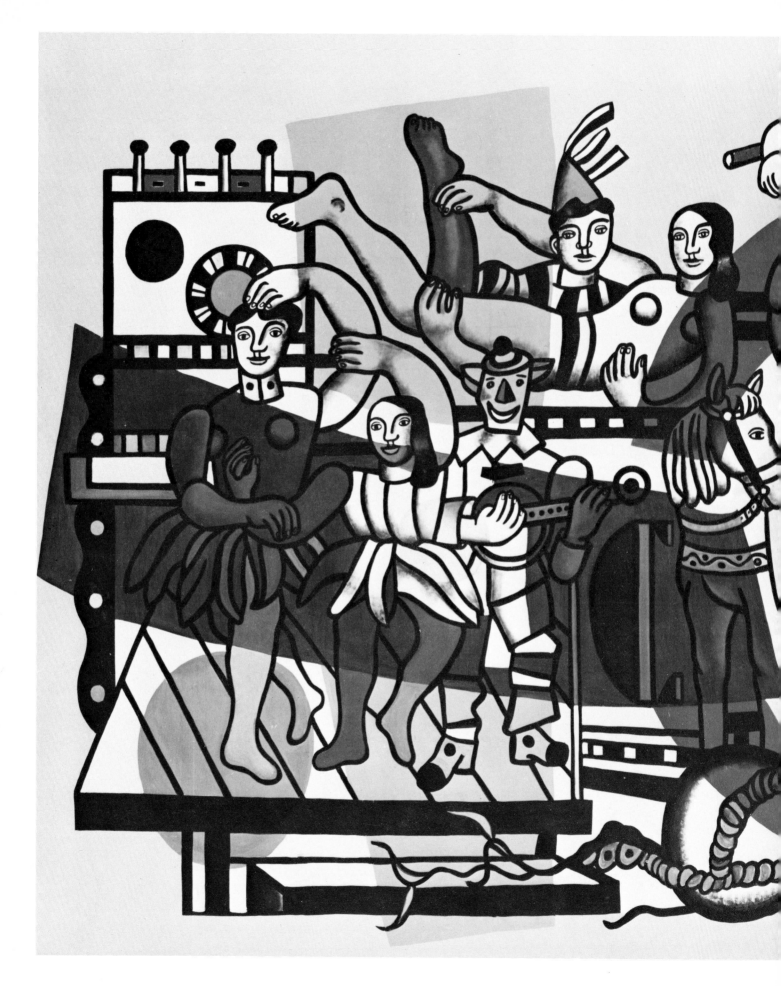

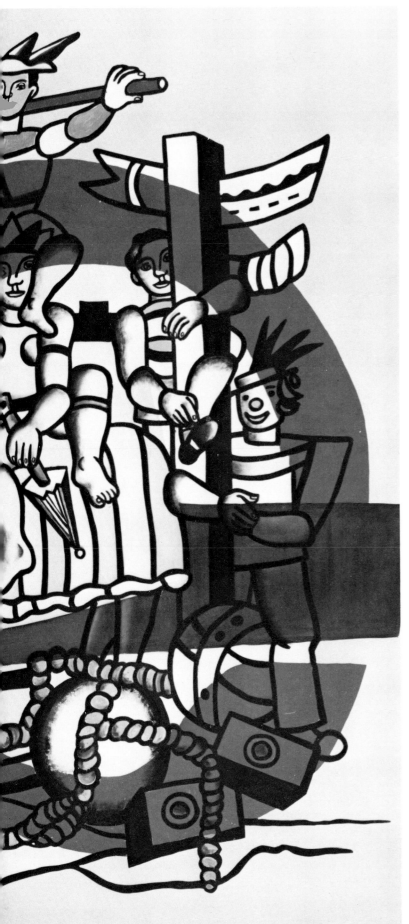

ments. The obvious parallel is with Picasso, but on a formal level only; for Picasso's later work, from the 1930s to the end, was not based on the artist's prior stylistic inventions alone. It was, rather, generated by his own intensely lived private experiences for the adequate rendition of which he was always reinterpreting not just his own Cubism but much of the history of art as well. Léger by contrast seems always to have been a public or at least antisubjective personality in his art. Objects, artifacts, buildings, plants, the human figure as formal object — the familiar trappings of everyday life provided the major inspiration for Léger's art. Almost all of his extensive writings were concerned either with formal problems or with the physical experience of the modern world, the modern city and modern innovations — from the cinema to publicity to industrial design.

In many ways Léger became a French, Cubist-derived equivalent of the attitudes and ideals of the Bauhaus, including its neo-medieval collectivism in both its internal organization and in its external political allegiances. The French equivalent of Bauhaus attitudes had its immediate locus in the milieu of *L'Esprit Nouveau,* and its emphasis on the impersonal, material and implicitly collective bases of modern life, as was subsequently demonstrated by the political ideals of its founders, Ozenfant and Le Corbusier, and their commitment to non-Marxist yet collective social goals. Léger himself joined the French Communist Party at the end of World War II.

It is, however, more important to realize that Léger was born before the Eiffel Tower was erected. His was the generation that witnessed a wholesale material transformation of everyday life, in which candle and gaslight gave way to electricity, the horsecart to the automobile and airplane; and above all, in which a predominantly rural society was becoming increasingly and unremittingly urban. Such a transformation of social conditions also created a new cultural situation, exemplified by Léger, whereby the old simplicities and certainties of visible, tangible experience remained present in altered form within the rapidly expanding urban environment. There, in the quintessential transaction of

Fig. 13. Fernand Léger. *The Great Parade (La Grande Parade),* 1954
oil on canvas, 117¾ x 157⅛ (299 x 400)
The Solomon R. Guggenheim Museum, New York, New York

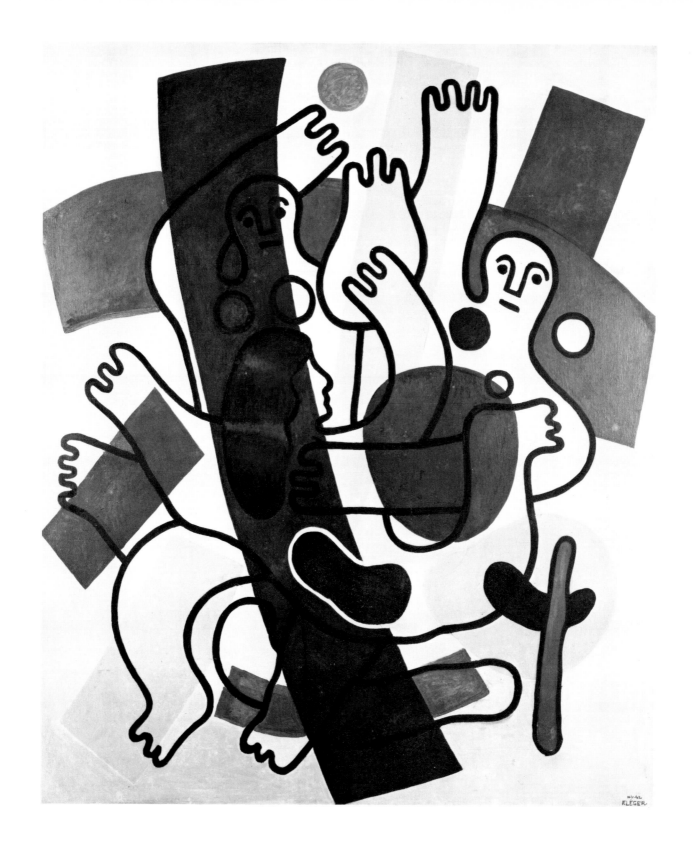

Cat. 59. *The Dance (La Danse),* 1942
Galerie Louise Leiris, Paris

(Right) Fig. 14. Fernand Léger. *Composition With Two Parrots
(Composition aux deux perroquets),* 1935-39
oil on canvas, 156 x 187⅕ (400 x 480)
Musée National d'Art Moderne, Paris

twentieth-century life and art, the direct experience of the natural world was gradually supplanted by the rise of the new, artificial nature of man-made tools, machines and all the other appurtenances of the modern city. At first, this new world of human artifice would be seen with eyes and minds conditioned by nature. Later, long after Léger's generation had reached maturity, urban reality would be understood in its own terms. The overall direction of this change was from the dualist phenomenology of man and nature to the more internalized and abstracted mental phenomenology of man and culture.

There is a trajectory of gradual change in Léger's art over a period of fifty years, from his direct involvement with the visible world of nature before 1909, to an interaction between mind and the world from around 1910 through the 1920s, to a preoccupation with the purely abstract mental and cultural world of form, style and structure after 1930. Léger's work thus parallels the fundamental shift in human experience during the twentieth century. But even at the end, he never quite let go of those vestiges of direct experience which remained from his youth, just as he never left the visible world in order to explore the invisible subjective mind. For him the goal was always either the direct experience, the object, or the rearrangement of objects into a clear-cut external and physical order. Such are the limitations but also the enduring virtues of his art.

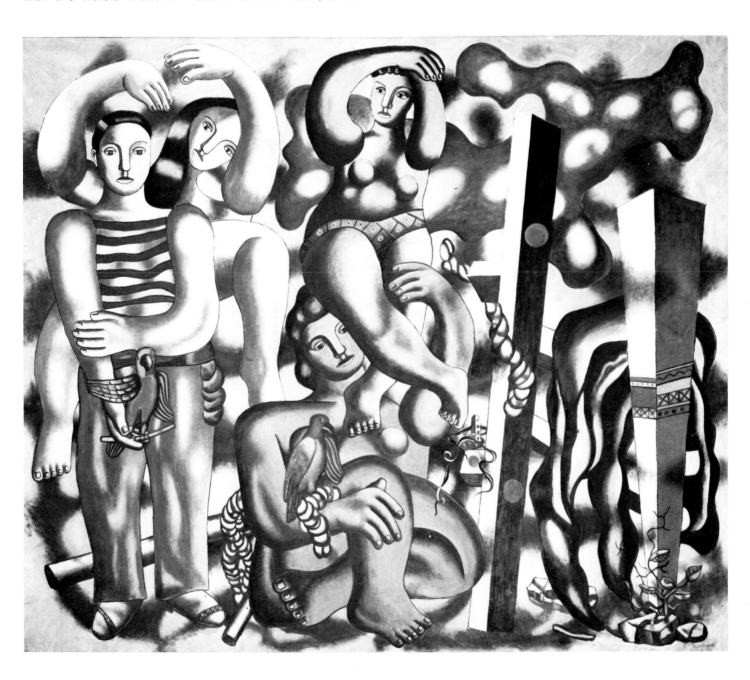

Fig. 15. Léger and Le Corbusier at Vezelay, 1938.

During the decade that began in 1918, Léger produced some of his most important and advanced works. At that time, his style, more than that of any other French artist of the period, came close to employing the new international visual language, known in Paris as Purism. Constructivism, Suprematism, de Stijl and other movements had all had their flowering, but had very little real

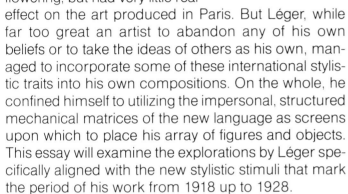

BY ROBERT T. BUCK

new themes, many of which would remain with him throughout his career, while simultaneously exploring a range of ideas, some of which gradually disappear from his work. Extolling the new age of man and his machines, Léger depicted the human being as a harmonious element of the fabricated environment. His move to depersonalize his work and rid the human element of sentimentality led him to create a new race of peaceful giants amidst a concentration of perfectly intermeshed mechanical elements.

effect on the art produced in Paris. But Léger, while far too great an artist to abandon any of his own beliefs or to take the ideas of others as his own, managed to incorporate some of these international stylistic traits into his own compositions. On the whole, he confined himself to utilizing the impersonal, structured mechanical matrices of the new language as screens upon which to place his array of figures and objects. This essay will examine the explorations by Léger specifically aligned with the new stylistic stimuli that mark the period of his work from 1918 up to 1928.

In his landscape paintings of this period, the subjects tend to be factories or other industrial buildings. The human figure, if it appears at all, is dwarfed in comparison to the scale and dynamics of interlocking urban structures, as can be seen in *Animated Landscape,* 1921 (Cat. No. 23). At the start of this productive period, Léger created two of his most important canvases, *The City,* 1919 (Fig. No. 10), now in the collection of the Philadelphia Museum of Art, and the related *Disks in the City,* 1919-20 (Cat. No. 16). Other cardinal works from the period upon which the artist's early reputation rests are: *The Typographer,* 1917-18 (Fig. No. 17); *The Mechanic,* 1920 (Fig. No. 18); *Three Women* (known as *Le Grand Déjeuner),* 1921 (Fig. No.11); and *Reading,* 1924 (Cat. No. 29). The last work was acknowledged immediately after its completion as one of Léger's most beautiful works, exemplary for an understanding of his handling of Purist concerns.

In this intense and rich decade, the artist developed

The Typographer was painted shortly after *The Card Players,* 1917, the last painting of the early portion of Léger's career, which has been defined as spanning 1905-18. However, a comparison of the two works reveals that they are worlds apart and that *The Card Players* has more stylistic affinity with Léger's first masterpiece, *Nudes in the Forest,* dating from 1909-10, than it does with *The Typographer,* which was begun late in the same year. The so-called "tubular" style of Léger, criticized as such from the start when he first used it in the *Nudes,* has all but disappeared from *The Typographer,* in which the brilliantly colored geometric elements of the composition are essentially two-dimensional. The effect is a sort of visual staccato, recalling the otherwise entirely dissimilar *Nude Descending the Staircase* of Marcel Duchamp. *The Typographer,* seen half from the back, blends into his surroundings so successfully that the viewer is obliged to study the compositional elements carefully in order to extricate the figure from its environment. The subject appears to be studying a press plate, only one letter of which, a giant "R," is actually discernible to the viewer. The illusion of a third dimension plays no part in this work and the artist specifically obscures any possible reference to spatial dimension in depth by the overlapping of elements. The curious round cap worn by the typographer thus becomes hinged to the background by a system recalling Suprematist

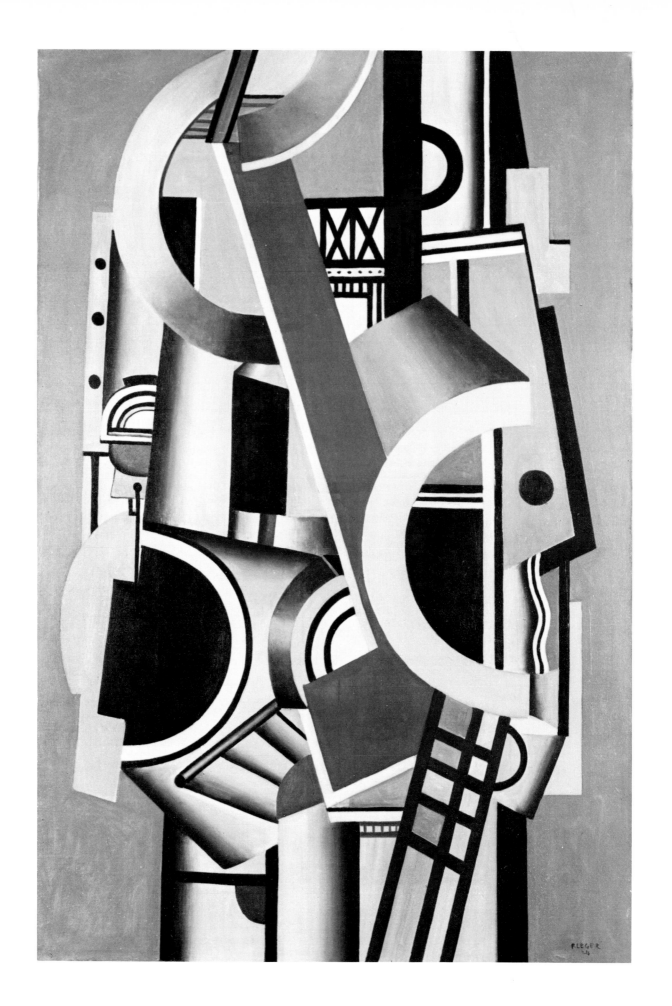

and de Stijl techniques. The background refuses to stay in place, however, and slips downward over the cap, again flattening out the work.

The significance for Léger of *The City,* both in terms of its extraordinary scale and the effect on the work that follows, was enormous. Several other works of this period, included in the exhibition, are close in style; indeed, some may actually have been preparatory studies. Some, such as *The Disks,* 1918 (Cat. No. 12); *Composition 1918 — The Disk,* 1918 (Cat. No. 10); *In the Factory,* 1918 (Cat. No. 11); *Follow the Arrow,* 1919 (Cat. No. 15), and *Still Life,* 1919, appear to be reworked portions of the larger composition. All of these are consistent intensifications of the style the artist developed in *The Typographer* and then expanded in *The City,* revealing a dramatic foreshortening of space, the total subordination of any human element to the mechanized environment, and a heightened sense of urgency resulting from the exaggeration of scale.

A curious and singular work done in 1919, *Abstract Composition,* appears to have no real precedent in Léger's work nor any direct later reference. This sizeable, tremendously powerful work presents the outline of a vaguely human form entirely subjected to a new segmented, emblematic vocabulary. In powerful, broad sections of primary color, Léger builds a figure at once as confident and structured as the new architecture, which culminated a few years later, notably in the work of Le Corbusier and in the Bauhaus style. The work is a personal *tour de force* of reductivist thinking, a step which the artist never pursued to quite the same degree again, with the possible exception of the entirely architectonic *Mural Composition,* 1926-36 (Cat. No. 39).

Léger's incorporation of the human figure into the compositions during the years dating from 1919 to 1921 differs significantly from the radical departure of *Abstract Composition* and returns to the example provided by *The Typographer.* The human figure is viewed as harmonious and integral, even subdued, in its surroundings and not in any way out of place. The sense of belonging with which the artist imbued his subjects, and their peaceful, strong attitudes are no doubt Léger's personal, confident expression of faith in contrast to the destructive, dark side of man which he had experienced at first hand during his service in World War I. Proud of his peasant background, Léger's personal philosophy embraced that sense of harmony with nature common to farmers. But with his broader life experience, Léger was also able to convey this harmony in his observation of the new urban landscape.

In works such as *Three Friends,* 1920 (Cat. No. 18), *Man With a Pipe,* 1920 (Cat. No. 17), and the two *Animated Landscapes,* 1921 (Cat. Nos. 22 and 23), modeling and shading of form have reappeared. In these later works these elements are stronger and add a sense of relief and, simultaneously, a greater focus on the figure. The geometrical background matrices upon which all compositional elements are placed in these works consist of bars of color intersecting mostly at right angles, where the influence of de Stijl painters and especially Mondrian, who had lived in Paris intermittently from 1911 to 1938, can be felt. The earlier works retain the disks and other symbols, often borrowed from railroad signals or other transportation codes, while one of the *Animated Landscapes* has a background imitative of Norman half-timbered farm architecture (Cat. No. 22). The other appears to contain a factory rendered in the same strong, right-angled motifs noted before (complete with a fuming smokestack).

It is in his still lifes and mural compositions of 1924-26 that Léger comes closest to Purism — that Parisian art movement generally regarded as the creation of Amédée Ozenfant and Charles-Edouard Jeanneret-Gris (the latter more commonly known as the architect, Le Corbusier). His works in this mode are, nonetheless, exclamatory, commanding, and arresting. They are by no means formalistic exercises in a new trend. As with all he attempted, Léger dealt with the possibilities of a strict formalism head-on, full tilt, and with boundless optimism.

Mural Composition, 1924 (Cat. No. 28) is the least

Fig. 16. Fernand Léger. *Mechanical Element (Elément mécanique),* 1924
oil on canvas, 57½ x 38¼ (146 x 97)
Musée National d'Art Moderne, Paris

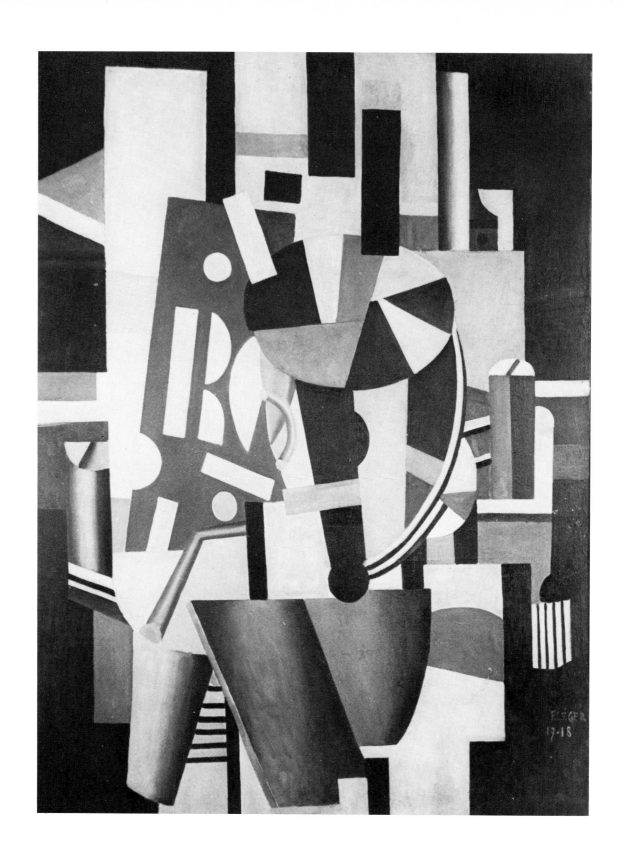

Fig. 17. Fernand Léger. *The Typographer (Le Typographe),* 1917-18
oil on canvas, 97 x 71½ (246.4 x 181.6)
Mr. and Mrs. Harold Diamond

personally identifiable of Léger's nonobjective works. This represents an enormous effort on his part to purge the composition of any but the most pure elements. The flatness of the wall is maintained and there are curved lines, although some are purposely drawn free-hand, as can be seen at the right edge of the work. The format, approximating a square, is quite unlike Léger's other vertical works of this style and much closer to the Purist movement. Léger characteristically and defiantly signed the work prominently in the lower right corner, a gesture in this case which could be seen as an intrusion into the purity of the style.

Another important example of Léger's efforts in Purist vocabulary is *Mural Painting,* 1924-25 (Cat. No. 32). The work's vertical format gives it immediate architectural affiliations, e.g., the shape of windows and doors, beyond the obvious title reference which he gave these particular works. This painting, like *Mural Composition,* is rendered in curiously subdued tones of color. It is as if Léger felt that the full effect of the vibrant, contrasting strong color that he preferred would have resulted in too overwhelming an effect. In *Mural Painting* the artist also breaks away from his use of straight lines that only intersect at ninety-degree angles and introduces a slowly curving border at the sides of two blocks of color. A rhythmic tension is thus created by a surprisingly simple method.

A third important nonobjective work of the period is entitled *Composition-Mechanical Elements,* 1925. This painting, in some ways, is the least characteristic of the three. Again muted in its tonalities, the work is dominated by two oddly angled black bars on white ground, one of which curves back before moving off the field of the painting at the top. A large, peculiar, balloonlike shape hovers behind these forms interspersed with segments of spheres, domino shapes, part of a picture frame, and even some things that look just like loose electric wires. In this last element, the ever-present humor of Léger is abundantly evident and the motif is reminiscent of similar images appearing in Francis Picabia's drawings of the same time. An oddly compelling work, *Composition-Mechanical Elements* is nonetheless the least typical of the artist's

efforts in the nonobjective mode — cramped, incongruously composed, busy, and disjunct. After this, Léger abandoned any further attempts into nonobjectivity per se, which was based on a lifetime of stylistic concerns that followed a mode of expression that would have been unnatural for him. The artist once commented on this issue:

> Purism never touched me; too meager for me that thing, that closed world. But it was nonetheless necessary that if it be done, that one go to the extreme.[1]

Among the outstanding works by Léger, *Reading* occupies a special place. The work was painted the same year that Léger completed his extraordinary film, *Le Ballet Mécanique,* with camera work by Man Ray and Dudley Murphy and a musical score by Georges Antheil. The film was the first produced with no scenario and consists of objects set into motion. Aside from being an important personal proof exercising "objectivity" in the most direct manner, the film had no effect on his painting, since, as he later explained, objectivity in movement is different from the immobile objectivity of painting which is achieved by contrast. The significant achievement which this film represents underscores the fertile agility of Léger's mind in this period during which he explores all possible avenues leading to his artistic goal.

Reading is the culmination of Léger's work, starting in 1920, on the theme of women in an interior space. Many of these works are of great importance (notably *Three Women,* at The Museum of Modern Art and *Woman Holding Flowers,* 1922, in the Nordrhein-Westfalen Collection, Dusseldorf), but *Reading* is the final presentation of a theme that had much occupied him and, of his figurative works, is the one that is the most affected by his Purist interests. The immediacy of the forms, exaggerated in their compelling though static presence, as if projected outward from the canvas, is clearly related to the cinematographic experience which he had just completed and which dealt with the field of the picture and its technical effects. A unity is achieved through the simplification and exaggeration of forms. He has, however, dropped the descriptive

Fig. 18. Fernand Léger. *The Mechanic (Le Mécanicien),* 1920
oil on canvas, 45½ x 34¾ (115.5 x 88.3)
The National Gallery of Canada, Ottawa, Canada

interior details, such as furniture, that appeared in the backgrounds of previous works developed along the same theme.

There exist several preparatory paintings and drawings for each of the two figures. The most startling difference and indeed, a troubling detail to the artist's contemporaries, is the disappearance of hair on the woman on the right of the painting. Explaining the situation to a friend some thirty years later, Léger wrote:

> I remember that when I brought *Reading* to Rosenberg [the artist's dealer at the time — *author's note*], I was short of money. He looked at the painting and said to me, 'But the woman has no hair. Listen, be reasonable, put a little on her. She has a scorched air. It's disagreeable to look at.' And he insisted. But really, with the best of goodwill, I could not put hair on her. I simply could not. In the place where her head was, I needed a clear and round form.[2]

The figures, modeled in the smooth, bulging forms seen so consistently in his works of the period, are imposing in their classical monumentality. The background orchestration of abstract forms is perhaps the most perfect of all of Léger's Purist attempts in this regard, while the foreground details of books and flowers serve through color and dynamic line to propel the figures forward with greater intensity. To achieve the greatest possible effect, the artist created the composition with a strict economy of means.

The year 1924 yielded a number of other works that were refinements of themes in the process of development or indications of future directions. *The Syphon* (Cat. No. 31) and *Still Life* (Cat. No. 30) are interior fragments related to studies for *The Breakfast, Mother and Child* of 1922, and *Reading*. From his experience as a film director, Léger transfers to the canvas in *The Syphon* the partial human figure in the form of the hand working the seltzer bottle mechanism, the exact moment chosen being that of the physical exertion. The work is Léger's first representation of the partial human figure, a technique he employed in *The Mirror* of the following year (Cat. No. 36), in *Composition With Hand and Hats*, 1927 (Fig. No. 19), and especially in later murals (such as his work in the gymnasium of the French pavilion of the Brussels Inter-

national Exhibition of 1935). Obvious in its humor, *The Syphon* contains curious formalistic contrasts implied by the intricately constructed Purist background, the stability of which serves literally as a relief to the physical movement of the hand. The simple act of working the system is so monumentalized by Léger as to imply a sardonic, Bergsonian wit at work behind it all. The artist's attitude in this regard was exceptional, as is frequently revealed by the works created in 1924, including *Reading*. The larger, serene *Still Life* repeats the same general compositional detail as *The Syphon*, concentrating on contrasted physical forms in place of movement but containing no human element.

In *Composition*, 1924 (Cat. No. 27), Léger continues to add detail to the structured interlocking of forms developed in *Mural Composition* and *Mural Painting*. This work, like those previously mentioned, was meant to represent part of a painted wall, serving as the ultimate enhancement for the new interior architectural spaces of the age and, in particular, those of Le Corbusier.[3] This was the case with *The Baluster*, 1925 (Cat. No. 33), which was first seen in the demonstration house by Le Corbusier at the Paris International Exhibition of Decorative Arts of the same year. Léger described the effects he was seeking as follows:

> About 1922-4 architects had rid walls of the welter of ornamentation imposed on them by the taste of the 1900s. White walls began to appear, and both Delaunay and myself managed to liberate color, too. Blue was no longer inevitably associated with the sky, nor green with trees. Pure tones were becoming independent and could be used objectively.

> Walls, being free from ornamentation, now invited new experiments with color. The coloring of wall surfaces modified one's impression of the appearance and dimensions of the rectangular habitation, a yellow area giving an impression of distance, while red appears closer. The rectangle, which had hitherto seemed fixed, had become elastic. . . . The new space was expanding still further.[4]

The accumulation of detail over the Purist grounds that are essentially alien to Léger's artistic psyche, results in a series of still-life works from 1926-28 which formulate objects within definitions of his "new space." It is a technique that he pursued in variants for the rest of his career.

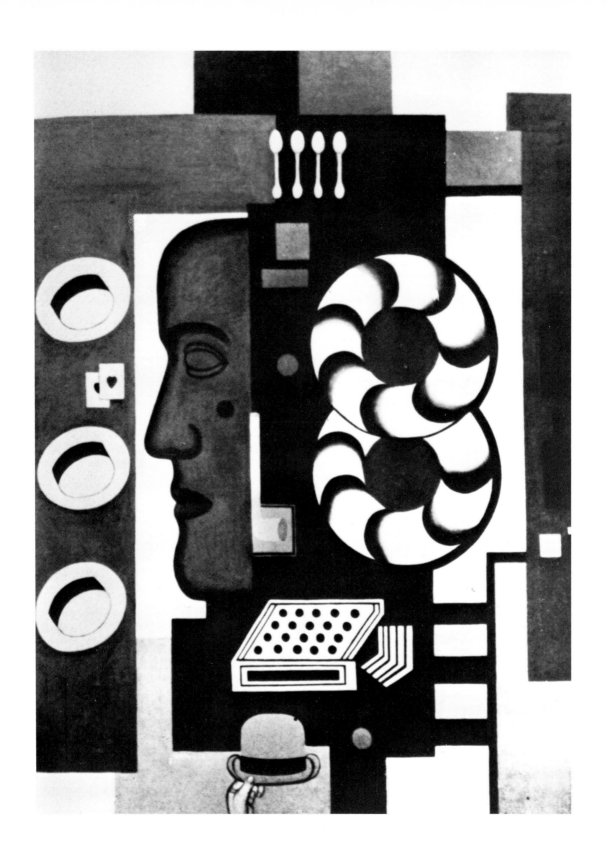

Fig. 19. Fernand Léger. *Composition With Hand and Hats
(Composition à la main et aux chapeaux)*, 1927
oil on canvas, 96¾ x 72⅕ (248 x 185)
Galerie Adrien Maeght, Paris

The first of these works chronologically, *The Accordion,* 1926 (Cat. No. 38), is also the last of Léger's Purist attempts. It is also a work of exceptional formal refinement and, in its compositional intricacies, somehow resembles an immense bottle form, not unlike those found in works of Ozenfant and Jeanneret, more than it resembles a musical instrument.

Shortly after this, Léger's attitudes shift, as can be seen in the paintings of 1927-28. These works generally return to an isolation of the object placed freely in other-worldly space, thus allowing Léger to concentrate fully on the object as subject and to illustrate its accompanying philosophy. The still life as subject matter served his purposes particularly well and was the dominant and important work of these years. Six important still-life paintings of the period — *Composition With Keys,* 1927; *Composition With a Leaf,* 1927 (Cat. No. 40); *Still Life ABC,* 1927 (Cat. No. 42); *Still Life With Plaster Mask,* 1927 (Cat. No. 43); *Two Profiles,* 1928 (Cat. No. 45); and *Composition With Hand and Hats* — demonstrate Léger's renewed focus and his enthusiastic return to a philosophy of the dominance of the object as the visual starting point. The accumulation of objects, the human figure being only one of them, was his perceived reality and he wrote:

> The subject no longer being principally the personage, the object replaces it. At this moment, in the spirit of the modern artist, a cloud, a machine, a tree are elements of the same interest as personages or figures. Some new paintings, some large compositions are thus going to be realized from an entirely different visual angle.[5]

These works mark the end of one period of Léger's development, in many ways the most important and, perhaps, the most creative of his career. At the same time, with their declaration of the return of object as subject for Léger, they indicated a turning point in the artist's work. Henceforth, he turned his attention to other formalistic developments, away from past experimentation, in directions that he continued to follow for the remainder of his productive career. It was as if he began to carve and sculpt in paint.

One work especially appears to be the quintessential statement of the direction he was to take. *Nude on a Red Background,* 1927 (Cat. No. 41) is the absolute isolation of one object/subject on a monochromatic background, the whole composed of a strength, dignity and dynamism worthy of one of the twentieth century's truly great artists. The immediacy and power of the work point the way to the future and in the artist's words:

> It's not the beauty of the thing that one has to paint which counts but the manner in which one plastically recreates the object, even if this last be a key. It is necessary then that this key have the dignity of an 'existent' object.[6]

Thus we may conclude that it was his enthusiastic and, in his own manner, existential embrace of reality, the world and life — his lifelong series of affirmations in paint — that was at the root of the genius of Fernand Léger.

FOOTNOTES

(1) English translation by author from French text by Fernand Léger in *Fernand Léger 1881-1955.* Paris: Musée des Arts Décoratifs, 1956, p. 172.
(2) English translation by author from French text by Fernand Léger in *Fernand Léger.* Paris: Musée National d'Art Moderne, 1971, p. 16.
(3) C. Green, "Painting for the Corbusian Home: Fernand Léger's Architectural Painting," *Studio International,* Vol. CXC, 1975, pp. 103-7.
(4) Felix H. Man, *Eight European Artists.* London: Wm. Heinemann, Ltd., 1954, p. 68.
(5) Musée des Arts Décoratifs, 1956, p. 192.
(6) Ibid, p. 206.

Fig. 20. Léger in New York, 1938.

LÉGER AND AMERICA

BY CHARLOTTA KOTIK

When Fernand Léger arrived in the United States on November 12, 1940, fleeing from defeated France, he was not a newcomer. During his previous extended visits in 1931, 1935 and his most recent one, spanning parts of 1938 and 1939, Léger had become familiar with the unique spirit of this country, which he came to admire and understand more profoundly than any other of the exiled artists. His own temperament was ideally suited to the American experience; from the very beginning his profound interest in the achievements of the modern era frequently led Léger to employ images derived from his empathetic understanding of mechanization and power. Léger's work had always explored the dynamism created by the juxtaposition of seemingly opposing elements — exploration of contrasts — and the American environment provided him with more than he had ever before encountered.

He was exhilarated by the overwhelming dynamism of contrasts inherent in the American situation: the lush vegetation and the deserts; the natural beauty and the industrial devastation; the small New England towns and the dynamic large urban centers; the unsurpassed scientific achievements side by side with total illiteracy; the infinite wealth and the dire poverty. His imagination was fired by the diversity of human types: by white and colored men living and working together, striving to improve the general lot. The pragmatic optimism he encountered in everyday American life was especially invigorating to a man emerging from war-torn Europe, which had been brought to the point of destruction by the psychology of racial hatred. In the Europe of Hitler and World War II, there had been little possibility of creativity and none, certainly, for a creativity of such vitality, directness and innate humanism as that of Fernand Léger. For him, if he was to be able to survive as an artist, the move to the United States was essential.

The change of environment provided Léger with fresh stimuli which he urgently needed to sustain the intensity of his work. It is generally accepted that the 1930s, although a period in which he created numerous outstanding works, almost all of them large-scale, were to a certain extent a time of stagnation in his artistic career. On the one hand, he produced several compositions that were static to the point of stiffness while, on the other, his attempts to loosen his style bordered on compositional confusion. Many of his works of this period failed to capture the originality and vitality of the previous two decades.

But almost from the moment of his arrival in New York, Léger's work assumed new splendor. The unbounded zest for life, the mass production of ingenious inventions, tolerance of the bizarre and, above all, the perpetual mobility, charged Léger's work with new energy. The most vital parts of his oeuvre have always responded to external stimuli, especially to those provided by an urban environment — and so, naturally the technology and materialism of America could not fail to have an inherent and enduring fascination for Léger. To what degree his extended visit influenced his work, however, has been frequently debated and there are conflicting opinions on this point.

> There is no specifically American period in Léger's artistic development. His art evolved slowly from its own premises. But there was an American phenomenon that made an impact on his art: Times Square at night, with the flashing lights of the advertisements throwing constantly changing colors on the scene. That experience led him to employ stripes and patches of color more freely and independently of the design. Léger applied this principle of free-colored forms in a large number of his works . . . but it did not dominate his late period. . . .
>
> Another American experience was that of "bad taste," which, if it did not influence him, at least confirmed him in his chosen path. In other respects America did not change either Léger's style or his subject matter. He was almost sixty years old when he settled there, and he no longer needed external stimuli.[1]

This is how Werner Schmalenbach, German art historian of distinction and authority on Léger, sum-

marized characteristics of Léger's work produced in the United States during the artist's stay here between 1940 and 1945.

> But during these years in America I do feel I have worked with greater intensity and achieved more expression than in my previous work. In this country there is a definitely romantic atmosphere in the good sense of the word — an increased sense of movement and violence.... I prefer to see America through its contrasts — its vitality, its litter and its waste.... Perhaps it is my old interest in "the object." But in any case the American period of my painting has certainly been different from the French.... What has come out most notably, however, in the work I have done in America is in my opinion a new energy — an increased movement within the composition.... And as a matter of fact I cannot imagine that my series of 1942 of moving figures would have ever been possible there [France].[2]

Those are the words of Fernand Léger himself, who obviously felt that his sojourn in America influenced his work to a greater degree than has been commonly believed until now. And indeed, a study of the work Léger accomplished during his stay in this country, would quickly reveal a distinct change in both the iconography and the formal structure of his oeuvre. And it would further become apparent that some of the new subject matter, as well as the stylistic innovation, did not, as has sometimes been suggested, disappear from his work after he left the United States, but became permanent components of his subsequent work.

Léger had learned a great deal about the United States long before his wartime arrival. In the 1920s, the Parisian avant-garde had developed a great interest in everything American. This was to a large degree due to the sudden influx of American expatriates — men and women of dazzling talents and, frequently, even more dazzling lifestyles. One of the legendary figures among them was Gerald Murphy, who had originally trained as a landscape architect, but who, under the influence of Cubist and Purist works he had seen in Paris, decided to become a painter.[3] Léger's painting, with its emphasis on subjects drawn from everyday life, was especially fascinating to Murphy, while his own meticulously executed canvases, certainly did not escape Léger's attention.

Léger prided himself on being the first modern painter to incorporate the images of the machine age into his compositions and could certainly be called a forerunner of the movement which was to become known in the early 1960s as Pop Art. Frequently depicting common mass-produced objects in a direct and immediately comprehensible manner, Léger painted concrete and legible images. His color tended to be flat, emblematic and impersonally applied, his iconography explicit and usually defined by a group of nonnarrative images.

This iconography was based on real things that are part of the everyday world — images of popular culture, household objects and billboard signs — as well as on references to other art works made known and commercialized through modern reproduction techniques. Typical of this new juxtaposition and of the manipulation of one artist's work by another, is Léger's *Mona Lisa With Keys*, 1930 (Fig. No. 22). In it, a bunch of keys and a can of sardines, two very mundane objects, are placed on the same level of iconographic hierarchy as the *Mona Lisa,* long an image considered an unsurpassable masterpiece.

Fig. 21. Gerald Murphy. *Razor,* 1922
oil on canvas, 32⅝ x 36½ (82.9 x 92.7)
Dallas Museum of Fine Arts, Foundation for the Arts Collection,
gift of Mr. Gerald Murphy

(Right) Fig. 22. Fernand Léger. *Mona Lisa With Keys (La Joconde aux clés),* 1930
oil on canvas, 35¹³⁄₁₆ x 28⅜ (91 x 72)
Musée National Fernand Léger, Biot, France

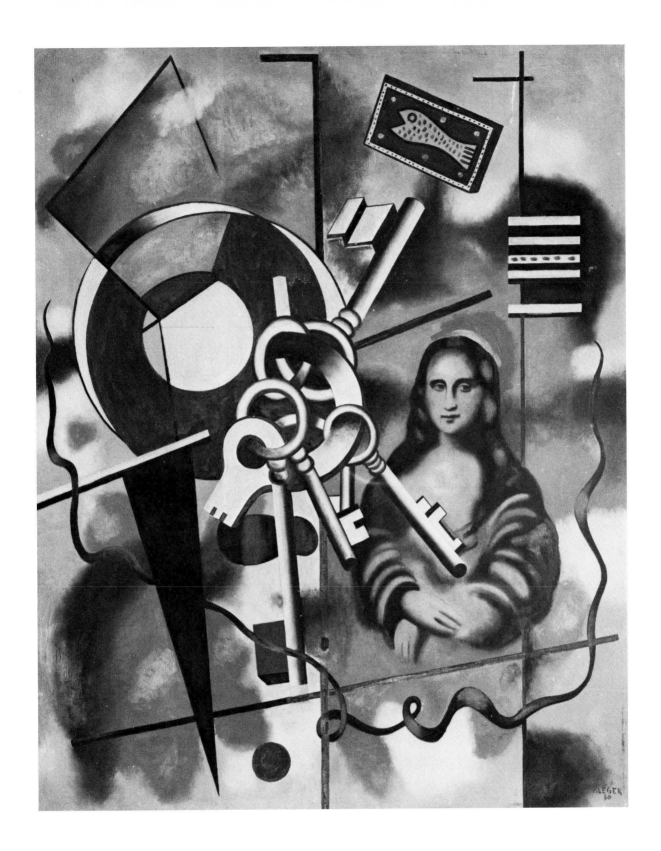

It was inevitable that this approach, which so sacrilegiously blurred the distinction between art and daily life, would become of interest first to Gerald Murphy and later to painter Stuart Davis, who had created proto-Pop work as early as the mid-1920s. Sharing similar views, Murphy and Léger became friends and forged a spiritual bond which was later to stimulate Léger's interest in coming to the United States.

Another of Léger's international friendships was with Frederick Kiesler. A Viennese architect, whose innovations in stage design resulted in his appointment as head of the modern theater section of the important Vienna Music and Theater Festival in 1924, Kiesler became a close friend of Léger. The two men shared many ideas about stage design, film making, and the interaction of both media. Kiesler's links with the United States date from 1926, when he mounted the exhibition, *New Theater Techniques,* in New York City. This exhibition marked the beginning of his career in America, which continued until the end of his life. It was Kiesler who, during a visit to Paris in 1930, introduced Léger to Alexander Calder. Léger became interested in Calder's work and wrote the catalogue introduction to his exhibition in the Galerie Percier in Paris in 1931. Their developing friendship became another of Léger's American connections.

In 1930, Kiesler published his exciting account of contemporary display technique, a book called *Contemporary Art Applied to the Store and Its Display,* "because the new beauty must be based on EFFICIENCY and not on decorative cosmetics" and "because the store window is a silent loud speaker and not a dead storage. Its language appeals to everybody and has proved to be the most successful Esperanto for promoting merchandise."[4] There is no doubt that this subject was of great interest to Léger, whose involvement with mass-produced objects has already been mentioned. And Léger further acknowledged his direct interest in the subject of store display.

In September 1931, Léger sailed for New York for the first time. Before his departure he was somewhat skeptical about the experience that lay ahead. According to George L. K. Morris:

> The true miracles of modern times for Léger are the Ford, the padlock, and the safety-pin. He cannot even be enthralled by tales of the American sky-scraper; during his projected visit to New York, he looks forward only to studying the shop-windows.[5]

However, upon his arrival, he was unable to maintain this attitude for long. His own description of New York bursts with enthusiasm:

> The most colossal spectacle in the world. Neither film nor photography nor reportage can dim the amazing spectacle that is New York at night, seen from the fortieth floor.... This is the apotheosis of vertical architecture: a bold collaboration between architects and unscrupulous bankers pushed by necessity. An unknown, unplanned elegance emerges from this geometric abstraction. Squeezed into two metal angles, these are figures, numbers that climb stiffly toward the sky, controlled by a distorting perspective. A new world.... The architectural severity is broken up by the myriad fantasy of colored lights. The great spectacle begins when they go on, and this radiant vision has that special something that no artist, however inspired, has captured, nor has any theater director had a hand in it.... All this astonishing orchestration is strictly utilitarian. The most beautiful spectacle "in the world" is not the work of an artist. New York has a natural beauty, like the elements of nature; like trees, mountains, flowers. This is its strength and its variety. It is madness to think of employing such a subject artistically. One admires it humbly, and that's all....[6]

Through Kiesler, Léger also met architect Harvey Wiley Corbett during this first American visit. Corbett was at that time working on Rockefeller Center, together with architect Wallace K. Harrison, whose friendship Léger enjoyed for many years to come and for whose Long Island house he designed murals in 1942. Léger was greatly impressed by the grandeur of the Rockefeller Center project, with its imposing design and complex technical problems. The magnitude of the whole undertaking, as well as the rational and analytical way of solving problems, seemed to him to be a typically American way of planning and mass production.

In 1935, Léger came to New York for his important retrospective in The Museum of Modern Art which was followed by an exhibition of works by Le Corbusier, whom Léger joined in his travels around the United States. The exhibition catalogue included an

essay of George L. K. Morris. Morris had briefly been a student of Léger's at the Académie Moderne in 1929 and became a lifelong interpreter of his work as well as that of other French Cubist painters. In the catalogue, he wrote:

> It has been the strength of Léger that he has always stood apart and hewn his own deep narrow road; it might have been another's weakness, but with Léger it could not have been otherwise. Surely such an art can never fail [to be] of interest, even though the soil may sometimes run a trifle thin where the creative mind takes its root apart from other growth, where the past brings so little to the present fruition. And for us today a Léger Exhibition with its fresh and positive address will compensate for loss in fullness and variety. The painter can point to everything before us here and say it is his own, and without too sharp an envy of the eclectic Cubists' greater richness. For he is the real primitive, the adventurer who draws upon his new horizon rather than on talk of art.[7]

In the 1930s, crucial years in the development of modern American art, George Morris played an influential role. He had a catalytic personality and communicated his deep knowledge of current European art movements to his American contemporaries, thus helping to create an atmosphere conducive to the development of a new independent American art. He was a supporter and member of the American Abstract Artists, an avant-garde group whose members, like Morris, were committed to the principles of geometric abstraction related to the Paris group Abstraction-Création. But there was a wide range of theoretical and stylistic approaches among the American Abstract Artists, incorporating diverse concepts of abstraction, thus creating a platform for the dissemination of various stylistic tendencies.

The 1935 Léger exhibition, which included *The City,* 1919 (Fig. No. 10), among other works, and his interpretation of his own oeuvre during his prolonged stay, were of greater importance for American artists than has hitherto been acknowledged. In his lecture at The Museum of Modern Art, Léger postulated his principles of *New Realism:*

> Subject matter being at last done for, we are free. In 1919 the painting *The Town (La Ville)* was executed in pure color. It resulted, according to qualified writers on art, in the birth of a worldwide publicity. This freedom expresses itself ceaselessly in every sense. It is, therefore, possible to assert the following: that color has a reality in itself, a life of its own;

Fig. 23. Arshile Gorky. *Study for a mural for Administration Building, Newark Airport, New Jersey,* 1935-36
gouache, 13⅝ x 29⅞ (34.6 x 75.9)
On extended loan from the United States WPA Art Program
to The Museum of Modern Art, New York, New York

that a geometric form has also reality in itself, independent and plastic. Hence composed works of art are known as "abstract," with these two values reunited. They are not "abstract," since they are composed of real values: colors and geometric forms.[8]

Léger's views, in very many ways, corresponded with the attitudes and frequently aided the theoretical development of the New York avant-garde.

The mid-1930s, deeply affected by the torment of the Depression, were times of heightened social consciousness in America. The artists' community, in particular, was in the forefront of the search for a solution which would bring social and economic equality and justice for all. The members of the avant-garde were concerned with the plight of fellow American artists as well as of the whole nation and many of them assumed activist roles in the Artists' Union or the American Artists' Congress.[9] It was felt that artists should not be concerned with the development of their personal style or with formal artistic problems at the expense of the larger social context. Artists should take responsibility for initiating social change through the acceptance and understanding of the concerns of modern society and should become leaders in the movement for social progress. Léger's ideas of creating art with social content directed toward the common man, his wish to elevate the masses through an understanding of modern art and his pronounced assurances that "[it] *is* possible for us to create and to realize a new collective social art; we are merely waiting for social evolution to permit it,"[10] coincided with and supported the views of his American contemporaries. This philosophy of the acceptance and transformation of current modern life and technology into primary subjects of art, found widespread acceptance among American artists and is clearly documented in numerous works of that period.

In the winter of 1933-34, during the hard times of the Depression, the federal art projects, the first of which was called the Public Works of Art Project, were established to provide partial financial security for artists. Growing into a complex structure of projects under separate names, too numerous to list here,[11] it became not only a haven which provided many artists — in particular young ones — with the basic means of survival, but also an important catalyst in the development of independent American contemporary art and a platform for formulating ways to bring artists into a new and close relationship with society. Stuart Davis stated, very clearly, the hopes and intentions of many artists at the time:

> Even if we were to rally all the American artists to our cause, we would achieve little working as an isolated group. But we have faith in our potential effectiveness precisely because our direction naturally parallels that of the great body of productive workers in American industrial, agricultural and professional life.[12]

Davis' work dating from the second half of the 1930s, shows his determination to convey meaningful social content through the utilization of abstract style. Although abstraction has frequently been rated as formalist and incompatible with any real social content, the possibility

Fig. 24. Léger in his New York studio, 1941.

Fig. 25. Lynes, George Platt, *Artists in Exile*
Photograph taken on the occasion of an exhibition at
Pierre Matisse Gallery, New York, New York, March 1942.
From left to right, first row: Matta Echaurren, Ossip Zadkine,
Yves Tanguy, Max Ernst, Marc Chagall, Fernand Léger; second row:
André Breton, Piet Mondrian, André Masson, Amédée Ozenfant,
Jacques Lipchitz, Pavel Tchelitchew, Kurt Seligmann, Eugene Berman.
The Museum of Modern Art, New York, New York

of the unification of these seemingly opposing entities was again a legacy of Léger's *New Realism.*

For the Works Progress Administration's Federal Art Project, known as the WPA/FAP, Stuart Davis created four large murals: *Waterfront Forms* in 1936, *Swing Landscape* in 1938, and *Municipal Broadcasting Company WNYC Studio B Mural* and *History of Communications* in 1939. While dealing with specific subjects and trying to develop a narrative social content, Davis employed an abstract style in his murals, although he was convinced that he had created his own kind of realism. His style, however, was not in keeping with that which has come to be associated with most federal art projects. In his version of realism, Davis strove for a visual rendering of the laws of inner reality of each element of composition, especially color and shape. He felt that once these were clearly defined, the true and absolute reality of the whole would be ensured.

Léger exerted a major influence on many of the younger artists at the time, largely as a result of his concern with the mechanization of modern life and his concentration on the urban environment. Since Léger also believed his work to be realistic according to his theory of New Realism, he was a spiritual leader of a generation which felt strongly that the social content of art should be conveyed in a realistic form, but which could not forsake the search for formal innovation in art. Their realism was that of a modern epoch, rich in scientific, philosophical and social evolutions. It corresponded with modern times and their complexity and it could not, therefore, repeat old plastic formulae which were incapable of conveying the blazing innovations of the present.

The appeal of Léger's social theory and its visualization in the works of art was widespread and is detectable in the work of many participants in Federal art projects. Burgoyne Diller was director of the WPA mural division of the Federal Art Project in New York. He was a member of the American Abstract Artists group, his work was rooted in geometric abstraction; therefore it came as no surprise when he supported the assignment of large mural projects to Stuart Davis,

Karl Knaths, Willem de Kooning and Arshile Gorky among others.

Gorky's murals in Newark Airport, New Jersey (Fig. No. 23), were installed in 1937. Out of ten panels only two have survived, but from these and the documentation of the others, we can see the importance of this project. The imagery, all drawn from the field of aviation, was based on the photographs of Wyatt Davis, Stuart's brother, who was a photographer for the project. Gorky abstracted various elements from the photographs and presented them in these large-scale compositions in new, unexpected configurations of bold primary colors and geometric shapes. His interest in the Cubism of Picasso is well known, but in the case of the Newark murals, it is Gorky's understanding of Léger's variant of Cubism, as well as the theory of Purism, which manifests itself clearly. The experience of working on the large-scale projects initiated by the Federal Art Projects murals was invaluable to Gorky and the other artists and radically affected the development of large-scale painting by New York School artists after World War II.[13]

While not all of the artists who worked on federal art projects went on to produce works that became landmarks in the history of American art, many of them contributed to the establishment of the highest standards in the field of government-sponsored public art. And for many, Léger's oeuvre proved to be stimulating. In New York City, Ruth Reeves' murals from the cycle *Student Activities in School,* 1940-41, in Andrew Jackson High School, Queens, and Eric Moses' *Power,*[14] for Samuel Gompers Industrial High School in the Bronx, employ in their compositional structure fragments of technological reality transformed into plastic symbols in a manner related to Léger's work.

In 1938, Léger came to the United States for the third time. One of his commissions was to decorate the apartment of Nelson D. Rockefeller. He also began work on an animated color film to be shown in the lobby of Radio City Music Hall as a kinetic mural. The film itself was never completed, but Léger created seven

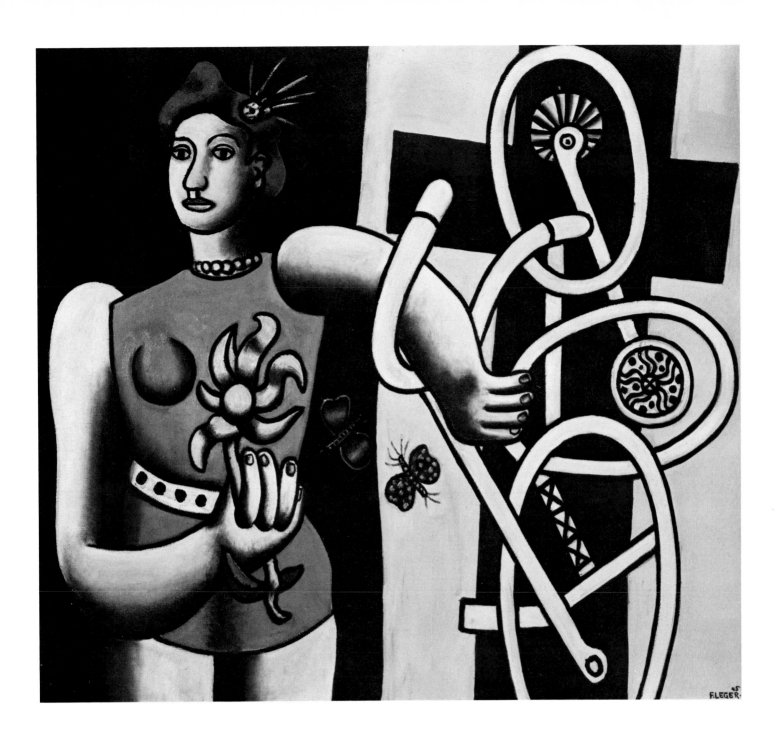

Fig. 26. Fernand Léger. *Big Julie (La Grande Julie),* 1945
oil on canvas, 44 x 50⅛ (111.8 x 127.3)
The Museum of Modern Art, New York, New York.
Acquired through the Lillie P. Bliss Bequest.

gouaches as primary studies for the project which, even condensed on a small scale, reveal the monumental feeling of the intended project. The gouaches have a definite relationship to some of the abstract murals executed for the WPA/FAP, in particular those of Stuart Davis. These works are clear evidence that artistic influence is not a one-way affair. Just as Léger exerted an obvious influence on a generation of American artists, so, reciprocally, his own work was enlivened by the vitality of the younger Americans. Iconographically, the gouaches for Rockefeller Center illustrate the image of the modern city so masterfully formulated by Alexander Rodchenko:

> The modern city with its many-storied buildings, the industrial plants, factories, the zones with two and three story store windows, street cars, automobiles, the three dimensional neon signs, ocean steamers, airplanes necessarily have transformed traditional perception. It looks as if only the camera could depict modern life.[15]

Léger returned to Paris in March of 1939 at a point when Europe was on the verge of collapse. He completed the magnificent *Composition With Two Parrots,* 1935-39 (Fig. No. 14), and executed *Airplane in the Sky,* 1939-52 (Cat. No. 55), one of many studies for a mural in the Aviation Center at Briey, the latter being a public commission Léger had obtained from the French Ministry of Education. In *Airplane in the Sky,* the airplane is described in the form of a symbol and concentric circles in the colors of the French flag present an image of a moving propeller. Propellers were a symbol of the modern age — they unified the speed and movement so vital for the machine age which Léger admired. They had made frequent appearances in his paintings over the years, starting in 1918 with the group of works called *The Propellers,* a prime example of which can be found in the Musées Royaux des Beaux-Arts de Belgique.

Unfortunately the Briey project was never realized. The political situation in France collapsed and, in October 1940, Léger arrived in Marseilles to await passage to the United States.

> In 1940 I was in Marseilles, when I worked on the *Divers* — five or six figures about to plunge. I got the idea for this picture there. Immediately afterwards I left for the United States, and then one day I went to a swimming pool. And what did I see? It was no longer five or six divers, it was two hundred at once. It was impossible to tell whose this head, this leg and that arm were. One could no longer distinguish. So then I mixed the limbs in my picture together and understood that in this way I was much closer to the truth than Michelangelo when he occupied himself with every individual muscle.[16]

Monumental figure painting, Léger's principal interest in the period immediately before his arrival in the United States, was exemplified in most of the works of the *Divers* series. But in these new works, his style was now endowed with a new quality — that of increased movement within the composition. The static quality of the sculpturesque figures of his earlier work was translated into a pattern of tightly interwoven bodies, modeled with chiaroscuro and floating freely in space:

> I was struck by the intensity of the contrasts of movement. It's what I have tried to express in painting. . . . I tried to translate the character of the human body evolving in space without any point of contact with the ground. I achieved it by studying the movements of swimmers diving into the water from very high. . . .[17]

Upon his arrival in New York in November 1940, Léger set up his studio at 40th Street and 6th Avenue and started to work immediately. The *Divers* series, with its inherent expression of movement, occupied most of his time. He also lectured about his work at Yale University and a variety of other places. Generally speaking there was no significant period of adjustment, which in any way affected his participation in artistic life.

Léger spent the summer of 1941 in California, teaching the summer session at Mills College, together with Darius Milhaud and André Maurois. Milhaud fondly remembers Léger's lectures as well as his involvement in various extracurricular activities, such as designing sets for student performances.

In 1935, on one of his earlier visits, Léger had taken the bus to Chicago for his exhibition which had travelled there from The Museum of Modern Art. He was an avid observer, and traveling by bus across this vast continent offered him an intimate visual knowledge of the country. And so, again in the summer of 1941,

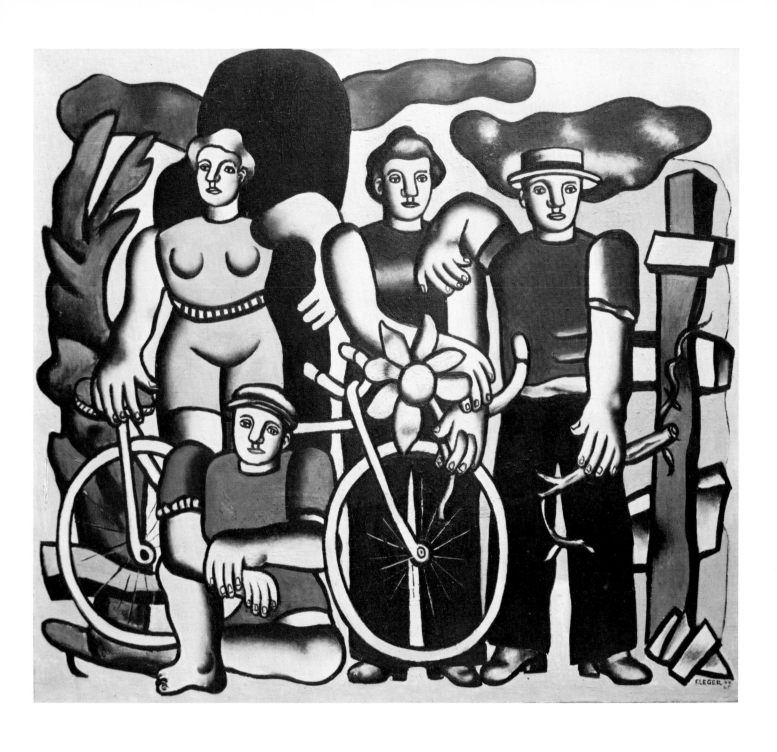

Fig. 27. Fernand Léger. *The Splendid Team (La Belle Equipe)*, 1944-45
oil on canvas, 44⅛ x 48⅖ (112 x 124)
Private collection

Léger deliberately undertook a long bus journey to reach Mills College. He was amazed at the visual richness of the American scenery and well aware that by carefully scrutinizing the externals he was learning about the internal qualities of this country and its people as well:

> It's not a country — it's a world. It's impossible to see the limits. In Europe, each nation is aware of its boundaries — whether it is France, England, Italy, Scandinavia. There, all is without limit.[18]

This unlimited space has stamped the character of the nation as well: the generosity and the violence of America are as uncurbed as the space itself. In the good and the bad, spiritually and physically, there is a grandeur that is rarely to be found in artificially segmented Europe.

Upon his return to New York in the fall of 1941, Léger continued to work on the *Divers* series. He employed the techniques of modeling the bodies with chiaroscuro and surrounding them with cloudlike patches of color. This style was a carry-over of elements present in his large-scale compositions of the late 1930s.

In *Divers II,* 1941-42 (Cat. No. 58), the swirling movement is clearly defined. Intertwined bodies are twisting forward and backward, reaching into the depths of polychromed space with the complexity of a baroque figure painting. They are modeled in radiant colors, strongly outlined with black lines.

But by 1942, a decisive change marked the *Divers* series as the result of a new compositional device derived by Léger from his observation of New York City:

> It is not imaginary. It is what you see. In 1942, when I was in New York, I was struck by the neon advertisements flashing all over Broadway. You are there, you talk to someone, and all of a sudden he turns blue. Then the color fades — another one comes and turns him red or yellow. The color — the color of neon advertisement is free: it exists in space. I wanted to do the same in my canvasses. It is very important for murals, because the scale is less limited, but I also used it in my easel paintings.... I could never have invented it. I am not capable of such fantasies.[19]

This new separation of design and color was the major innovation introduced into Léger's work by his stay in America. Freeing color completely, Léger endowed it with the degree of independence to which he felt it was entitled. He wrote in 1938:

> Color is a vital necessity. It is raw material indispensable to life, like water and fire. Man's existence is inconceivable without an ambiance of color. Plants and animals are naturally colored; man dresses himself in colors. His action is not merely decorative; it is also psychological. Connected with light, it becomes intensity; it becomes a social and human need.[20]

He still used color to model the shapes of intertwined bodies in some canvases, but its interest for Léger was now primarily as an independent entity. Bands of color were organized on canvas to create a composition which could exist on its own if the design of the now-simplified figures was suddenly lifted off. A pure color abstraction was thus created, presenting a sharp contrast to the black outlines of figurative design. Léger had created another of his famous contrasts — that of stylized figurative painting and pure color abstraction coexisting within one picture plane.

Léger's style in the *Divers* series evolved from the works in which he emphasized his modeling of bodies in the round, to the works begun in 1942, which focussed on the flatness of all elements. The new style subsequently appeared in the series *Acrobats* and *Dancers* which were also done during Léger's stay in America.

Mr. Sidney Janis, collector, important dealer and friend of many artists, recollects seeing the *Divers* series late in 1942 in Léger's New York studio:

> Most transfixing in these *Couleur en d'hors Plongeurs* pictures was the unusual and independent role Léger gave to color as well as form, for in these works, color no longer existed in a descriptive sense but was made to flow in and out of existing linear figures and forms. As an extension of the picture's title, interdependence as well as interaction of form and color give dynamics to his divers-in-space and in this sense become a logical sequence to and a raison d'être for the artist's theme....
>
> The New York scene continued its tonic effect upon Léger's work. Captivated by the tempo of the streets, bombarded by new and dynamic visual confrontations [these things] quickened his enthusiasm and continued to exert a salutory

effect upon his paintings. New and valid plastic ideas continued to evolve and these were to spill over into his final years at Giffe-sur-Yvette not too far from Paris where upon his return to France he had taken a farmhouse with a newly constructed studio to work. In this larger, well lighted studio he persevered with a great number of works in *Couleur en d'hors* on the theme of the circus, culminating in the large (13 foot) magnificent *Grand Parade* (1954) now an invaluable work in the collection of the Guggenheim Museum.[21]

The *Divers* series was in some sense the culmination of Léger's intent to translate the static quality of his sculpturesque figures into a fluid composition filled with continuous motion. The transformation, which resulted from the serious research into the possibilities of visually connecting the conflicting values of two dimensional planes, movement and the human figure, was also influential in other work by Léger.

The *Cyclists* series was developing almost concurrently with *Divers*. Wartime gasoline rationing had made bicycling very popular, both as a way of transportation as well as a pastime. The movement of youthful bodies, clad in multi-colored outfits, fascinated Léger, who had always been an admirer of disciplined physical activity. His love of externals, of the colorful juxtaposition of various segments of perpetually changing visual reality, made him a natural admirer of circus performances. But Léger's love for the circus was not only a love of the colorful spectacle full of daring and suspense, nor was it simply the nostalgia explored by so many twentieth-century artists. Léger endowed the external spectacle with a depth of inner meaning:

> A circus is a whirlpool of masses, people, animals and objects. The stiff dry angle does not fit in it. Go to the circus! You will leave your right angles, your geometric windows, and you will get into the land of the active circles. It is something so human to break through the barriers, to reach out farther, to push through to freedom. The round is free, it has neither beginning nor end.[22]

In *The Grey Acrobats,* 1942-44 (Cat. No. 62), there is a very real sense of arrested movement within this perfectly balanced composition. This quality is in keeping with the commitment to a more kinetic composition first seen in the *Divers* series; a dynamism of interlocking volumes of human figures placed against a yellow backdrop, and a development of pictorial planes. It is a monumental composition partially based on the powerful earlier works which incorporated figures of acrobats, such as the aforementioned *Composition With Two Parrots.*

Léger's choice of acrobats, dancers, divers and swimmers as his subject matter was in tune with the artist's belief that he was creating an image of the ideal man whose healthy, strong and controlled body is governed by an equally balanced, conquering spirit. In none of his paintings do we see an older person nor do many children find their way into Léger's compositions. His landscapes are peopled by men and women who control their own future; people for whom the Machine Age is not threatening but is the Age of Progress, full of poetry. Léger himself believed in this new world and his wholehearted sincerity, exemplified through his expert use of technical means, makes much of his figurative work entirely convincing. It is futile to look for artistic movements which would help us to place Léger's late work in a defined stylistic category. His association with styles had, in any case, always been more than loose. We should approach his work with the same sincerity and idealism with which they were created.

In 1944, Léger finished his large canvas *Three Musicians* (Cat. No. 66), in which the color is strictly bound by design and the modeling of the statuesque figures is achieved by juxtaposing lighter and darker tonal values. Based on a large 1924 drawing, *Three Musicians* recalls some of the qualities of Léger's prewar oeuvre, namely its static frontality. However, Léger himself points out that:

> ...even in this canvas, for all its static character, there is strength which is new. It would have been less tense and colder had it been done in France.[23]

In *Three Musicians* Léger created one of the masterpieces of his war period. The work is firmly placed within the continuity of his entire oeuvre, documenting his attempt to produce order by juxtaposing contrasting elements. The yellows, blues and reds are pure and aggressive, the simplicity of the forms builds the composition with architectural monumentality. There

is a variety of amusing details in this particular work, such as the ornamentation on the top of the bass, a flower on the lapel of the horn player which clearly indicates the shape of *Walking Flower,* done much later in ceramic, or the green bow tie of the bass player. The accordion, an instrument Léger always admired, is decorated with the miniature image of two acrobats. We cannot fail to recognize, in this small ornament, the reference Léger makes to his own earlier compositions with acrobats. There is a definite resemblance between the figure of the horn player on the right and Léger himself.

Léger's iconography is most probably based on an image he had encountered when he was living in Montparnasse and frequenting the popular dance halls. The strict frontality alludes to folk painting and also to the work of Le Douanier Rousseau. The posed figures remind us of the photographic poses which were often used by Rousseau in his group portraits.

The three musicians appear in numerous drawings by Léger as well as in large-scale compositions. A large canvas, dating from 1930, is now in the Von-der-Heydt Museum in Wuppertal, Germany; another, of the same period, is in the Musée National Fernand Léger in Biot.

Acrobats and Musicians, 1945 (Cat. No. 68), shows the group of musicians on the left, firmly planted on the ground, facing us with familiar directness. The acrobats and an abundance of their props are placed in the central and right part of the picture in this well-balanced composition. This painting implies a close relationship with Léger's monumental figure compositions of the 1930s, but, as a result of his American experience, this work displays an increased sense of movement and dynamism within its intricately interwoven elements. *Acrobats and Musicians,* with its complex compositional schemes, leads towards Léger's ultimate figurative work, *The Great Parade,* 1954 (Fig. No. 13).

Léger's ability to treat with equal virtuosity compositions that were bursting with movement and those of a more static value, is exemplified in *The Splendid Team,*

1944-45 (Fig. No. 27). Rarely did Léger compose a work of such balance and intensity. Every element has its counterpart, its companion patch of color and shape. The composition grows from the very center of the canvas, which is occupied by a beautiful yellow marguerite which opens in all directions, filling the canvas with a density of colors and shapes. Two men and women, posing as if for a photograph, are enjoying a country outing. On their right is a ranch fence, balanced in volume and color by a tree on the far left. Total calm and contentment emanate from the faces of the two couples who appear to be thoroughly enjoying their leisure time. The static quality of *The Splendid Team* foreshadows the resolved and more serene design of the *Leisure* series.

The most famous in the *Leisure* group, *Homage to Louis David,* 1948-49, which Léger himself said was begun in the United States in 1944, certainly displays several close similarities to the work done here in 1944 and 1945, including the idea of an inscription. But since the signature and dates "48-49" are clearly discernible on the verso, it is now dated as being from the late 1940s. Following *Adieu New York,* 1946 (Cat. No. 69), his farewell to the United States, *Homage to Louis David* would seem to express the artist's happiness at his return to France in a logical sequence. It is also considerably more static than the majority of his American compositions and is subjected to a predetermined order. There are explicit references to Jacques-Louis David within the work. The girl in the

Fig. 28. The abandoned farm at Rouses Point, New York, which provided Léger with materials for a series of "waste" paintings done in 1943-45.
Photograph by Martin James, *Magazine of Art* (New York), December 1945

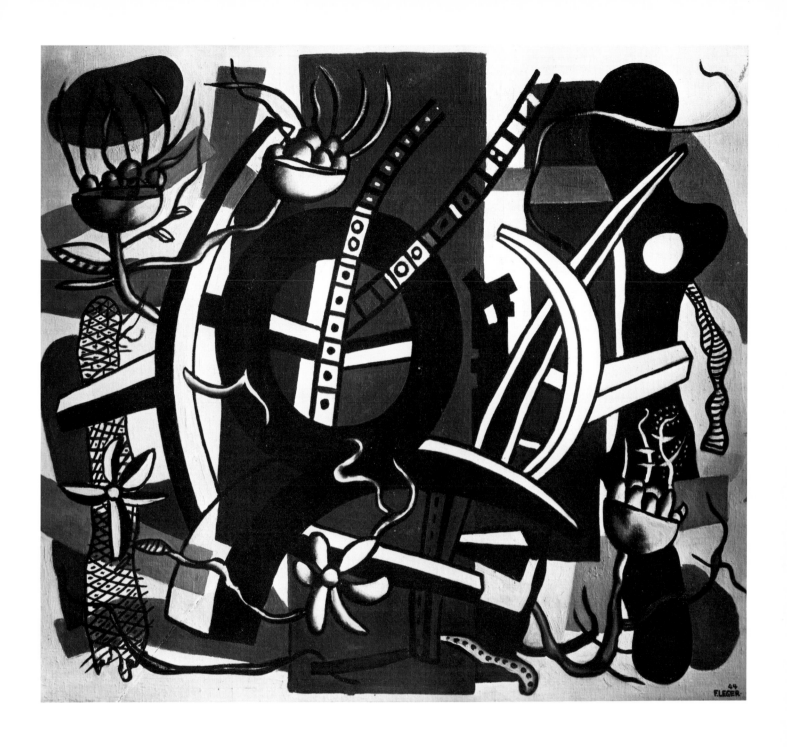

Cat. 64. *The Black Wheel (La Roue noire)*, 1944
Private collection

foreground, who is depicted in a pose similar to that of David's famous *Madame Récamier,* is holding a sheet of paper bearing his name. But the allusion is also implicit in the strictly defined qualities of the composition which is in the French tradition of firmly set rules. Léger admired David and frequently mentioned his name in his writing. It might not be farfetched to suppose that the incorporation of the sheet of paper is a double allusion — referring also to the sheet held by the murdered Marat in David's masterpiece, *The Death of Marat.*

Although Léger's prime interest during his stay in the United States was in figurative work, he was so struck by the intensity of the American landscape, that he described it in many of his paintings. He spent part of the summer of 1942 in New Hampshire, where he painted *The Forest,* 1942 (Cat. No. 61). In this painting, Léger used brilliant colors to portray a dense and almost threatening forest. Thick vegetation obscures one's view, intertwining around the main elements. For a man from Europe, where every inch of land has been worked for centuries and where most forests have an almost manicured appearance, the image of the White Mountains forest is that of a complete and overwhelming wilderness. It is an imposing sight, and one that must have been appealing to Léger's natural romanticism, however deeply suppressed.

The composition of this work is carefully balanced in its employment of forms as well as colors. It recedes in depth, suggesting the depth of an actual forest. Red birds, making their way through the branches, accentuate the movement inherent in this work.

In May 1943, on his way to Montreal to attend the opening of his exhibition at the Dominion Gallery, Léger had to wait several hours for his train at Rouses Point, a small village on the border of Canada and the United States. Close to Quebec, the Champlain Valley, with its fresh green orchards and French-speaking population, bears a resemblance to Normandy which must have captivated Léger. He found a house there that summer and returned for the next two years. Not far from his rented house, Léger discovered an aban-

doned farm. Sigfried Giedion, who spent the summers of 1944-45 nearby, described it as follows:

> ... abandoned as only American farms can be: the barn roof collapsed, its doors half torn from their hinges. Harrows, plows ... mowers, all lay widely scattered, half sunk into the earth, overgrown with aggressive weeds. And everywhere wagon wheels, intact or with rims falling off in every stage of decay. ... It almost took one's breath away. The farm did not seem to have been abandoned many years before; it did not exhale the atmosphere of ruin — it seemed rather that some sudden catastrophe had arrested daily living, that we were in the midst of a kind of Pompeian excavation. And yet it had been an affair of only yesterday. Obsolescence. Artificial obsolescence, premature obsolescence. *"Ce spectacle ne se voit pas en Europe,"* said Léger. "It *is* a sight such as one would never see in Europe."[24]

For people brought up in Europe, where material goods were frequently scarce, the sight of still-intact artifacts decaying unused, is unusual, often disturbing. The carelessness and disregard for anything worn or aged, the entirely pragmatic approach to material things without the least sense of nostalgia, are typically American. Newcomers to the society have to deal with this element of culture shock according to their individual temperaments. Some adjust by buying and discarding even more freely than the natives; some passively deplore the sadness and futility of this wastefulness, which is ultimately so detrimental to the public good, leading as it does to the eventual exhaustion of resources. And then there are those who immortalize the problem of waste and debate this question — which is essential for the survival of Western civilization — in timeless works of art. Léger's dismay at this wholesale wastefulness is a theme that runs through many of his American works, anticipating by more than thirty years a feeling that was to become more widely shared by the Americans themselves.

A special atmosphere emanates from the group of works, frequently called the American Landscape series, created during Léger's summers at Rouses Point. All of Léger's American oeuvre displays a pictorial area densely covered with compositional elements. The group of Rouses Point landscapes is no exception. In *Tree in the Ladder,* 1943 (Cat. No. 63), the man-made objects — the ladder, part of the wire fence and twisted pieces of rope and wires — are intertwined with

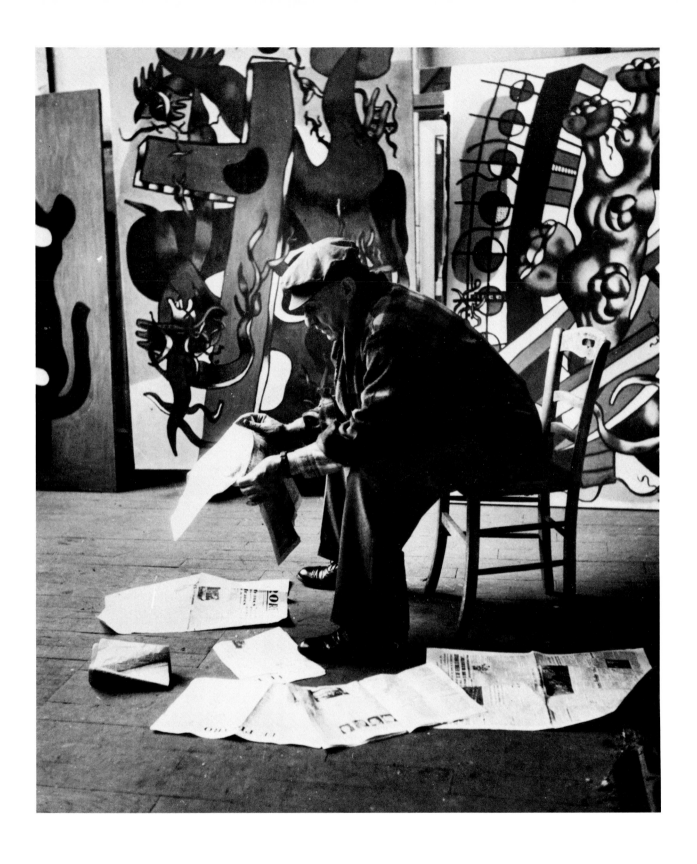

Fig. 29. Léger in his Paris studio, after his return
from the United States, 1945.

57

and devoured by the overgrown vegetation. Contrasts always fascinated Léger, and there are many in this picture. The vegetation enveloping man-made artifacts, the straight lines and curves, the planes and volumes — all are brought together to create a dynamic composition that recedes into the depths of the pictorial plane. There is an obvious struggle between abstract forms and organic shapes symbolizing the perpetual struggle of man's civilization against the dominant forces of nature.

At the very end of Léger's series of American landscapes is *Adieu New York.* It was begun in New York in 1945 and finished, early in 1946, in Paris. It is still firmly rooted in Léger's American oeuvre, displaying all its attributes with startling bravado. Patches of free color are placed throughout the canvas with the intention of balancing its volume. The discarded artifacts range from a piece of old scrap iron, wires and pieces of fence, to articles of human embellishment — ties hanging on a line, waving in the winds which have swept away the past. The inscription *Adieu New York* runs across the bottom part of the painting — a last-minute salute to the city which brought Léger so many new experiences and which, in return, he deeply admired.

In a simplified form, *Romantic Landscape,* 1946 (Cat. No. 70), follows the general compositional theme of *Adieu New York.* It illustrates Léger's conviction that America, with all its violent contrasts, was a romantic country. An air of melancholy is created by the juxtaposition of industrial waste — chains, machine parts, and multicolored cans — with the more personal reference of a man's coat, hanging discarded on a wooden fence. All of these items are displayed against a background of pale mountains and blue sky and there is a pervasive feeling of loneliness about this work.

"I painted in America better than I had ever painted before," Léger stated in an interview in 1949.[25] During his stay in the United States he painted more than 120 large canvases and produced innumerable studies and works on paper. A majority of his works are marked by an unprecedented surge of vigor, in response to the agitated and energetic environment. Léger masterfully incorporated into his works the power of this environment, transformed into visual energy. His own secure personality, deeply rooted in the land of Normandy, gave him the confidence to undertake serious explorations during his worldwide travels. And he also had a gift for perceiving deeper national characteristics through his exploration of externals. He detested the restrictive "good taste" of Europe, and was quick to appreciate the popular symbols of American culture, their unique poetry exemplified in mass-produced objects, billboard signs, painted neckties and burlesque shows. He claimed that his work here was more realistic than ever; he certainly incorporated more figures into his compositions, sometimes in a highly-stylized and sometimes in a quasi-realistic manner.

This interest in figuration was to dominate Léger's work upon his return to France. His subjects were drawn from the members of the urban proletariat, depicted both at work or enjoying their leisure time.

His determination to depict the common man, as well as to create for him, was a result of socialist theories widespread among the avant-garde both before and after World War II. However, Léger's social conscience was not that of a fierce Marxist, but of a passionate humanist — one of those indispensable personalities, who, through their wholehearted belief in mankind, ensure the spiritual survival of this world despite the unending catastrophes that smite it.

Léger's work here was characterized at once by consistency and by variety. For the most part, several major themes were repeated and reworked in a great variety of formal renderings. But there was a continuous thread in his American work which led him from the doctrine of classicism, so obviously present in his prewar years, to the dynamic compositions of intertwined elements, bordering on the acceptance of baroque compositional schemes. There was a certain inevitability in this change in Léger's work, born of the fact that it would have been almost impossible to

capture the perpetual motion of this country by using the tools of strictly defined classicism. But it took artistic courage and perspicacity to realize this and to seek and find solutions.

Léger found these solutions by incorporating new elements into his works—he moved from strictly ordered forms toward an agitated intricacy of abundant forms, from clearly discernible planes toward an array of overlying shapes. He understood that there is no single solution to describe infinitely changing reality. It necessitated a constant search for the mode of expression that would most accurately capture the original impetus, an elusive idea requiring different solutions at different times. He was capable of incorporating elements of two basic morphological systems, which had always been present in the arts—the classical and baroque orders. Through the interplay of seemingly incompatible tendencies, he arrived at the creation of new and fresh values which were to enliven his subsequent work. It was precisely this lack of strict adherence to either of these opposing systems and his ability to perceive their inherent interdependence, which enabled Léger to comprehend spiritually and to describe visually the vitality of the melting pot of various cultures called America.

The American period was a time of great liberation in Léger's work—liberation of color from the boundaries of design, liberation of elements within the explosive compositions, and liberation in the selection of new themes. It was also a time of exploration and hard work, in response to the power and harshness of a new land. The resulting style was not destined to continue on its initial level of high-pitched intensity, but, as Léger absorbed and assimilated the experiences of those years, it was to become a permanent presence in his subsequent work. After the war, Léger returned to France richer for the legacy of understanding that he had acquired in America, which profoundly affected both the form and content of his work:

> Above any faults the Americans may have—there is the deep sense of liberty they have. It is futile to look elsewhere for a spirit as liberal.[26]

FOOTNOTES

(1) Werner Schmalenbach, *Fernand Léger.* New York: Abrams, 1976, p. 37.
(2) James Johnson Sweeney, "Eleven Europeans in America: Fernand Léger," *The Museum of Modern Art Bulletin* (New York), vol. XIII, nos. 4-5, 1946, pp. 13-14.
(3) Gerald Murphy was born in Boston in 1888, son of Patrick Francis Murphy, owner of Mark W. Cross, saddlery shop, who later expanded his firm and moved to New York. Gerald Murphy moved to Paris in 1921, where he studied with Natalia Goncharova. All of his work was executed between 1922 and 1930, when he returned to the United States. His paintings display a style midway between realism and abstraction, depicting commonplace objects and their details with great precision. Murphy and his wife, Sara, often visited Léger's studio. They became close friends and spent a lot of time together in Paris, in their Villa America on the Riviera and later during Léger's visits to the United States.
(4) Frederick Kiesler, *Contemporary Art Applied to the Store and Its Display.* New York: Brentano's, 1930, p. [3]. Frederick Kiesler, a friend of Léger, was himself deeply involved in the theory of shop-window display and obviously transferred his enthusiasm to Léger.
(5) George L.K. Morris, "On Fernand Léger and Others," *The Miscellany* (New York), vol. I, no. 6, March 1931, p. 16.
(6) Fernand Léger, "New York," in *Functions of Painting.* New York: The Documents of 20th-Century Art, The Viking Press, 1973, pp. 84-85.
(7) George L.K. Morris, "Fernand Léger Versus Cubism," *The Bulletin of the Museum of Modern Art* (New York), vol. 1, no. 3, October 1935, pp. [5-6].
(8) Fernand Léger, "The New Realism" in *Functions of Painting*, 1973, pp. 109-110. This essay is based on a lecture delivered by Léger at The Museum of Modern Art, New York, New York. Part of the lecture appeared in *Art Front* in 1935.
(9) In 1933, artists organized themselves into an Unemployed Artist Group to press the federal government for support for artists during the Depression. The group became known as an Artists' Union. The American Artists' Congress was formed in 1936 to band the artists together in their effort to participate actively in creating positive conditions for the existence of art in a just society freed from the threat of war and fascism. The first exhibition of the American Artists' Congress was held in Rockefeller Center in 1937.
(10) Fernand Léger, "The New Realism Goes On" in *Functions of Painting*, 1973, p. 115.
(11) The Government Art Projects of 1930s are described in detail in an indispensable publication dealing with the federal support to the arts at the time of the depression, called *New Deal for Art.* This publication accompanied a traveling exhibition organized by Marlene Park and Gerald E. Markowitz for the Gallery Association of New York State in 1977.
(12) Stuart Davis, "Why an Artists' Congress?" *First Artists' Congress*, p. 6. Footnote from Marlene Park and Gerald E. Markowitz, *New Deal for Art.* Hamilton, New York: 1977, p. 9.
(13) Among the latest books on the subject see Harry Rand, Arshile Gorky or the Implication of Symbols. Montclair, N.J.: Allen-Held & Schram Publisher, 1981, Chapter 3.
(14) There is no date for this project in Park and Markowitz, *New Deal for Art.* 1977.
(15) English translation by author from catalogue for *Alexander Rodtschenko, Fotografien 1920-1938.* Baden-Baden: Staatliche Kunsthalle, 1978, p. 137.
(16) English translation by author from French text by Fernand Léger in *Fernand Léger 1881-1955.* Paris: Musée des Arts Décoratifs, 1956, p. 296.
(17) Andre Warnod, "America Isn't a Country — It's a World, Says Fernand Léger," *Arts* (Paris), January, 4, 1946. Reprinted in *Architectural Forum* (New York), April 1946, p. 62.
(18) Ibid. Reprinted in *Architectural Forum*, April 1946, p. 54.
(19) English translation by author from French text by Fernand Léger in *Fernand Léger 1881-1955.* Paris: Musée des Arts Décoratifs, 1956, p. 296.
(20) Fernand Léger, "Color in the World," in *Functions of Painting*, 1973, p. 119.
(21) This passage is quoted verbatim from the unpublished manuscript of book tentatively called *Recollections of Another Art Dealer* prepared by Sidney Janis, who kindly gave his permission to use it in the essay.
(22) English translation by author from French text by Fernand Léger in *Fernand Léger 1881-1955.* Paris: Musée des Arts Décoratifs, 1956, p. 320.
(23) James Johnson Sweeney, "Eleven Europeans in America: Fernand Léger," *The Museum of Modern Art Bulletin* (New York), vol. XIII, nos. 4-5, 1946, p. 14.
(24) Sigfried Giedion, "Léger in America," *Magazine of Art* (Washington, D.C.), vol. 38, no. 8, December 1945, p. 295.
(25) Russell Warren Howe: "Chalk and Cheese: Puy and Léger," *Apollo* (London), vol. 50, no. 294, August 1949, p. 33.
(26) Andre Warnod, "America Isn't a Country — It's a World, Says Fernand Léger." Reprinted in *Architectural Forum*, April 1946, p. 62.

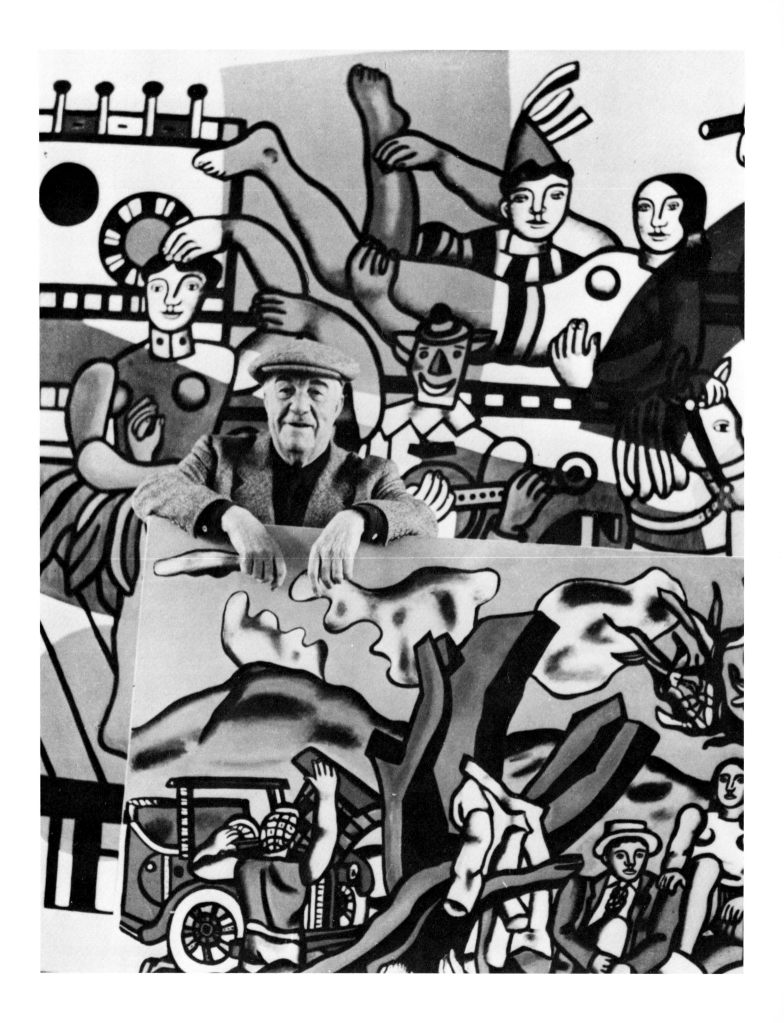

Dimensions are given in inches followed by centimeters in parentheses. Height precedes width. Page numbers for illustrations are indicated in parentheses at end of each entry. English translations of titles are for the purposes of this catalogue only.

CATALOGUE
OF THE EXHIBITION

1. *Corsican Village at Sunset (Village corse au couchant)*, 1905
oil on canvas, 19¹¹⁄₁₆ x 25⅝ (50 x 65)
Perls Galleries, New York, New York (p. 66)

2. *The Village of Belgodère in Corsica (Village de Belgodère en Corse)*, 1905
oil on canvas, 25 x 20⅜ (63.5 x 51.8)
Private collection, courtesy Richard L. Feigen & Co., Inc., New York, New York (p. 65)

3. *Fortifications of Ajaccio (Les Fortifications d'Ajaccio)*, 1907
oil on canvas, 23¼ x 42½ (59 x 108)
E. J. Van Wisselingh & Co., Amsterdam, The Netherlands (p. 66)

4. *The Smokers (Les Fumeurs)*, 1911-12
oil on canvas, 51 x 38 (121.4 x 96.5)
The Solomon R. Guggenheim Museum, New York, New York, gift of Solomon R. Guggenheim, 1938 (p. 68)

5. *The Level Crossing (Le Passage à niveau)*, 1912
oil on canvas, 36⅝ x 31⅞ (93 x 81)
Galerie Beyeler, Basel, Switzerland (p. 67)

6. *Smoke (La Fumée)*, 1912
oil on canvas, 36¼ x 28¾ (92 x 73)
Albright-Knox Art Gallery, Buffalo, New York, Room of Contemporary Art Fund, 1940 (p. 69)

7. *Contrast of Forms (Contraste de formes)*, 1913
oil on canvas, 39½ x 32 (100.3 x 81.1)
The Museum of Modern Art, New York, New York, The Philip L. Goodwin Collection, 1958 (p. 70)

8. *Still Life With a Lamp (Nature morte à la lampe)*, 1914
oil on canvas, 25½ x 18 (64.7 x 45.7)
Private collection (p. 71)

9. *Village in the Forest (Le Village dans la forêt)*, 1914
oil on burlap, 29⅛ x 36⅜ (73.9 x 92.4)
Albright-Knox Art Gallery, Buffalo, New York, gift of A. Conger Goodyear, 1960 (p. 72)

10. *Composition 1918 — The Disk (Composition 1918 — Le Disque)*, 1918
oil on canvas, 25⅝ x 21¼ (65 x 54)
Thyssen-Bornemisza Collection, Lugano, Switzerland (p. 73)

11. *In the Factory (Dans l'Usine)*, 1918
oil on canvas, 22¹⁄₁₆ x 14¹⁵⁄₁₆ (56.1 x 38)
Sidney Janis Gallery, New York, New York (p. 74)

12. *The Disks (Les Disques)*, 1918-19
oil on canvas, 51⅛ x 38¼ (129.8 x 97.2)
Los Angeles County Museum of Art, Los Angeles, California, David E. Bright Bequest (p. 75)

13. *Abstract Composition (Composition abstraite)*, 1919
oil on canvas, 60⅝ x 44⅞ (154 x 114)
Mme. N. Léger, Biot, France (p. 76)

14. *The City (study) (La Ville [étude])*, 1919
oil on canvas, 36¼ x 28¾ (92.1 x 72.1)
The Museum of Modern Art, New York, New York, acquired through the Lillie P. Bliss Bequest, 1952 (p. 77)

15. *Follow the Arrow (Le Passage à niveau)*, 1919
oil on canvas, 25½ x 28⅛ (53.8 x 64.8)
Art Institute of Chicago, Chicago, Illinois, gift of Mrs. Patrick Hill in memory of Rue Winterbotham Carpenter to the Joseph Winterbotham Collection (p. 78)

16. *Disks in the City (Les Disques dans la ville)*, 1920
oil on canvas, 51³⁄₁₆ x 63 (130 x 160)
Galerie Louise Leiris, Paris (p. 79)

17. *Man With a Pipe (L'Homme à la pipe)*, 1920
oil on canvas, 35⅞ x 25⅝ (91 x 65)
Musée d'Art Moderne de la Ville de Paris, Paris (p. 80)

18. *Three Friends (Les Trois Camarades)*, 1920
oil on canvas, 36¼ x 28¾ (92 x 73)
Stedelijk Museum, Amsterdam, The Netherlands (p. 81)

Léger in his studio at Gif-sur-Yvette, c. 1953.

19. *Three Women Holding Flowers (Les Trois Femmes aux fleurs),* 1920
oil on canvas, 38³/₁₆ x 51³/₁₆ (97 x 130)
Private collection (p. 82)

20. *The Tugboat Bridge (Le Pont du remorqueur),* 1920
oil on canvas, 37¾ x 51³/₁₆ (96 x 130)
Musée National d'Art Moderne, Paris (p. 83)
Buffalo only

21. *The Wounded II (Le Blessé II),* 1920
oil on canvas, 36⅜ x 27⅞ (92.9 x 70.9)
Milwaukee Art Museum, Milwaukee, Wisconsin,
gift of Mrs. Harry Lynde Bradley (p. 84)

22. *Animated Landscape (Paysage animé),* 1921
oil on canvas, 19⅞ x 25⅜ (50.5 x 64.4)
Sidney Janis Gallery, New York, New York (p. 86)

23. *Animated Landscape (Paysage animé),* 1921
oil on canvas, 36 x 28¾ (91.5 x 73)
Sidney Janis Gallery, New York, New York (p. 87)

24. *Reclining Nude (Femme couchée),* 1921
oil on canvas, 19¾ x 25⅝ (50.2 x 65)
Perls Galleries, New York, New York (p. 85)

25. *Still Life With Chandelier (Nature morte au chandelier),* 1922
oil on canvas, 45¹¹/₁₆ x 31½ (116 x 80)
Musée d'Art Moderne de la Ville de Paris, Paris
(p. 88)

26. *Composition,* 1923-27
oil on canvas, 51½ x 38¼ (130.8 x 97.1)
Philadelphia Museum of Art, Philadelphia,
Pennsylvania, The A. E. Gallatin Collection (p. 89)

27. *Composition,* 1924
oil on canvas, 50⁹/₁₆ x 38¾ (128.4 x 98.4)
Indiana University Art Museum, Bloomington,
Indiana (p. 90)

28. *Mural Composition (Composition murale),* 1924
oil on canvas, 63 x 51³/₁₆ (160 x 130)
Musée National Fernand Léger, Biot, France (p. 91)

29. *Reading (La Lecture),* 1924
oil on canvas, 44⅞ x 57½ (114 x 146)
Musée National d'Art Moderne, Paris (Cover)

30. *Still Life (Nature morte),* 1924
oil on canvas, 36½ x 23½ (92.3 x 60)
Galerie Beyeler, Basel, Switzerland (p. 92)

31. *The Syphon (Le Siphon),* 1924
oil on canvas, 25½ x 17⅞ (64.8 x 45.7)
Albright-Knox Art Gallery, Buffalo, New York, gift
of Mr. and Mrs. Gordon Bunshaft, 1977 (p. 93)

32. *Mural Painting (Peinture murale),* 1924-25
oil on canvas, 71 x 31⅝ (180.3 x 80.2)
The Solomon R. Guggenheim Museum, New
York, New York (p. 94)

33. *The Baluster (Le Balustre),* 1925
oil on canvas, 51 x 38¼ (129.5 x 97.2)
The Museum of Modern Art, New York, New York,
Mrs. Simon Guggenheim Fund, 1952 (p. 95)

34. *Composition (Definitive) (Composition [Définitive]),* 1925
oil on canvas, 51¼ x 38⅜ (130.2 x 97.4)
The Solomon R. Guggenheim Museum, New
York, New York, gift of Solomon R. Guggenheim,
1937 (p. 96)

35. *Landscape (Paysage),* 1925
oil on canvas, 36¼ x 25⅝ (92 x 65)
Private collection (p. 97)

36. *The Mirror (Le Miroir),* 1925
oil on canvas, 51 x 39¼ (129.5 x 99.7)
Mr. and Mrs. Gordon Bunshaft, New York, New
York (p. 98)

37. *The Viaduct, 1st version (Le Viaduc, 1ᵉʳ état),*
1925
oil on canvas, 19¾ x 25½ (50.2 x 64.8)
Norton Gallery and School of Art, West Palm
Beach, Florida (p. 99)

38. *The Accordion (L'Accordéon),* 1926
oil on canvas, 53⅛ x 35¹/₁₆ (130.5 x 89)
Stedelijk Van Abbemuseum, Eindhoven, The
Netherlands (p. 100)
Buffalo only

39. *Mural Composition (Composition murale),*
1926-36
oil on canvas, 44½ x 38 (113 x 97)
Musée National Fernand Léger, Biot, France
(p. 101)

40. *Composition With a Leaf (Composition à la feuille)*, 1927
oil on canvas, 51³⁄₁₆ x 38³⁄₁₆ (130 x 97)
Musée National Fernand Léger, Biot, France
(p. 102)

41. *Nude on a Red Background (Nu sur fond rouge)*, 1927
oil on canvas, 51³⁄₁₆ x 32¹⁄₁₆ (130 x 81.5)
Hirshhorn Museum and Sculpture Garden,
Smithsonian Institution, Washington, D.C.
(p. 104)

42. *Still Life ABC (Nature morte ABC)*, 1927
oil on canvas, 25⅝ x 36¼ (65 x 92)
Musée National Fernand Léger, Biot, France
(p. 103)

43. *Still Life With Plaster Mask (Nature morte au masque de plâtre)*, 1927
oil on canvas, 35¹⁄₁₆ x 51³⁄₁₆ (89 x 130)
Galerie Beyeler, Basel, Switzerland (p. 105)

44. *Bunch of Grapes (La Grappe de raisin)*, 1928
oil on canvas, 37⅞ x 51 (96.2 x 129.5)
Perls Galleries, New York, New York (p. 106)

45. *Two Profiles (Les Deux Profils)*, 1928
oil on canvas, 35¹⁄₁₆ x 51³⁄₁₆ (89 x 130)
Perls Galleries, New York, New York (p. 107)

46. *Composition I*, 1930
oil on canvas, 55½ x 114½ (141 x 291)
Galerie Beyeler, Basel, Switzerland (p. 108)

47. *Comet's Tail on Brown Background (Queue de comète sur fond marron)*, c. 1930
oil on canvas, 79½ x 108¼ (201 x 275)
Musée National Fernand Léger, Biot, France
(p. 110)

48. *Composition With Umbrella (Composition au parapluie)*, 1932
oil on canvas, 51⅜ x 35 (130 x 89)
Galerie Louise Leiris, Paris (p. 112)

49. *Two Sisters (Les Deux Soeurs)*, 1935
oil on canvas, 63¹³⁄₁₆ x 44⅞ (162 x 114)
Staatliche Museen Preussischer Kulturbesitz,
Nationalgalerie, Berlin, West Germany (p. 114)

50. *Butterfly and Flower (Papillon et fleur)*, 1937
oil on canvas, 35 x 51³⁄₁₆ (89 x 130)
Private collection (p. 113)

51. *Man With a Blue Hat (L'Homme au chapeau bleu)*, 1937
oil on canvas, 28¾ x 36¼ (73 x 92)
Musée National Fernand Léger, Biot, France
(p. 115)

52. *Composition With Yellow Canary (Composition au serin jaune)*, 1937-39
oil on canvas, 38⅜ x 51³⁄₁₆ (97 x 130)
Galerie Beyeler, Basel, Switzerland (p. 116)

53. *Adam and Eve (Adam et Eve)*, 1939
oil on canvas, 44½ x 63 (113 x 160)
Musée National Fernand Léger, Biot, France
(p. 117)

54. *Still Life With Green Plant (Nature morte à la plante verte)*, 1939
oil on canvas, 38⅜ x 51³⁄₁₆ (97.5 x 130)
Galerie Adrien Maeght, Paris (p. 118)

55. *Airplane in the Sky (L'Avion dans le ciel)*, 1939-52
oil on canvas, 22⅞ x 35⁷⁄₁₆ (58 x 90)
Musée National Fernand Léger, Biot, France
(p. 120)

56. *The Black Root (La Racine noire)*, 1941
oil on canvas, 69¾ x 48 (177 x 122)
Galerie Adrien Maeght, Paris (not illustrated)

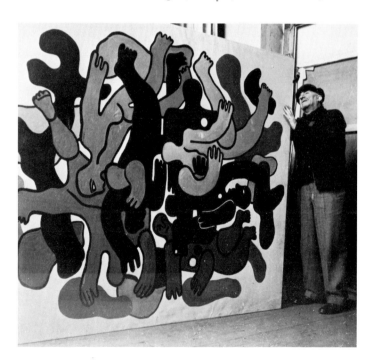

Léger with *The Great Divers*, c. 1955.

57. *Elements on a Blue Background (Eléments sur fond bleu),* 1941
oil on canvas, 68¹⁵⁄₁₆ x 39¹⁵⁄₁₆ (175 x 101.5)
Galerie Adrien Maeght, Paris (p. 119)

58. *The Divers, II (Les Plongeurs, II),* 1941-42
oil on canvas, 90 x 68 (228.6 x 172.8)
The Museum of Modern Art, New York, New York,
Mrs. Simon Guggenheim Fund, 1955 (p. 122)

59. *The Dance (La Danse),* 1942
oil on canvas, 72 x 60⅝ (183 x 154)
Galerie Louise Leiris, Paris (p. 27)

60. *Divers (Red and Black) (Plongeurs [rouge et noir]),* 1942
oil on canvas, 50 x 58 (127 x 147.4)
James H. and Lillian Clark Foundation, Dallas,
Texas (p. 123)

61. *The Forest (La Forêt),* 1942
oil on canvas, 72¹⁄₁₆ x 49⅝ (183 x 126)
Galerie Adrien Maeght, Paris (p. 121)

62. *The Grey Acrobats (Les Acrobates en gris),* 1942-44
oil on canvas, 72 x 57⅞ (183 x 147)
Musée National d'Art Moderne, Paris (p. 124)

63. *Tree in the Ladder (L'Arbre dans l'échelle),* 1943-44
oil on canvas, 72⅞ x 50 (185 x 127)
Galerie Louise Leiris, Paris (p. 125)

64. *The Black Wheel (La Roue noire),* 1944
oil on canvas, 44⅙ x 55 (112 x 127)
Private collection (p. 55)

65. *The Great Divers (black) (Les Grands Plongeurs [noirs]),* 1944
oil on canvas, 73⅜ x 85⅞ (186 x 221)
Galerie Adrien Maeght, Paris (p. 126)

66. *Three Musicians (Les Trois Musiciens),* 1944
oil on canvas, 68½ x 57¼ (174 x 145.4)
The Museum of Modern Art, New York, New York,
Mrs. Simon Guggenheim Fund, 1955 (p. 127)

67. *The Women Cyclists (Les Belles Cyclistes),* 1944
oil on canvas, 29 x 36 (73.8 x 91.5)
Gallery of Art, Washington University, St. Louis,
Missouri (p. 128)

68. *Acrobats and Musicians (Acrobates et musiciens),* 1945
oil on canvas, 44⅞ x 57½ (114 x 146)
Galerie Aimé Maeght, Paris (p. 130)

69. *Adieu New York,* 1946
oil on canvas, 51³⁄₁₆ x 63¾ (130 x 162)
Musée National d'Art Moderne, Paris (p. 132)
Buffalo only

70. *Romantic Landscape (Paysage romantique),* 1946
oil on canvas, 25½ x 26¼ (65 x 66.6)
Galerie Louise Leiris, Paris (p. 129)

71. *Construction Workers With Rope (Constructeurs au cordage),* 1950
oil on canvas, 63½ x 44⅞ (161.3 x 114)
The Solomon R. Guggenheim Museum, New
York, New York, fractional gift of Evelyn Sharp,
1977 (p. 134)

72. *Study for The Construction Workers (Etude pour Les Constructeurs),* 1950
oil on canvas, 63¾ x 51½ (162 x 130)
McCrory Corporation, New York, New York
(p. 135)
Buffalo only

73. *The Camper (Le Campeur [couleur en dehors]),* 1953-54
oil on canvas, 51 x 38 (129.5 x 96.5)
Galerie Beyeler, Basel, Switzerland (p. 136)

74. *Composition With Two Birds (Composition aux deux oiseaux),* 1954
oil on canvas, 36¼ x 23⅝ (92 x 60)
Galerie Louise Leiris, Paris (p. 137)

75. *The Juggler and the Dancer (Le Jongleur et la danseuse),* 1954
oil on canvas, 37½ x 50½ (95.3 x 128.3)
Sidney Janis Gallery, New York, New York
(p. 138)

76. *Two Women With Flowers (Deux Femmes tenant des fleurs),* 1954
oil on canvas, 38¹⁄₁₆ x 51³⁄₁₆ (97 x 130)
The Trustees of the Tate Gallery, London,
England (p. 139)

Cat. 2. *The Village of Belgodère in Corsica (Village de Belgodère en Corse),* 1905
Private collection, courtesy Richard L. Feigen & Co., Inc., New York, New York

Cat. 1. *Corsican Village at Sunset (Village corse au couchant),* 1905
Perls Galleries, New York, New York

Cat. 3. *Fortifications of Ajaccio (Les Fortifications d'Ajaccio),* 1907
E. J. Van Wisselingh & Co., Amsterdam, The Netherlands

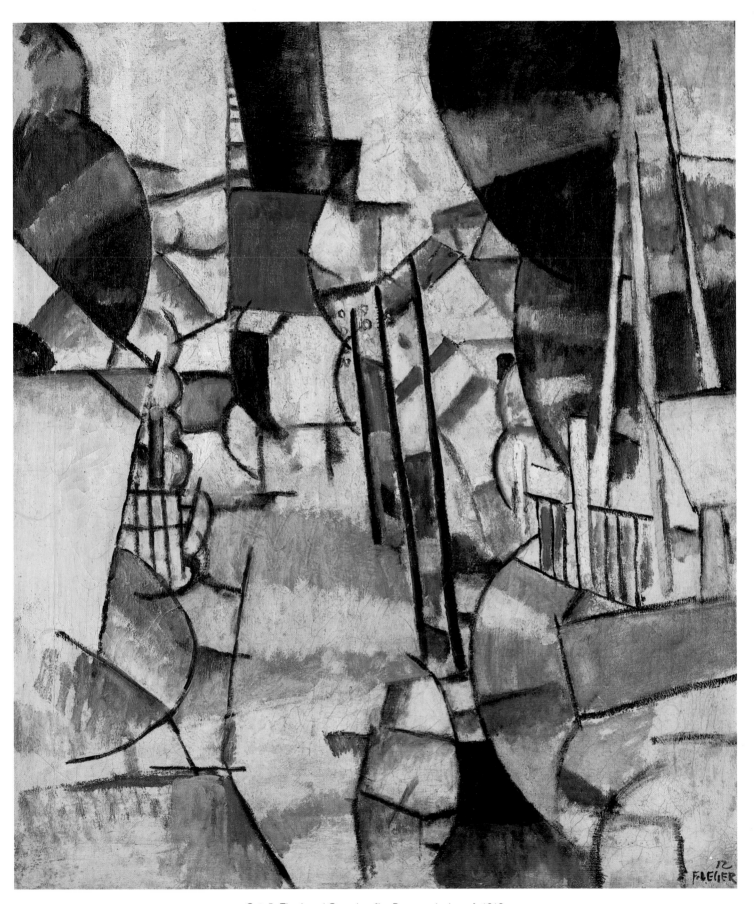

Cat. 5. *The Level Crossing (Le Passage à niveau)*, 1912
Galerie Beyeler, Basel, Switzerland

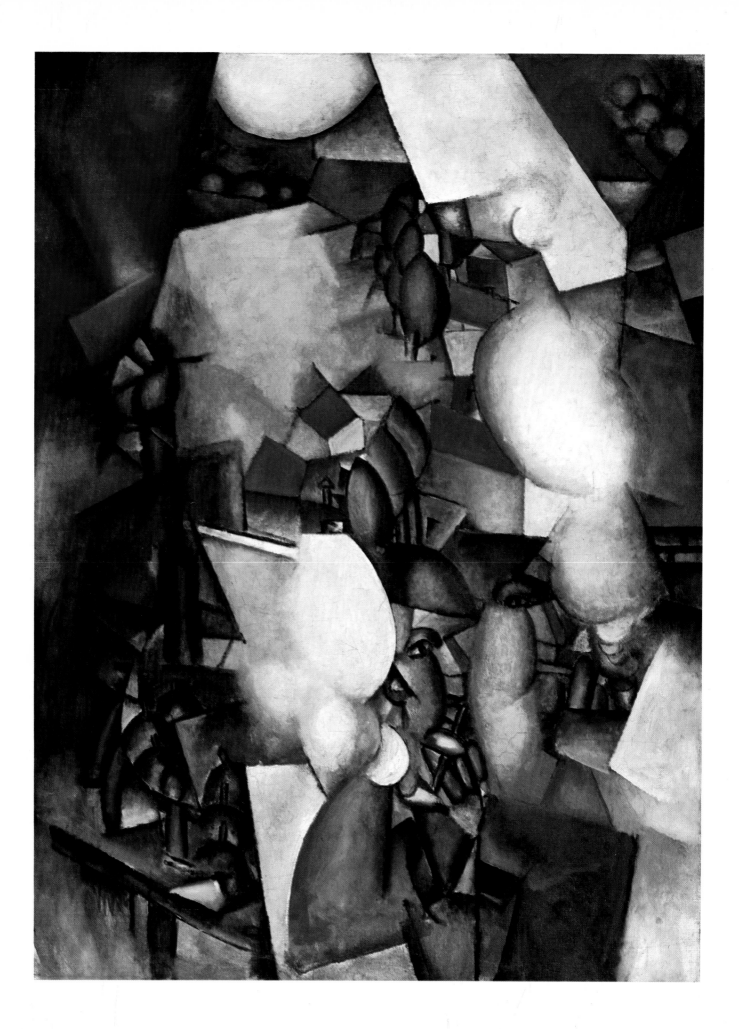

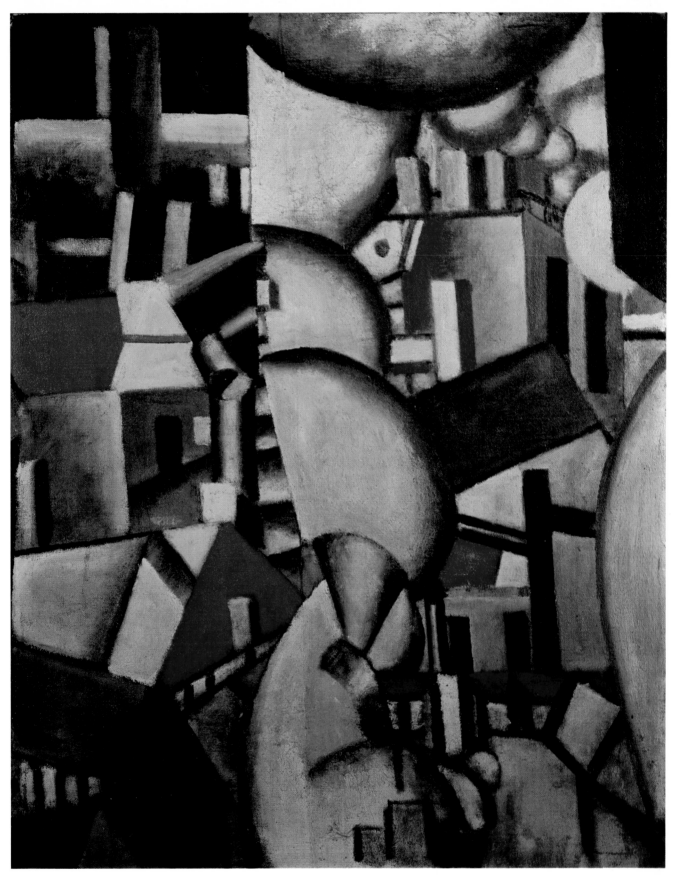

Cat. 6. *Smoke (La Fumée)*, 1912
Albright-Knox Art Gallery, Buffalo, New York,
Room of Contemporary Art Fund, 1940

(Left) Cat. 4. *The Smokers (Les Fumeurs)*, 1911-12
The Solomon R. Guggenheim Museum, New York, New York,
gift of Solomon R. Guggenheim, 1938

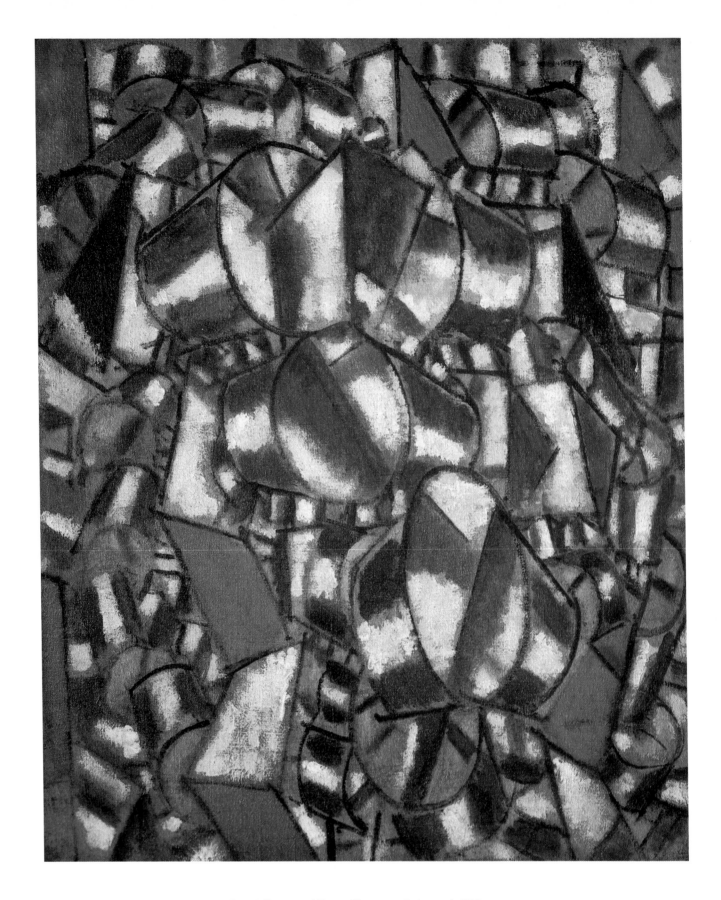

Cat. 7. *Contrast of Forms (Contraste de formes),* 1913
The Museum of Modern Art, New York, New York,
The Philip L. Goodwin Collection, 1958

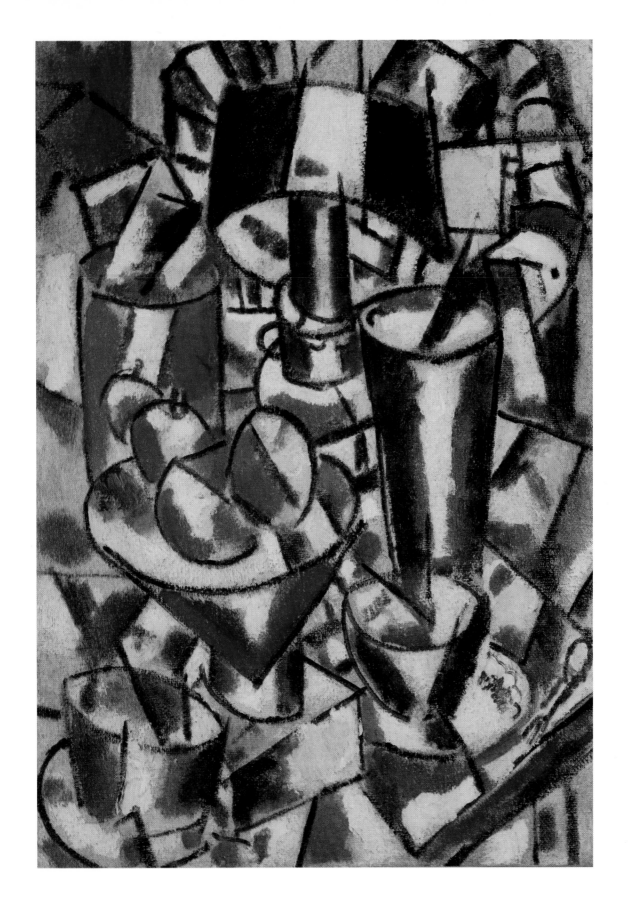

Cat. 8. *Still Life With a Lamp (Nature morte à la lampe),* 1914
Private collection

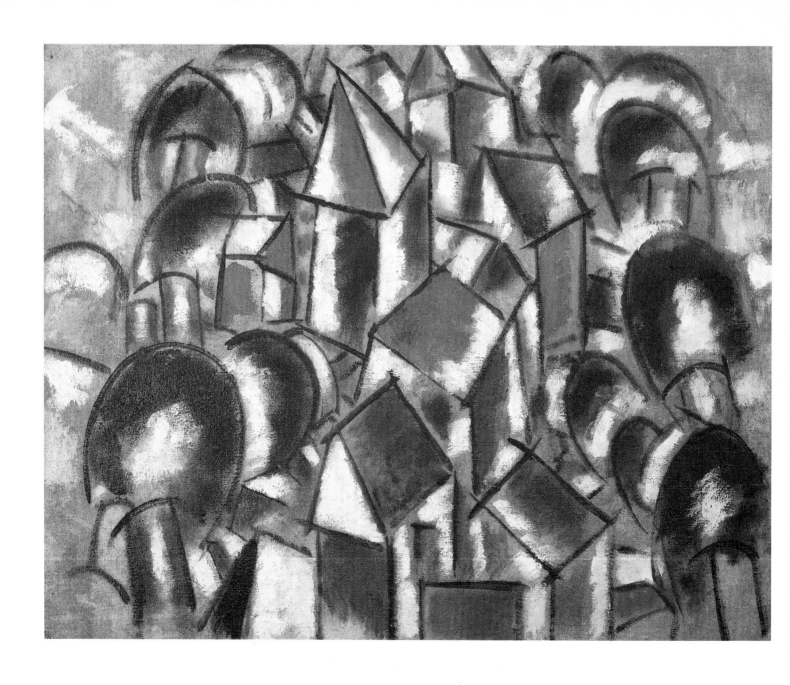

Cat. 9. *Village in the Forest (Le Village dans la forêt),* 1914
Albright-Knox Art Gallery, Buffalo, New York,
gift of A. Conger Goodyear, 1960

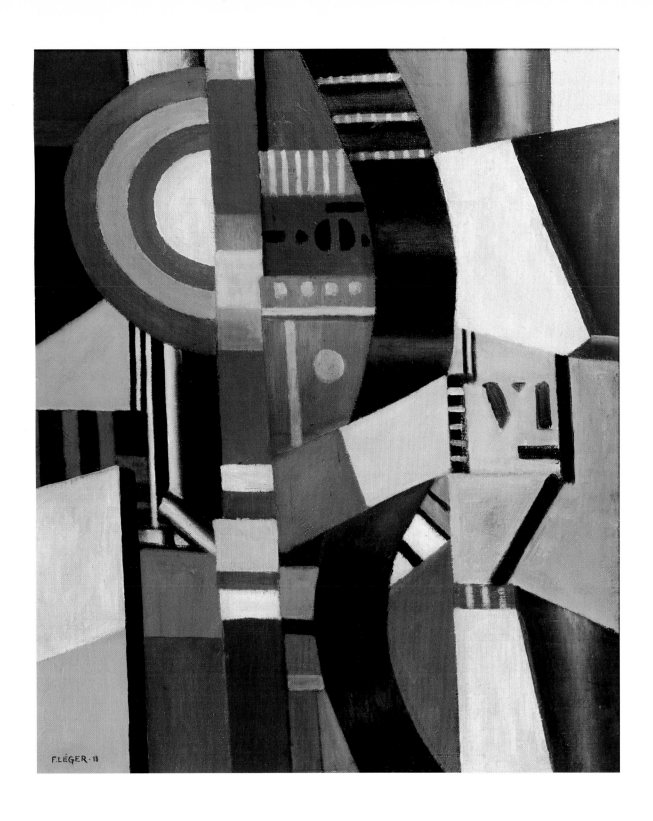

Cat. 10. *Composition 1918 — The Disk (Composition 1918 — Le Disque)*, 1918
Thyssen-Bornemisza Collection, Lugano, Switzerland

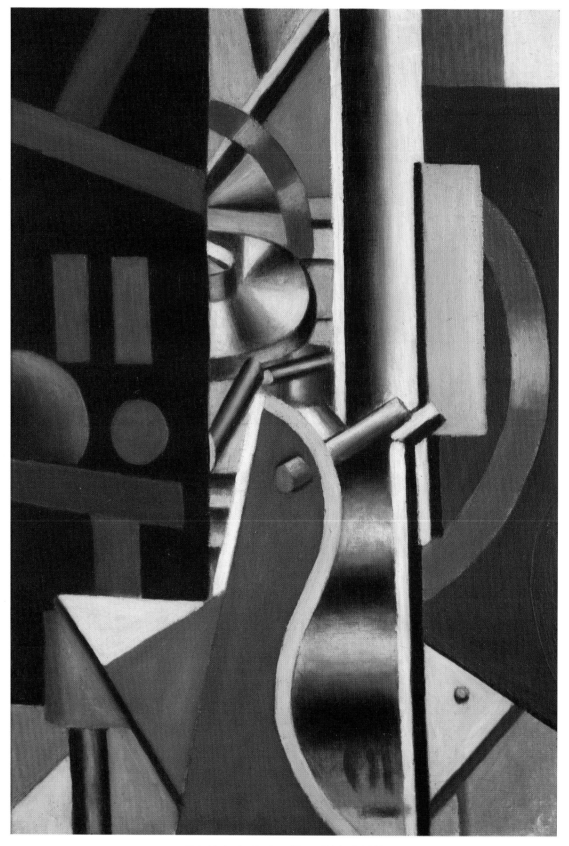

Cat. 11. *In the Factory (Dans l'Usine),* 1918
Sidney Janis Gallery, New York, New York

(Right) Cat. 12. *The Disks (Les Disques),* 1918-19
Los Angeles County Museum of Art, Los Angeles, California,
David E. Bright Bequest

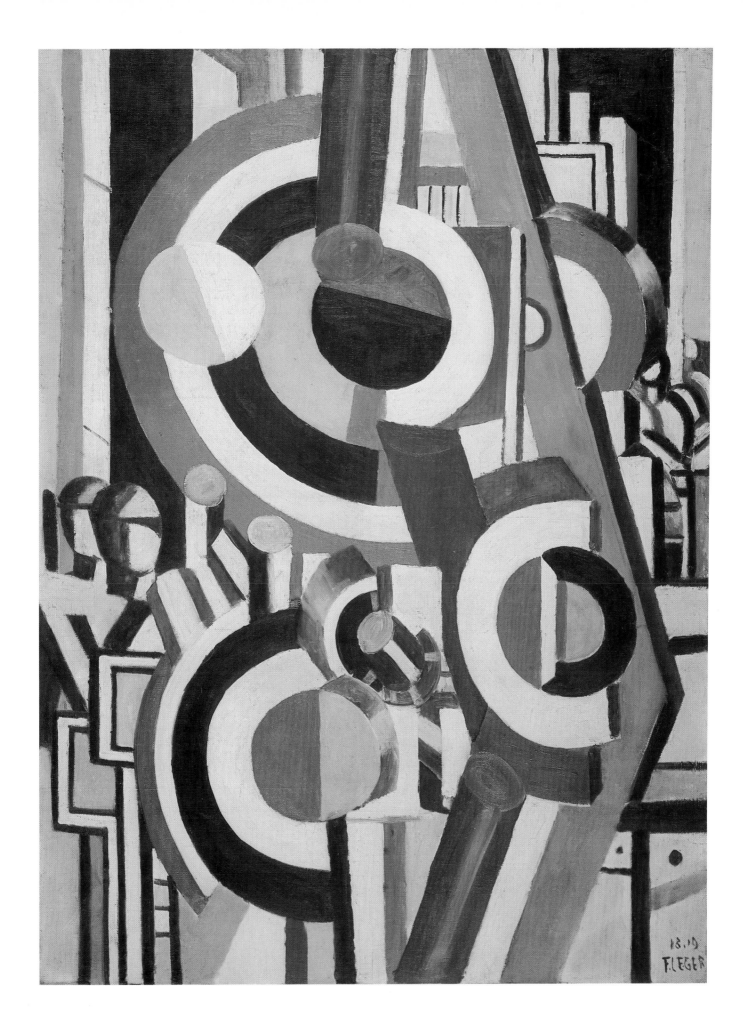

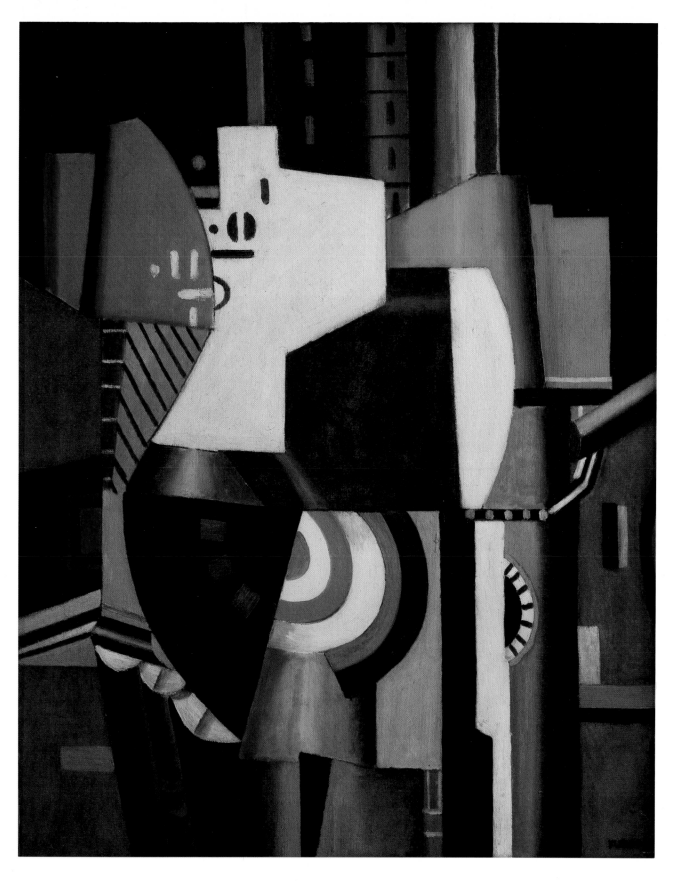

Cat. 14. *The City (study) (La Ville [étude])*, 1919
The Museum of Modern Art, New York, New York,
acquired through the Lillie P. Bliss Bequest, 1952

(Left) Cat. 13. *Abstract Composition (Composition abstraite)*, 1919
Mme. N. Léger, Biot, France

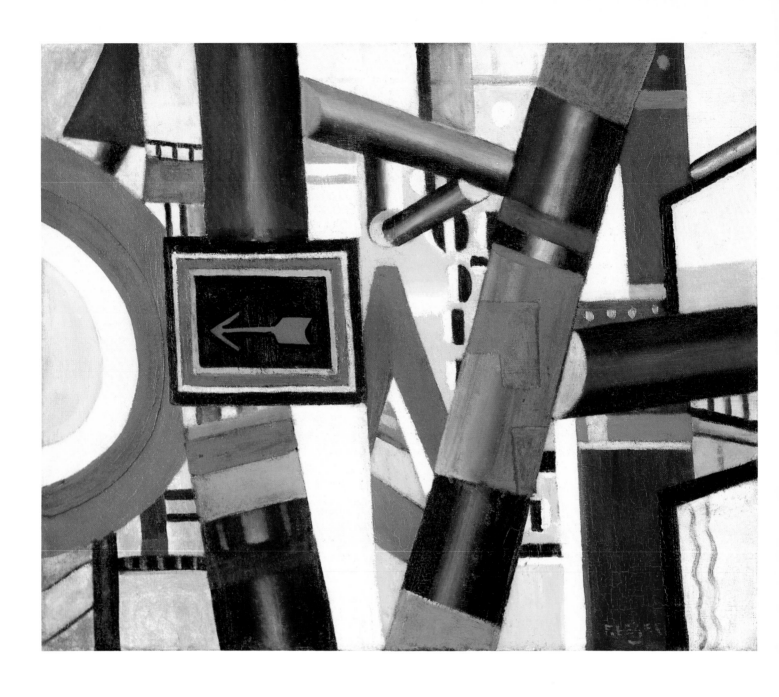

Cat. 15. *Follow the Arrow (Le Passage à niveau)*, 1919
Art Institute of Chicago, Chicago, Illinois,
gift of Mrs. Patrick Hill in memory of Rue Winterbotham Carpenter
to the Joseph Winterbotham Collection

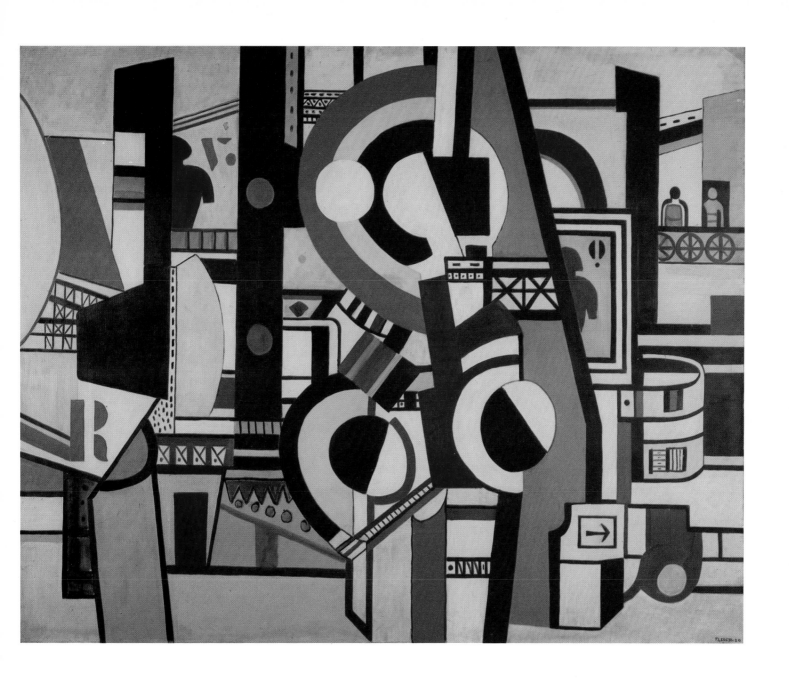

Cat. 16. *Disks in the City (Les Disques dans la ville)*, 1920
Galerie Louise Leiris, Paris

79

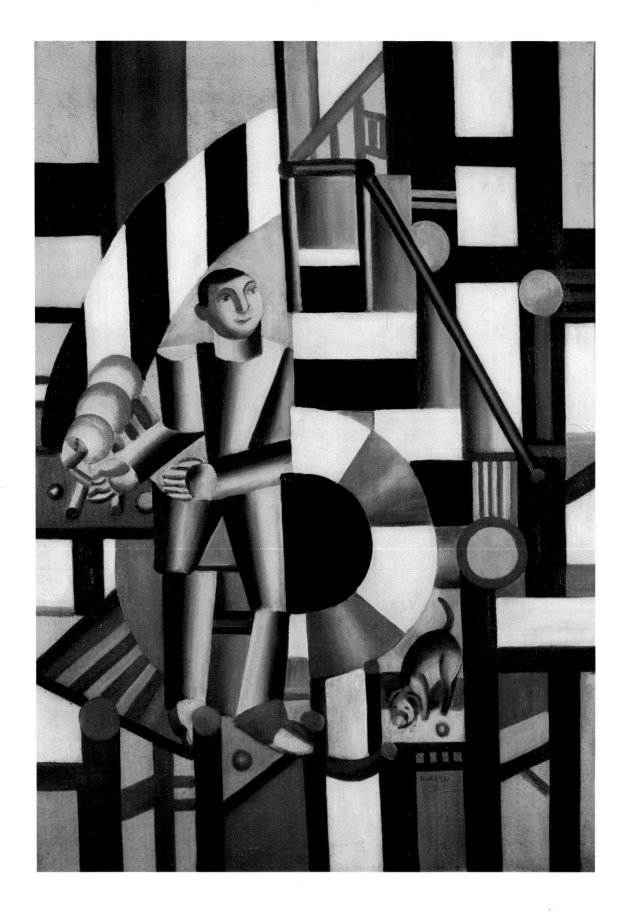

Cat. 17. *Man With a Pipe (L'Homme à la pipe)*, 1920
Musée d'Art Moderne de la Ville de Paris, Paris

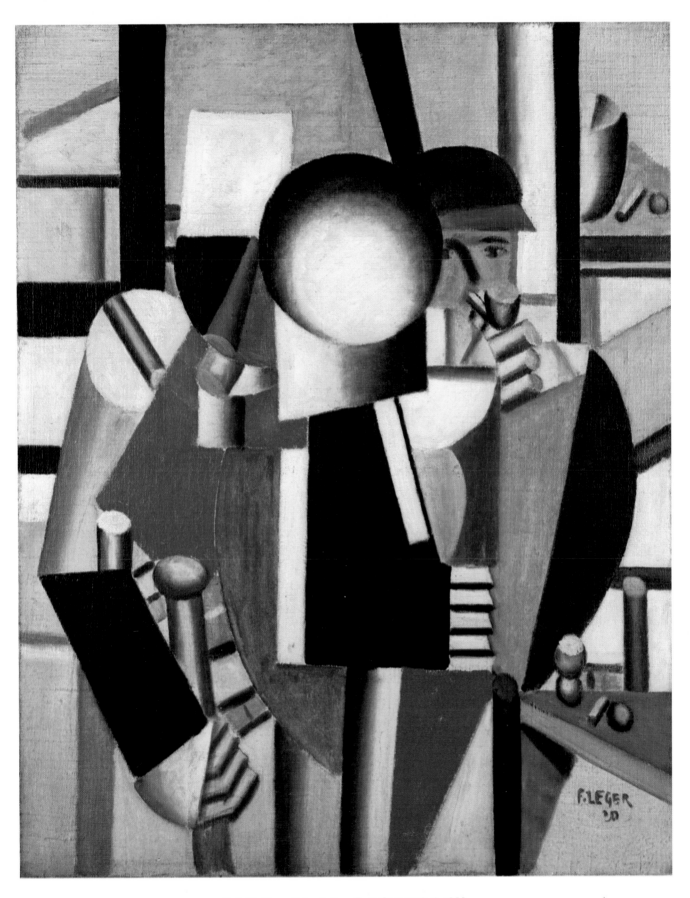

Cat. 18. *Three Friends (Les Trois Camarades)*, 1920
Stedelijk Museum, Amsterdam, The Netherlands

81

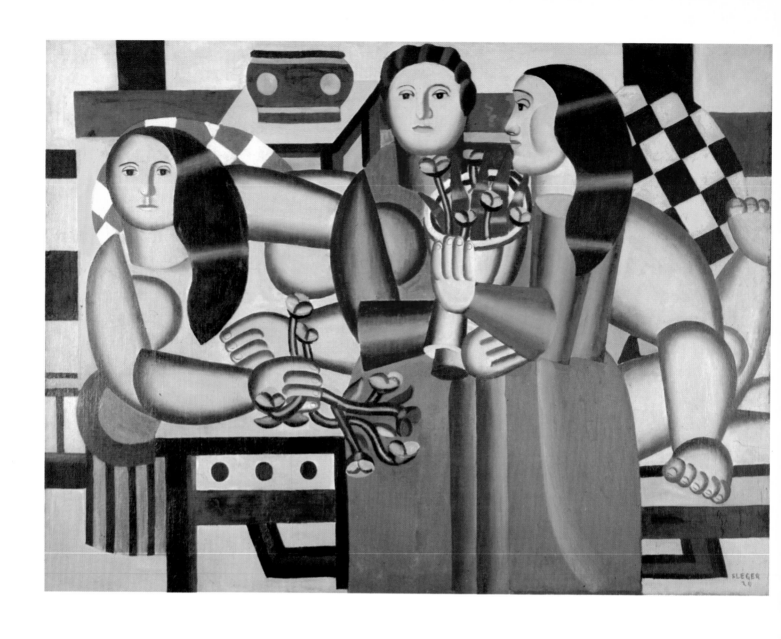

Cat. 19. *Three Women Holding Flowers (Les Trois Femmes aux fleurs)*, 1920
Private collection

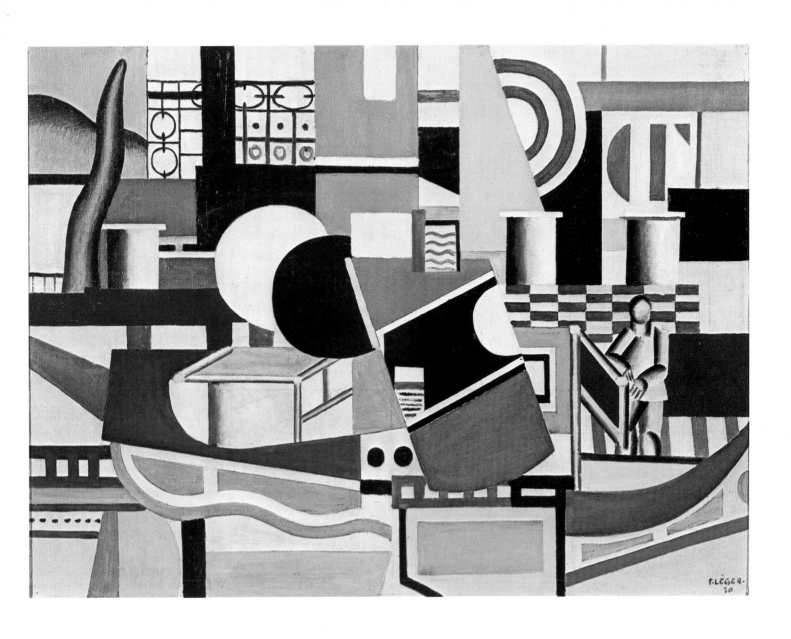

Cat. 20. *The Tugboat Bridge (Le Pont du remorqueur),* 1920
Musée National d'Art Moderne, Paris

83

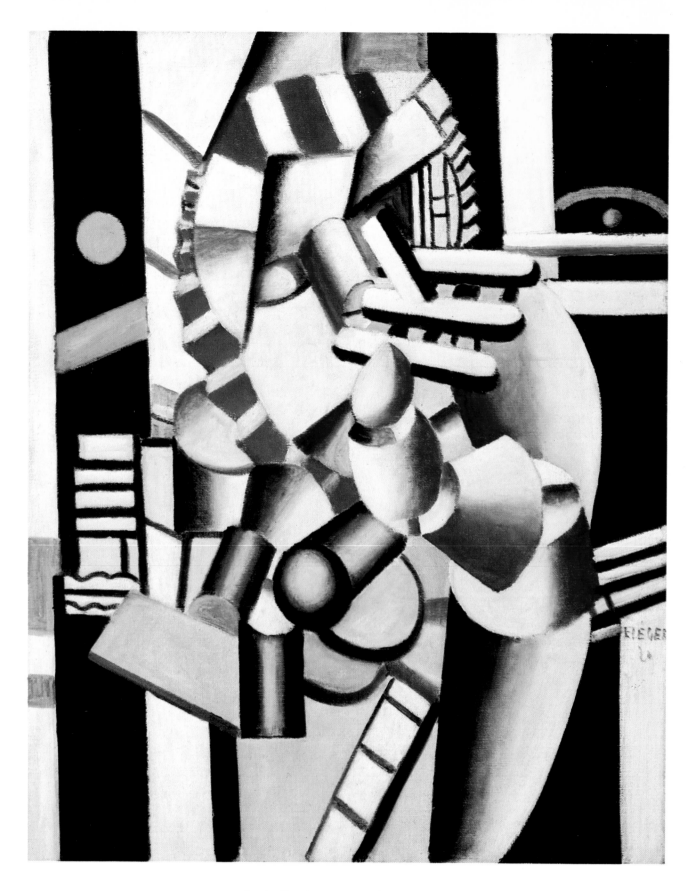

Cat. 21. *The Wounded II (Le Blessé II),* 1920
Milwaukee Art Museum, Milwaukee, Wisconsin,
gift of Mrs. Harry Lynde Bradley

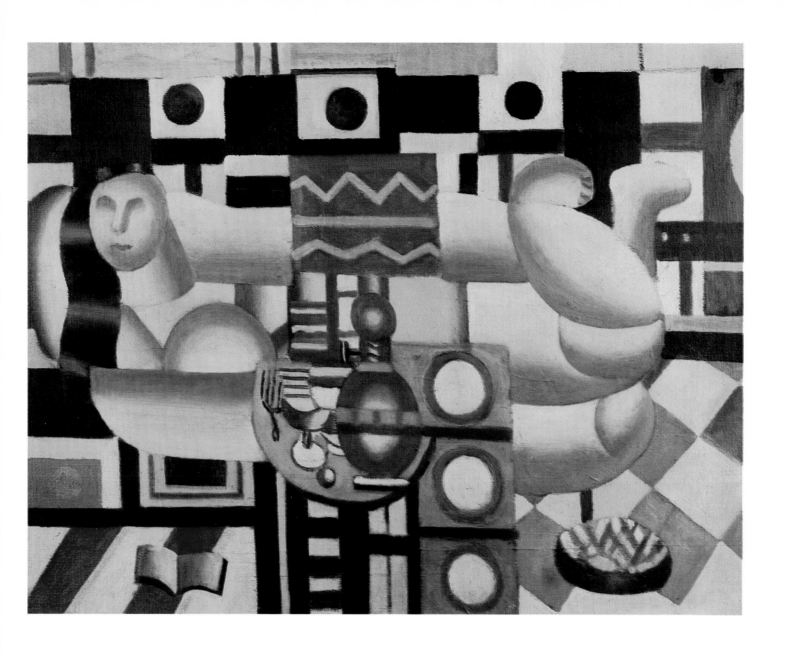

Cat. 24. *Reclining Nude (Femme couchée),* 1921
Perls Galleries, New York, New York

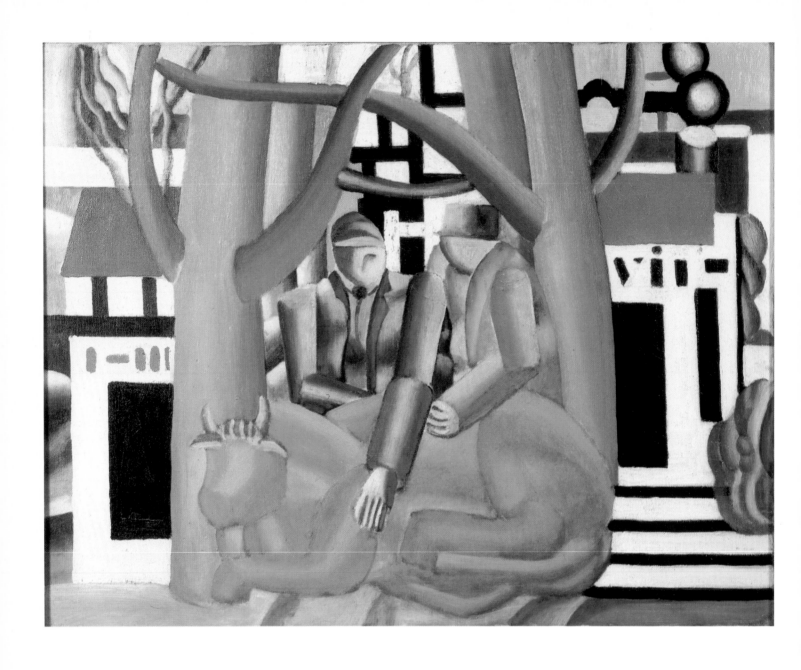

Cat. 22. *Animated Landscape (Paysage animé)*, 1921
Sidney Janis Gallery, New York, New York

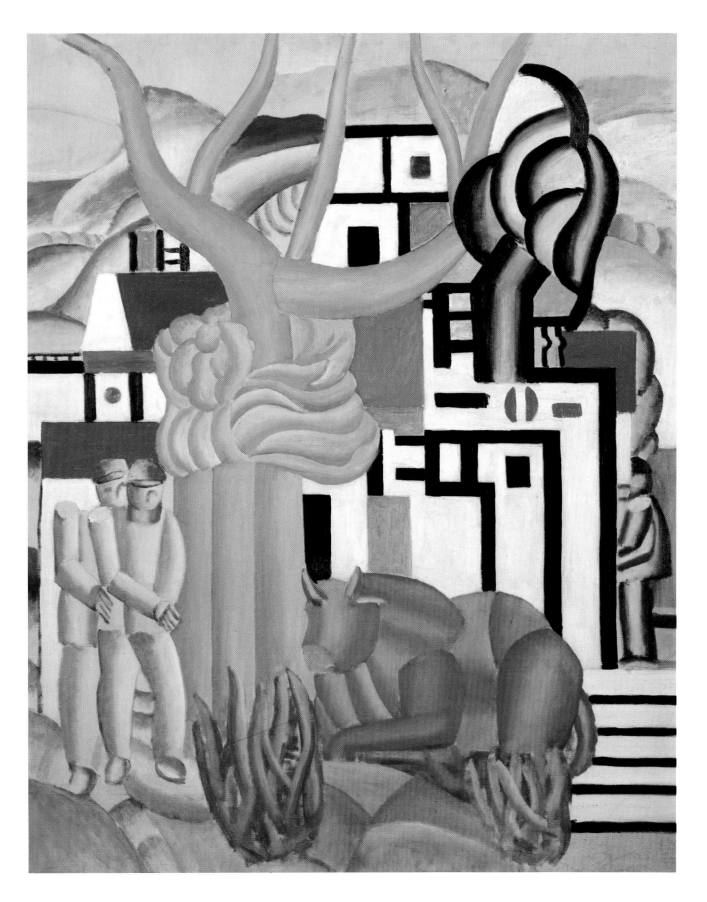

Cat. 23. *Animated Landscape (Paysage animé),* 1921
Sidney Janis Gallery, New York, New York

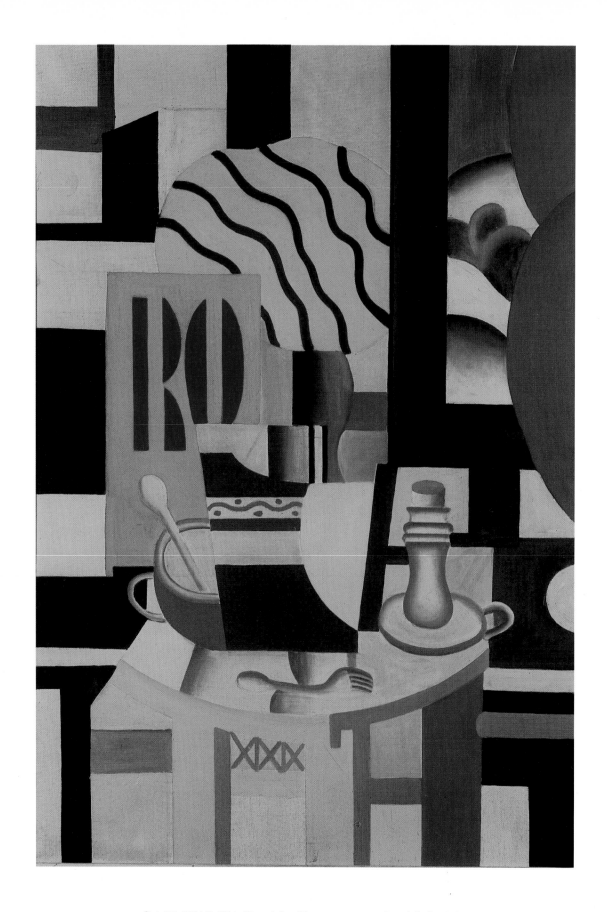

Cat. 25. *Still Life With Chandelier (Nature morte au chandelier),* 1922
Musée d'Art Moderne de la Ville de Paris, Paris

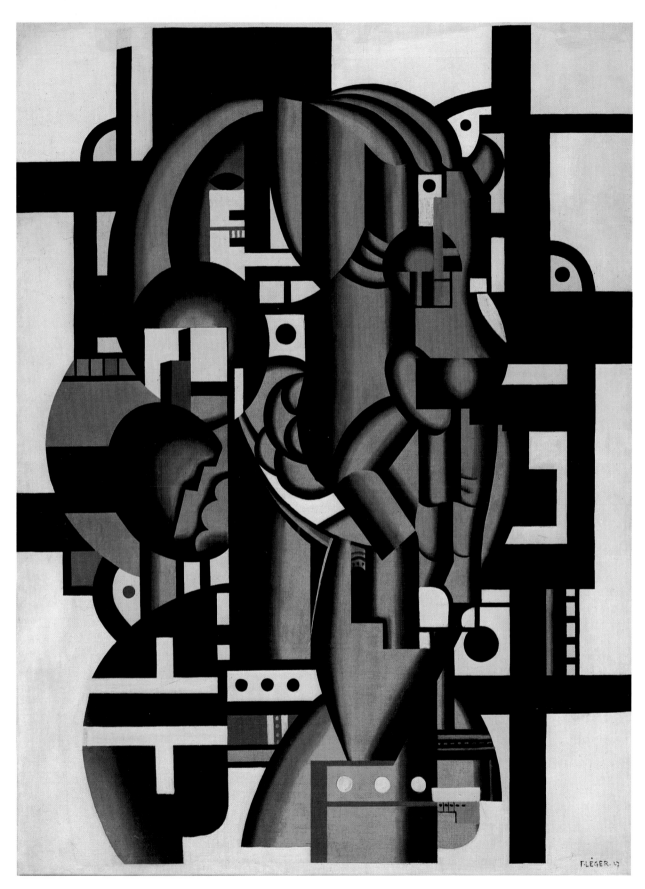

Cat. 26. *Composition*, 1923-27
Philadelphia Museum of Art, Philadelphia, Pennsylvania,
The A. E. Gallatin Collection

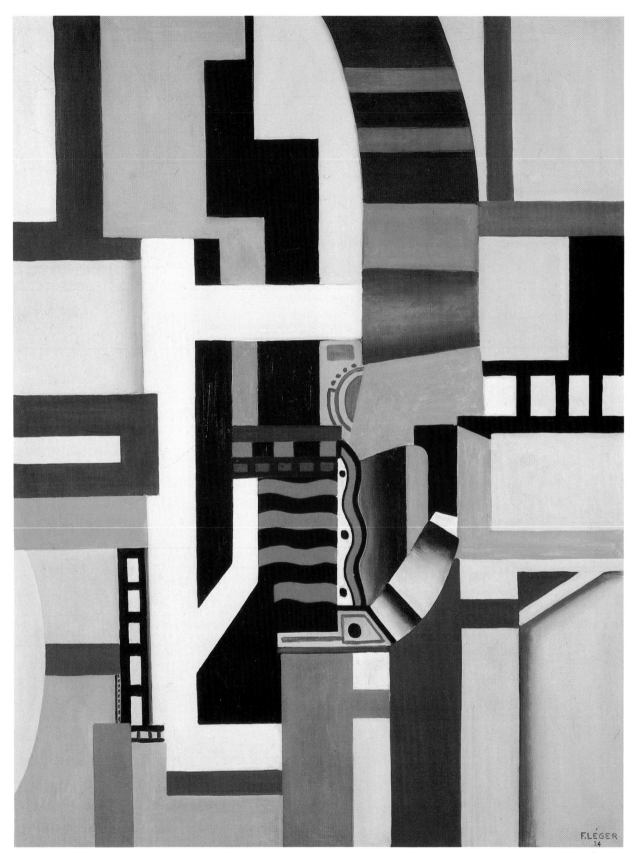

Cat. 27. *Composition*, 1924
Indiana University Art Museum, Bloomington, Indiana

(Right) Cat. 28. *Mural Composition (Composition murale)*, 1924
Musée National Fernand Léger, Biot, France

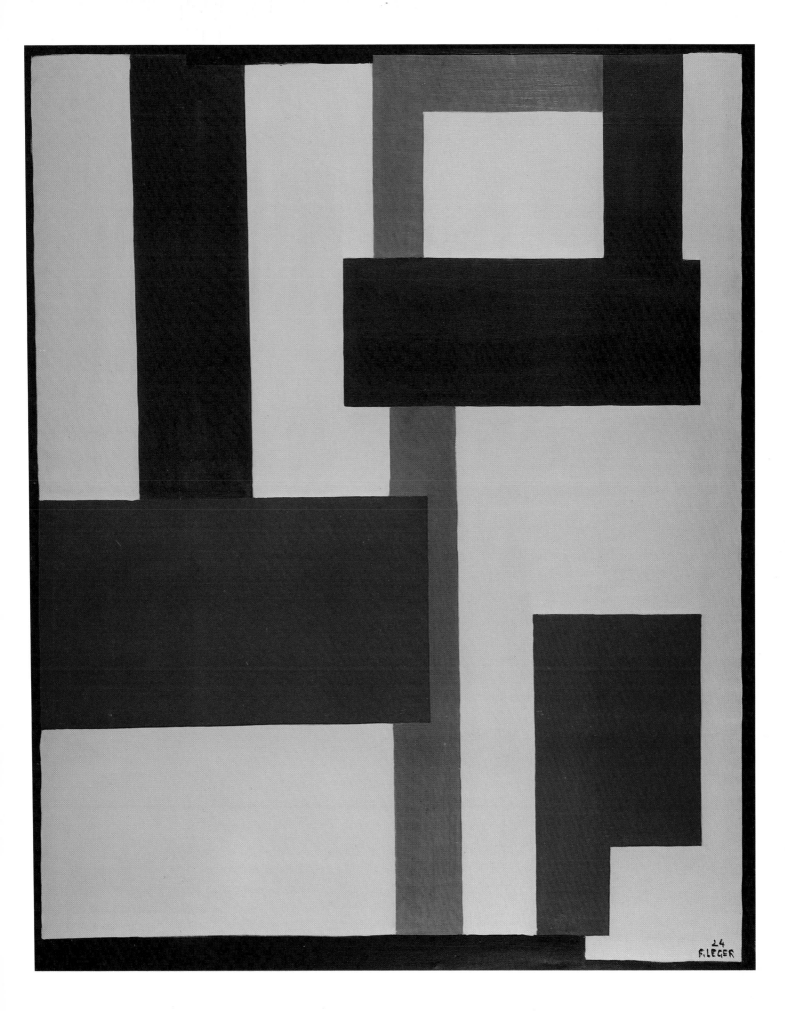

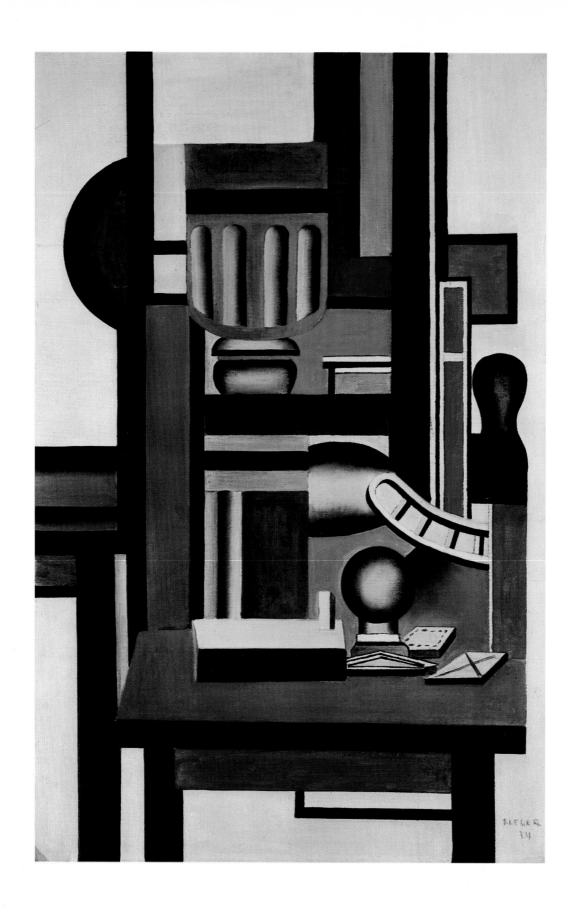

Cat. 30. *Still Life (Nature morte),* 1924
Galerie Beyeler, Basel, Switzerland

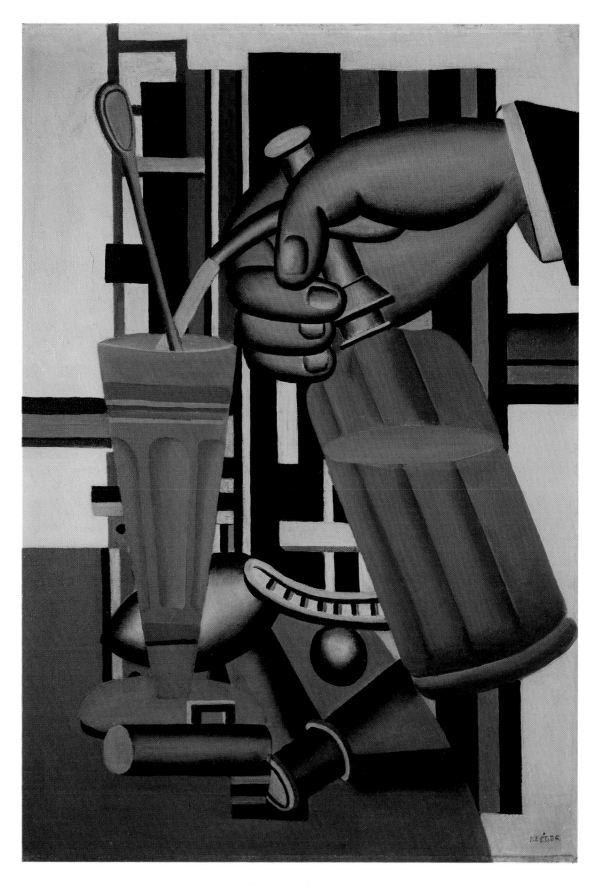

Cat. 31. *The Syphon (Le Siphon)*, 1924
Albright-Knox Art Gallery, Buffalo, New York,
gift of Mr. and Mrs. Gordon Bunshaft, 1977

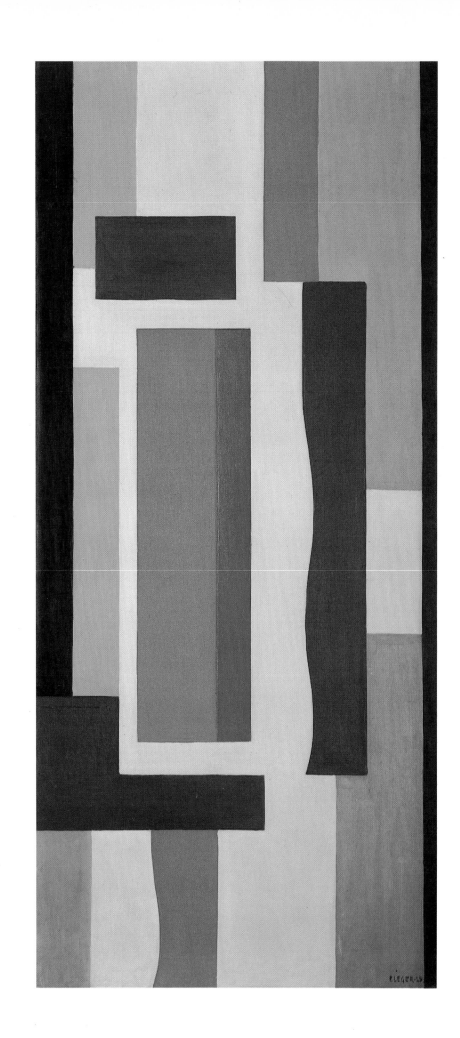

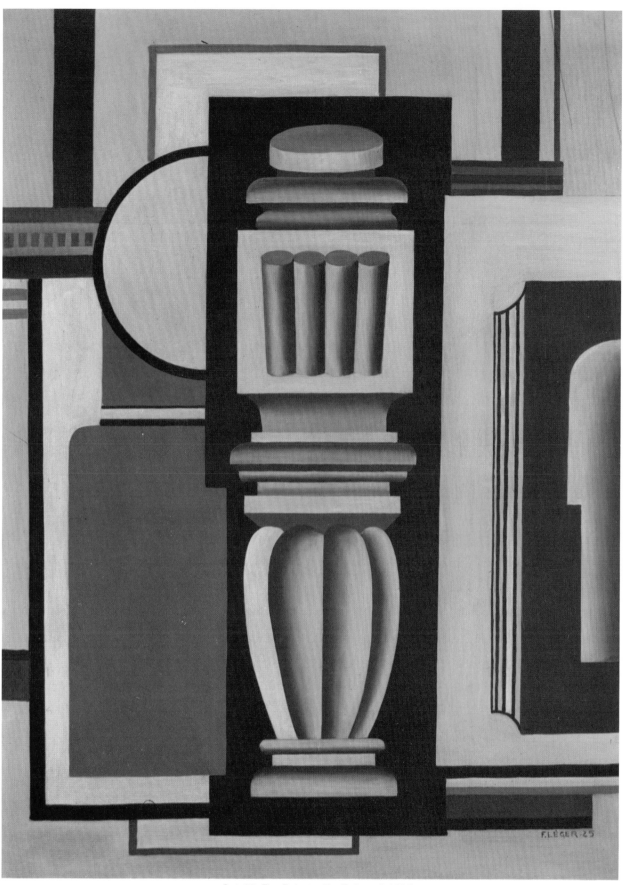

Cat. 33. *The Baluster (Le Balustre)*, 1925
The Museum of Modern Art, New York, New York,
Mrs. Simon Guggenheim Fund, 1952

(Left) Cat. 32. *Mural Painting (Peinture murale)*, 1924-25
The Solomon R. Guggenheim Museum, New York, New York

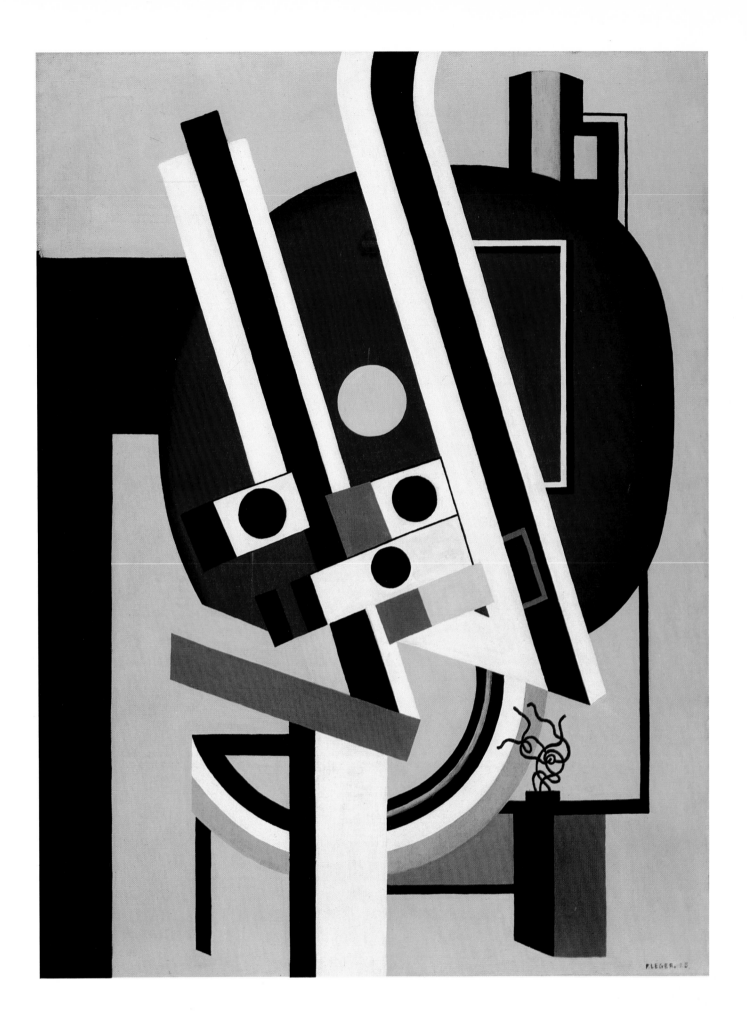

Cat. 35. *Landscape (Paysage)*, 1925
Private collection

(Left) Cat. 34. *Composition (Definitive) (Composition [Définitive])*, 1925
The Solomon R. Guggenheim Museum, New York, New York,
gift of Solomon R. Guggenheim, 1937

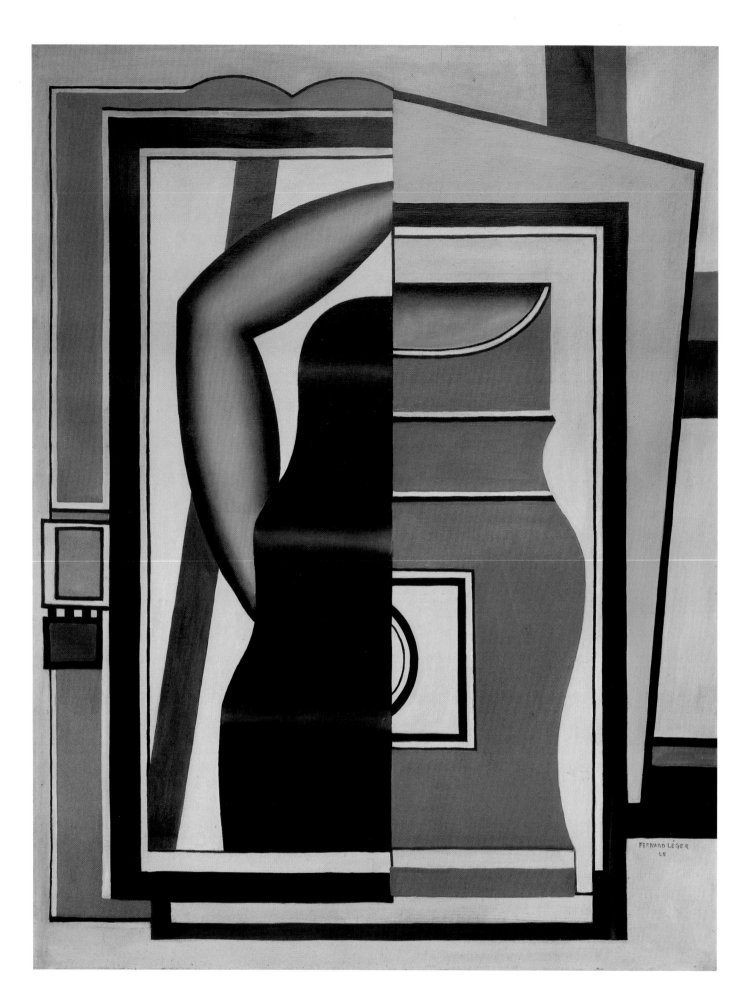

Cat. 37. *The Viaduct, 1st version (Le Viaduc, 1er état),* 1925
Norton Gallery and School of Art, West Palm Beach, Florida

(Left) Cat. 36. *The Mirror (Le Miroir),* 1925
Mr. and Mrs. Gordon Bunshaft, New York, New York

Cat. 39. *Mural Composition (Composition murale),* 1926-36
Musée National Fernand Léger, Biot, France

(Left) Cat. 38. *The Accordion (L'Accordéon),* 1926
Stedelijk Van Abbemuseum, Eindhoven, The Netherlands

Cat. 42. *Still Life ABC (Nature morte ABC)*, 1927
Musée National Fernand Léger, Biot, France

(Left) Cat. 40. *Composition With a Leaf (Composition à la feuille)*, 1927
Musée National Fernand Léger, Biot, France

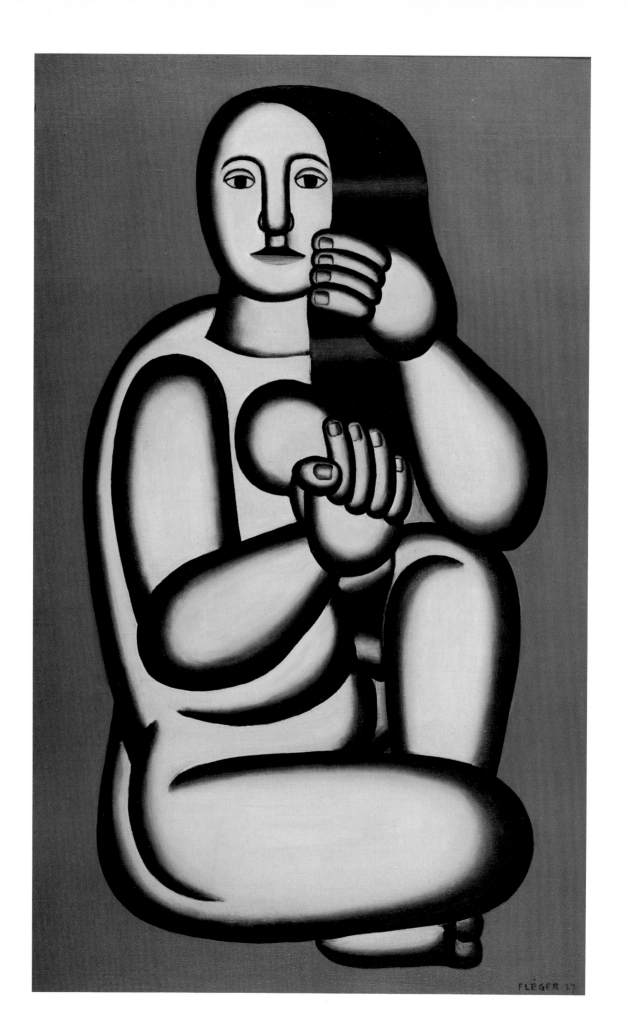

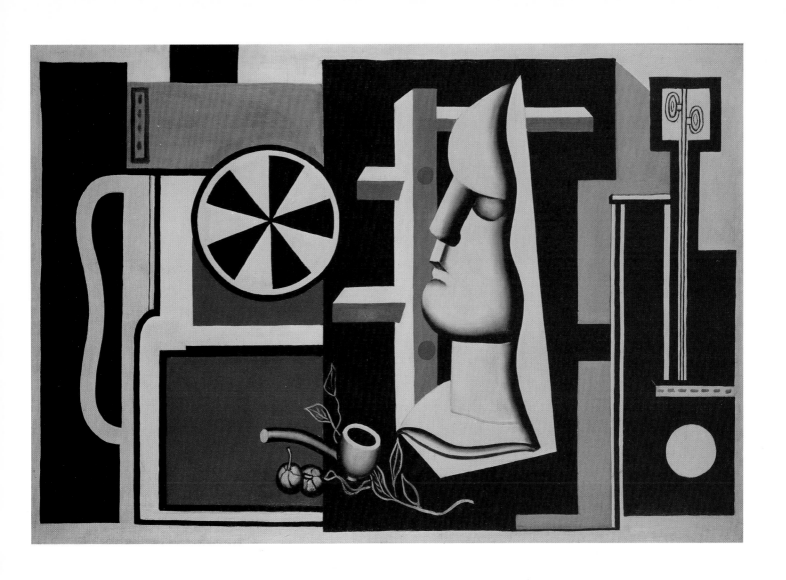

Cat. 43. *Still Life With Plaster Mask (Nature morte au masque de plâtre),* 1927
Galerie Beyeler, Basel, Switzerland

(Left) Cat. 41. *Nude on a Red Background (Nu sur fond rouge),* 1927
Hirshhorn Museum and Sculpture Garden,
Smithsonian Institution, Washington, D.C.

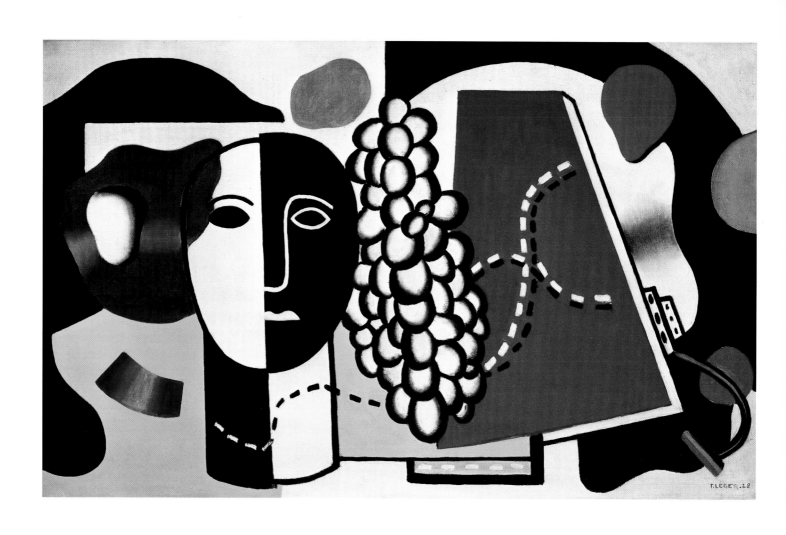

Cat. 44. *Bunch of Grapes (La Grappe de raisin),* 1928
Perls Galleries, New York, New York

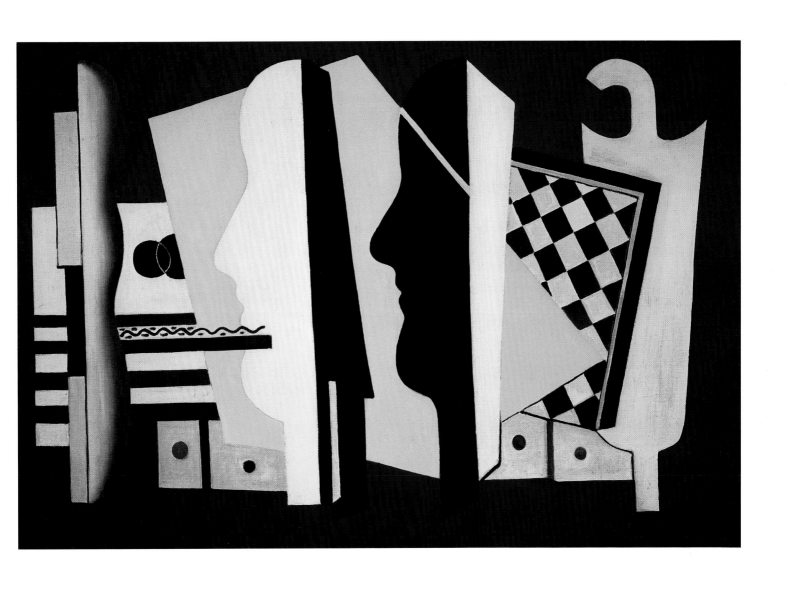

Cat. 45. *Two Profiles (Les Deux Profils),* 1928
Perls Galleries, New York, New York

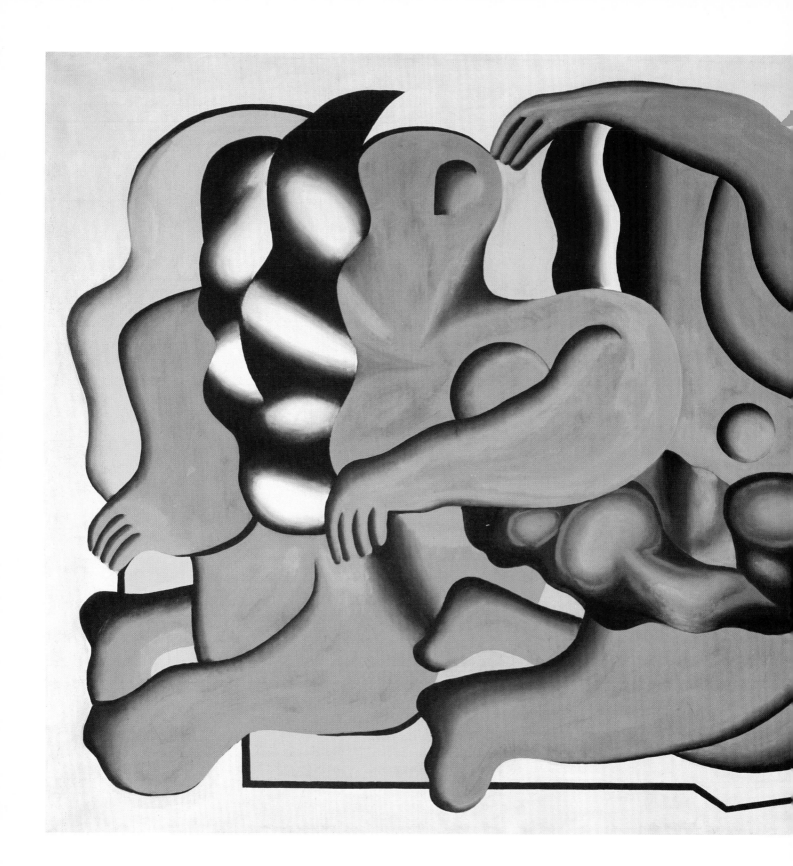

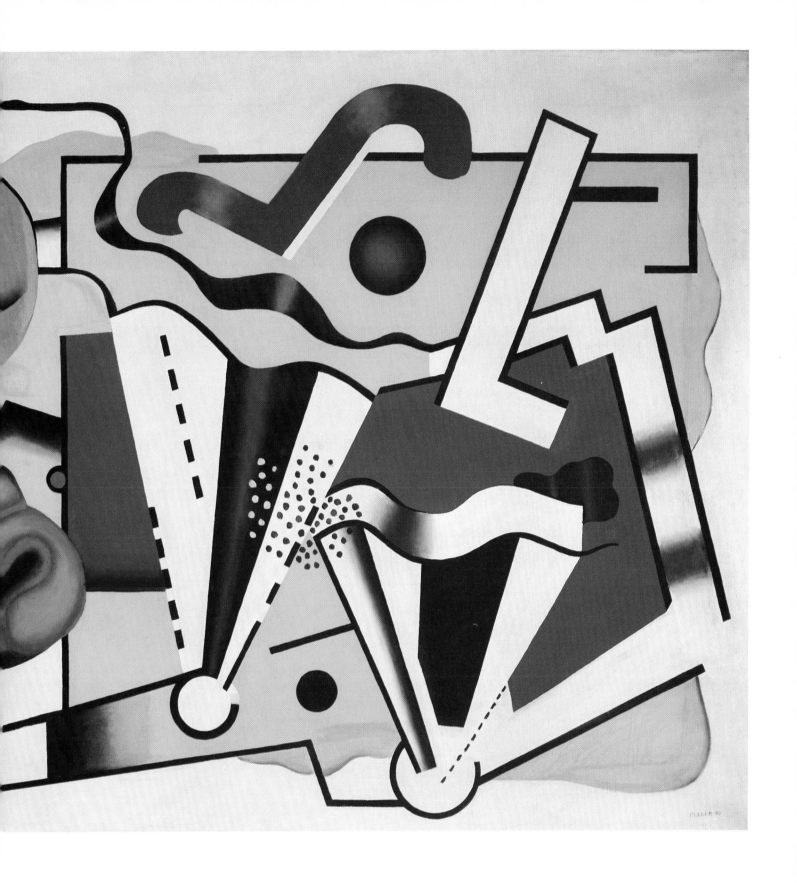

Cat. 46. *Composition I*, 1930
Galerie Beyeler, Basel, Switzerland

109

Cat. 47. *Comet's Tail on Brown Background*
(Queue de comète sur fond marron), c. 1930
Musée National Fernand Léger, Biot, France

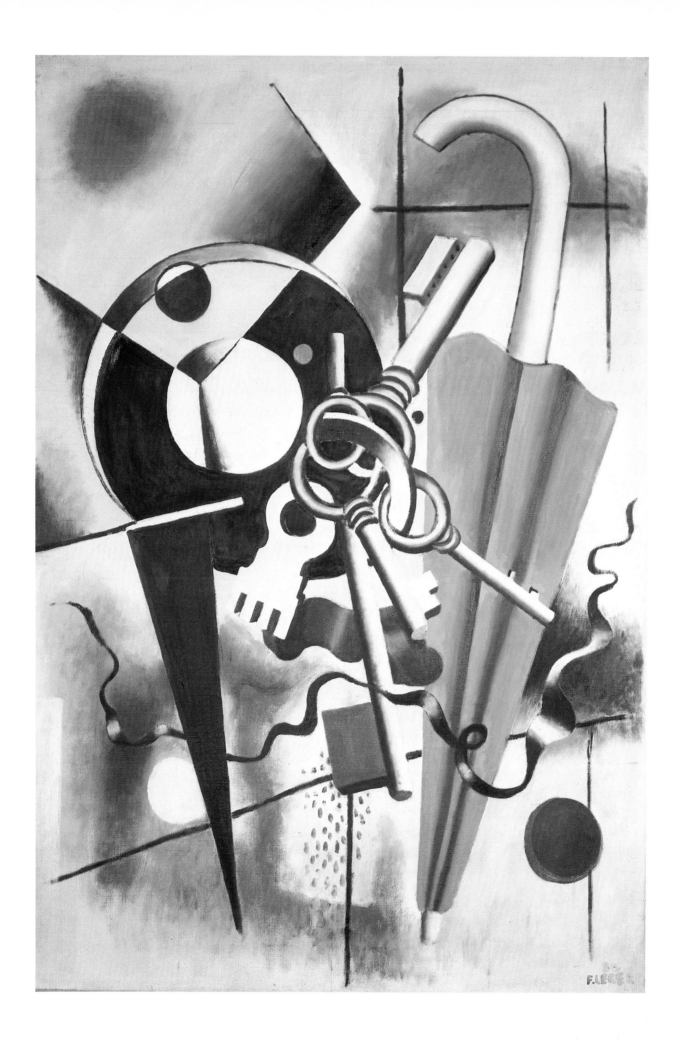

Cat. 50. *Butterfly and Flower (Papillon et fleur)*, 1937
Private collection

(Left) Cat. 48. *Composition With Umbrella (Composition au parapluie)*, 1932
Galerie Louise Leiris, Paris

Cat. 51. *Man With a Blue Hat (L'Homme au chapeau bleu),* 1937
Musée National Fernand Léger, Biot, France

(Left) Cat. 49. *Two Sisters (Les Deux Soeurs),* 1935
Staatliche Museen Preussischer Kulturbesitz, Nationalgalerie,
Berlin, West Germany

115

Cat. 52. *Composition With Yellow Canary (Composition au serin jaune),* 1937-39
Galerie Beyeler, Basel, Switzerland

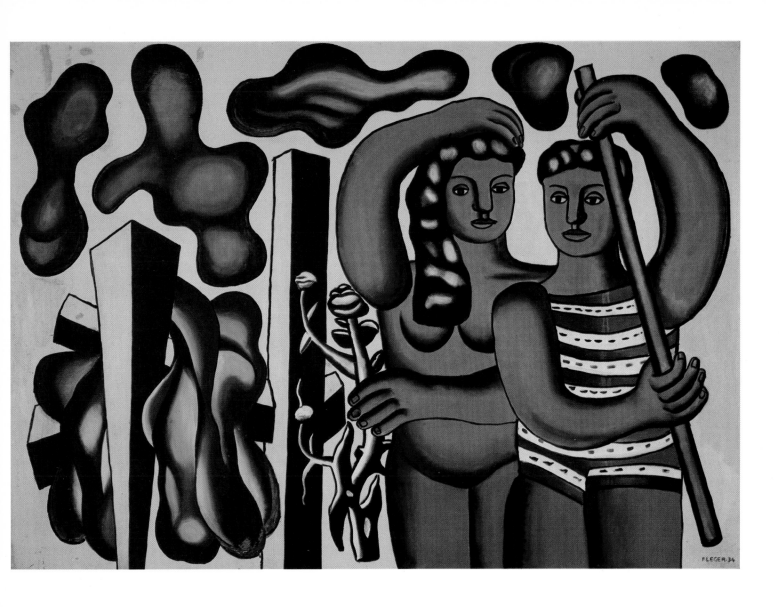

Cat. 53. *Adam and Eve (Adam et Eve),* 1939
Musée National Fernand Léger, Biot, France

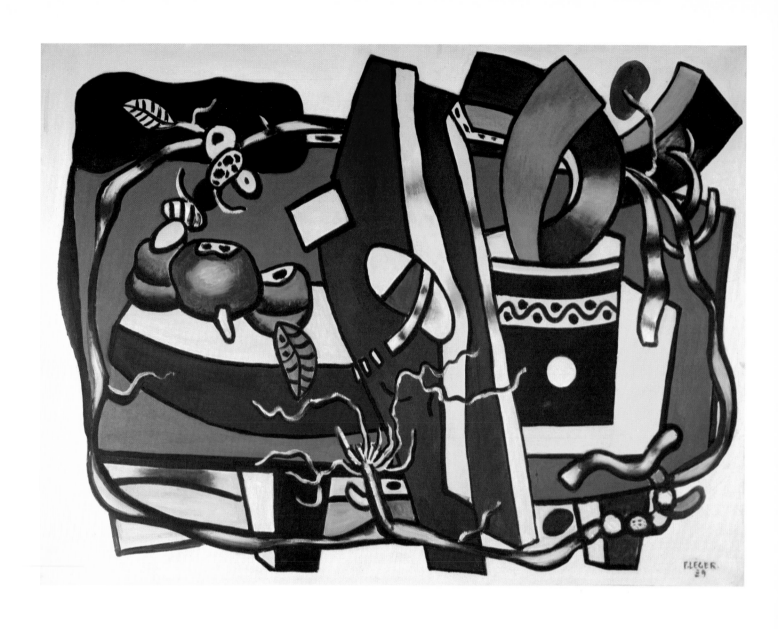

Cat. 54. *Still Life With Green Plant (Nature morte à la plante verte),* 1939
Galerie Adrien Maeght, Paris

(Right) Cat. 57. *Elements on a Blue Background (Eléments sur fond bleu),* 1941
Galerie Adrien Maeght, Paris

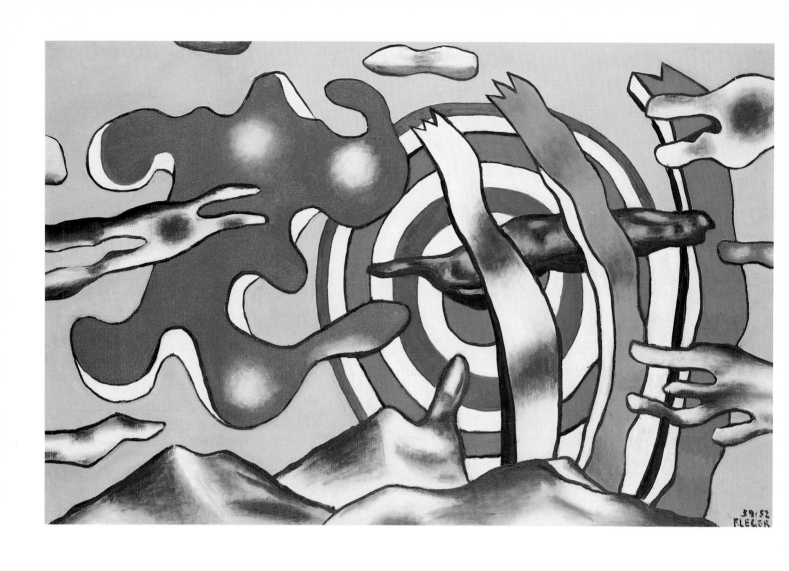

Cat. 55. *Airplane in the Sky (L'Avion dans le ciel)*, 1939-52
Musée National Fernand Léger, Biot, France

(Right) Cat. 61. *The Forest (La Forêt)*, 1942
Galerie Adrien Maeght, Paris

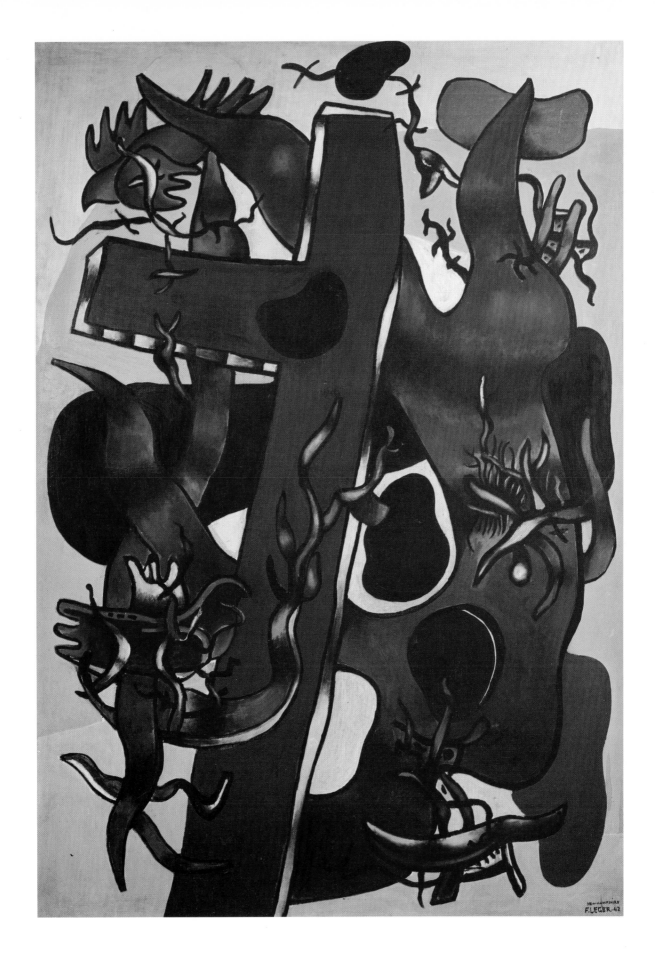

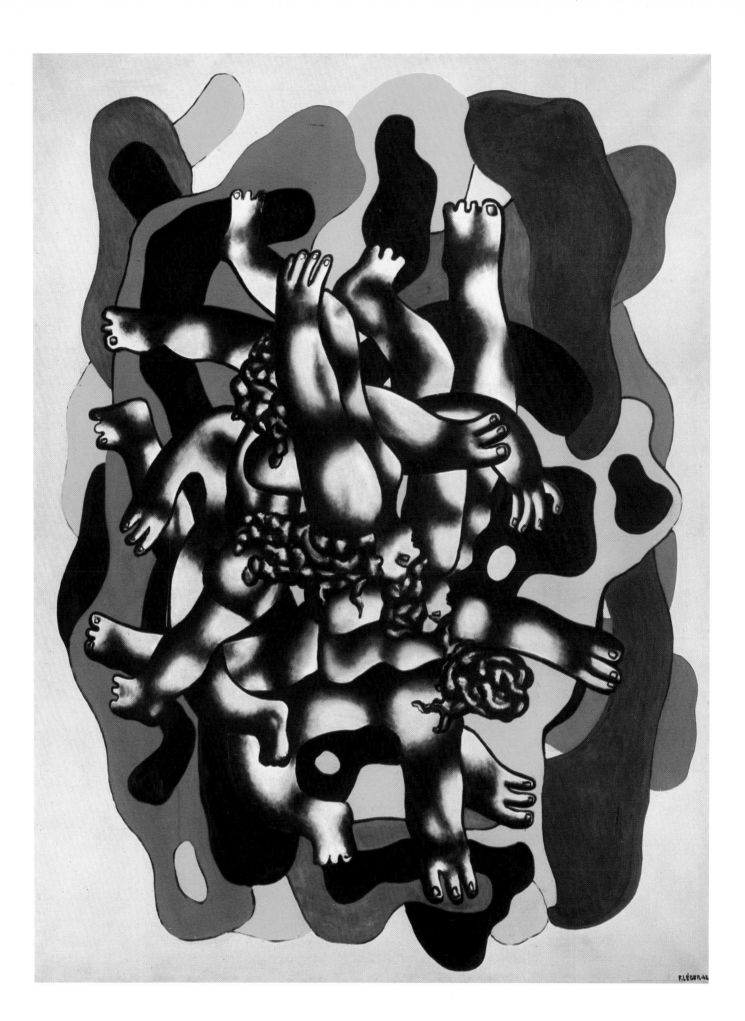

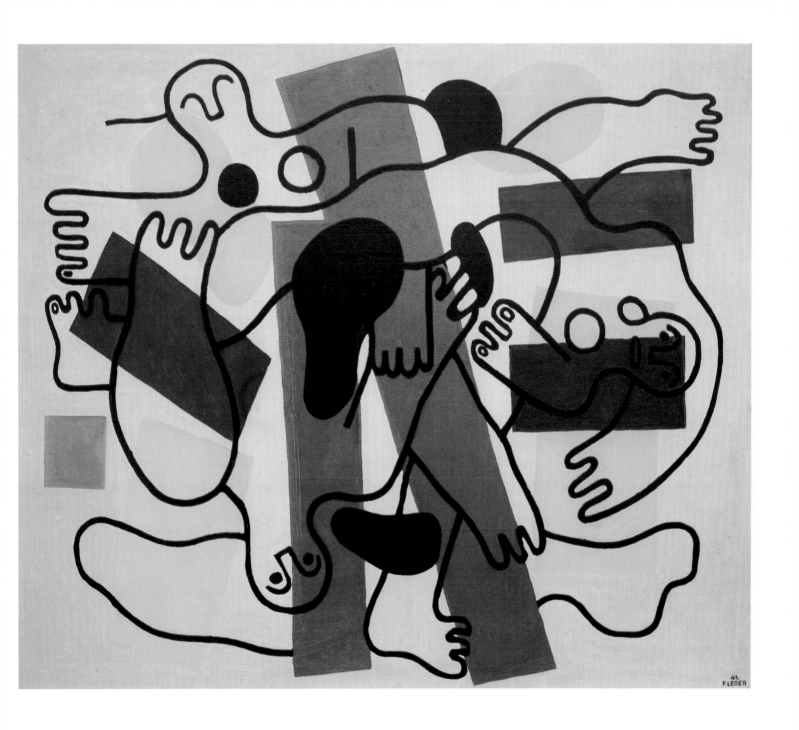

Cat. 60. *Divers (Red and Black) (Plongeurs [rouge et noir]),* 1942
James H. and Lillian Clark Foundation, Dallas, Texas

(Left) Cat. 58. *The Divers, II (Les Plongeurs, II),* 1941-42
The Museum of Modern Art, New York, New York,
Mrs. Simon Guggenheim Fund, 1955

(Pg. 124) Cat. 62. *The Grey Acrobats (Les Acrobates en gris),* 1942-44
Musée National d'Art Moderne, Paris

(Pg. 125) Cat. 63. *Tree in the Ladder (L'Arbre dans l'échelle),* 1943-44
Galerie Louise Leiris, Paris

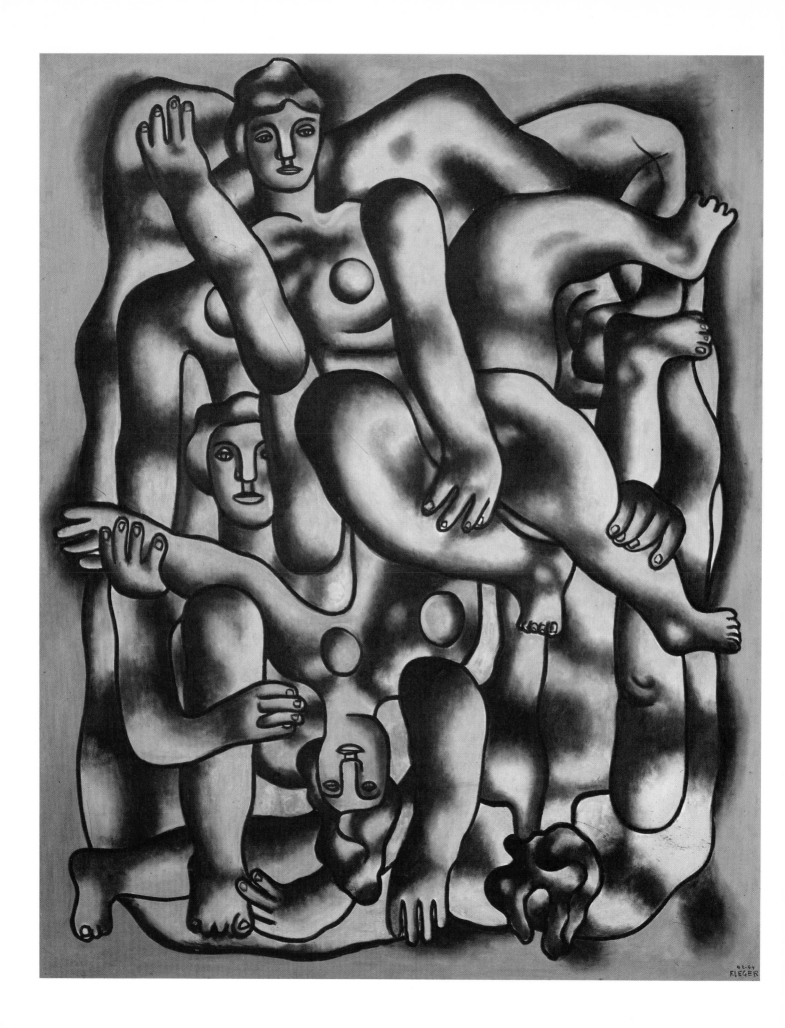

Cat. 65. *The Great Divers (black) (Les Grands Plongeurs [noirs])*, 1944
Galerie Adrien Maeght, Paris

(Right) Cat. 66. *Three Musicians (Les Trois Musiciens)*, 1944
The Museum of Modern Art, New York, New York,
Mrs. Simon Guggenheim Fund, 1955

Cat. 67. *The Women Cyclists (Les Belles Cyclistes)*, 1944
Gallery of Art, Washington University, St. Louis, Missouri

128

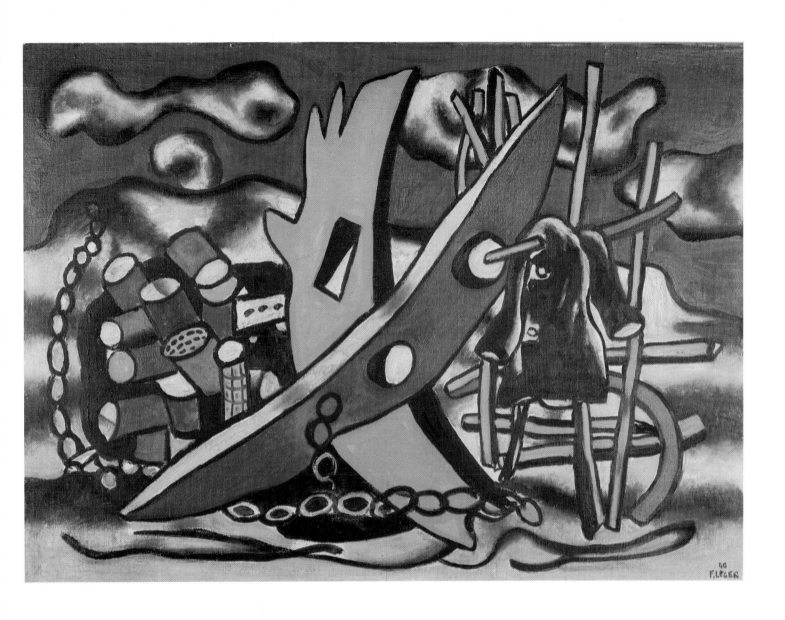

Cat. 70. *Romantic Landscape (Paysage romantique)*, 1946
Galerie Louise Leiris, Paris

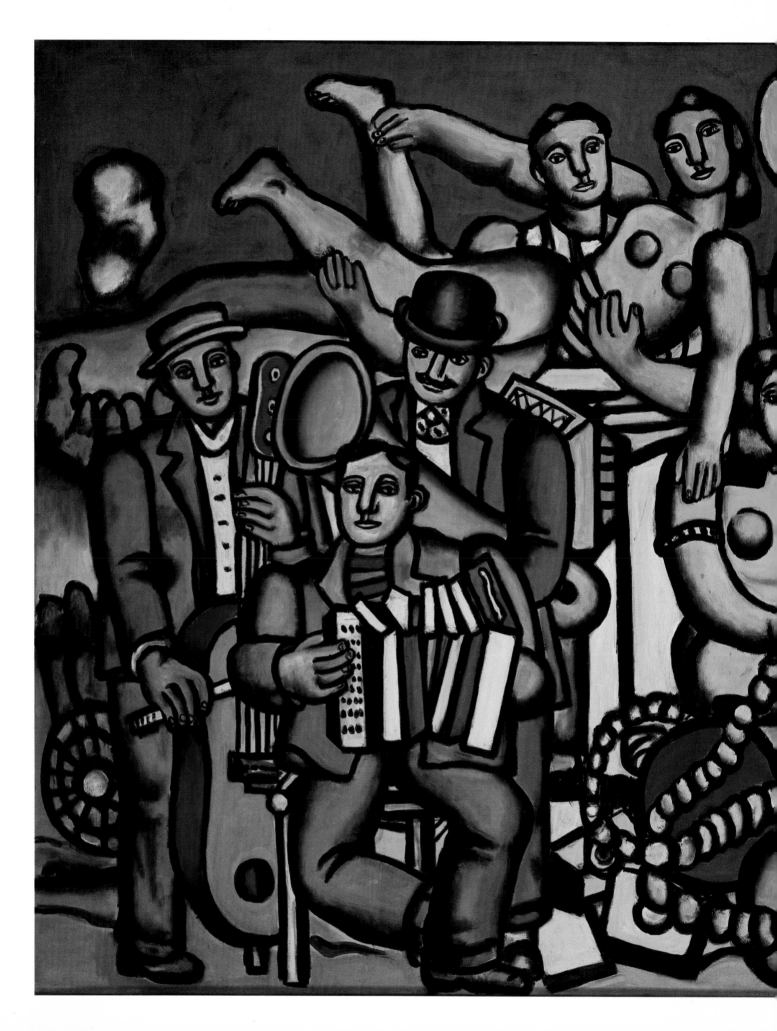

Cat. 68. *Acrobats and Musicians (Acrobates et musiciens),* 1945
Galerie Aimé Maeght, Paris

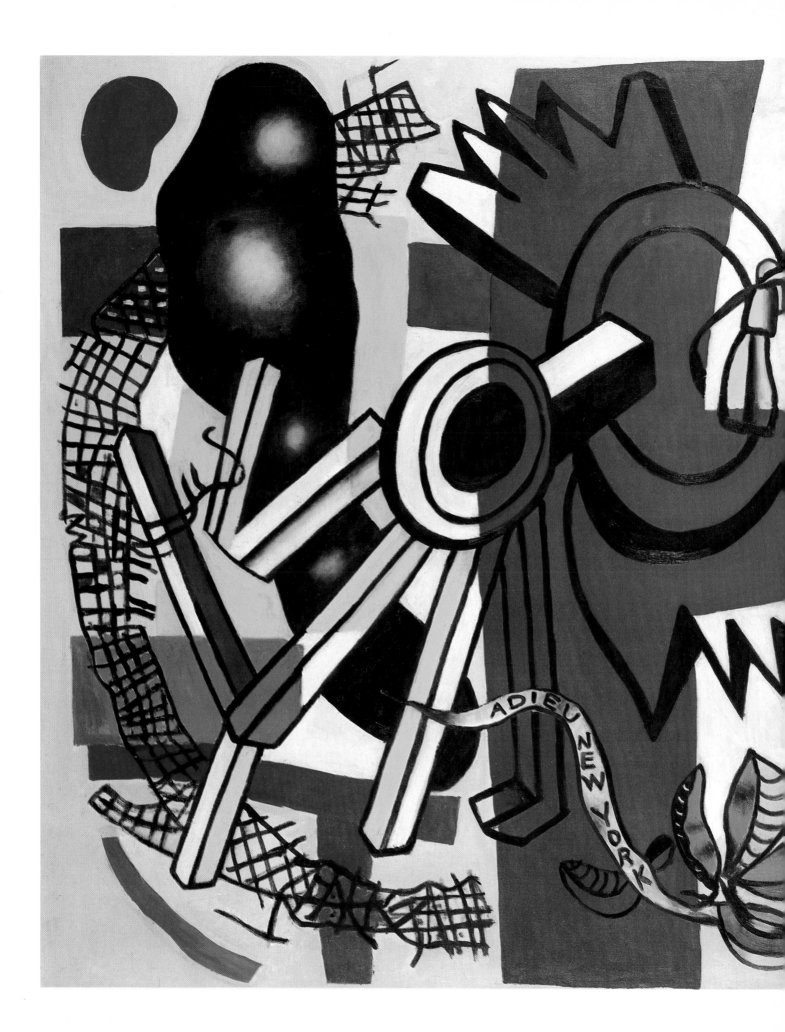

Cat. 69. *Adieu New York*, 1946
Musée National d'Art Moderne, Paris

(Pg. 134) Cat. 71. *Construction Workers With Rope*
(Constructeurs au cordage), 1950
The Solomon R. Guggenheim Museum, New York, New York,
fractional gift of Evelyn Sharp, 1977

(Pg. 135) Cat. 72. *Study for The Construction Workers*
(Etude pour Les Constructeurs), 1950
McCrory Corporation, New York, New York

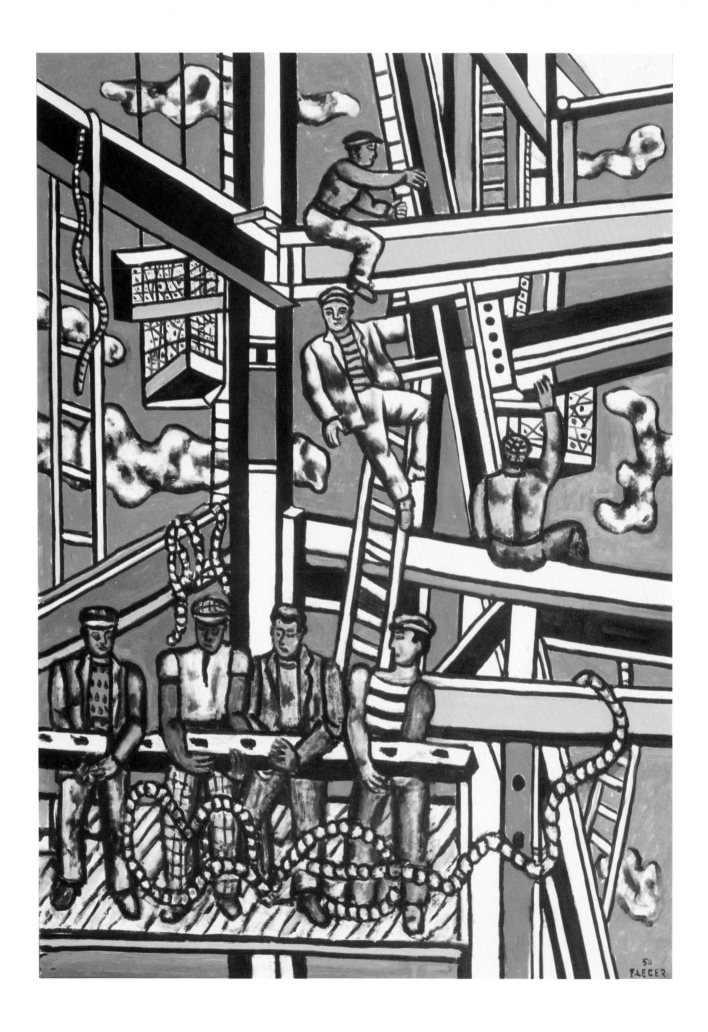

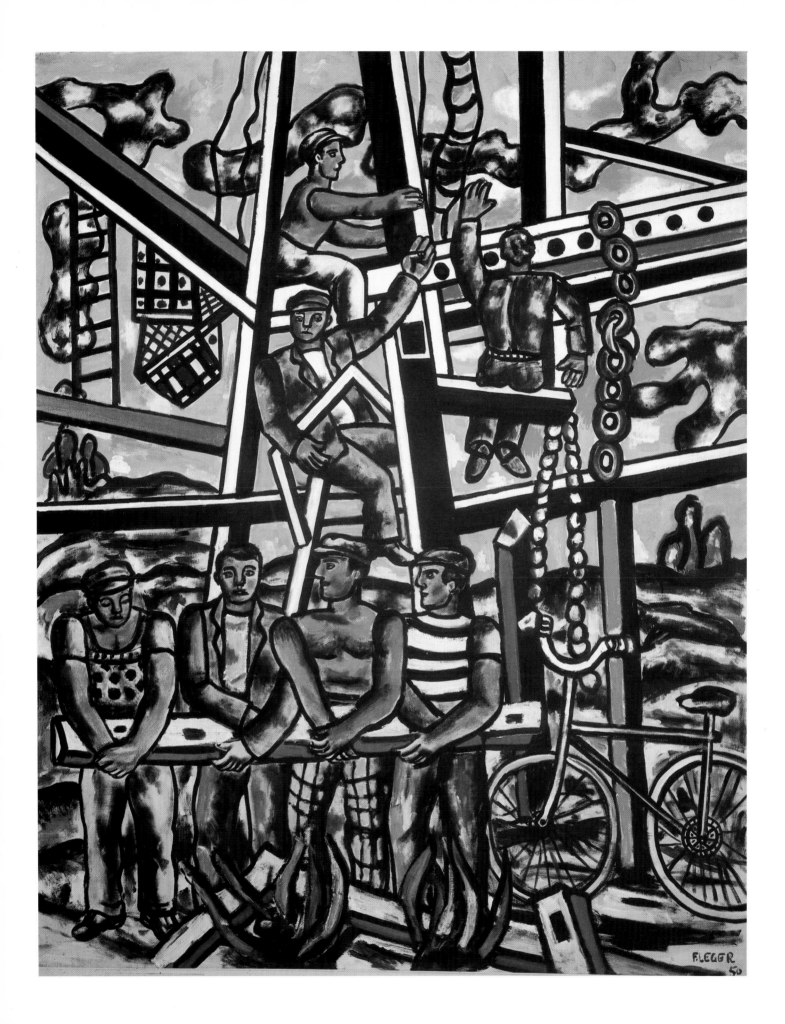

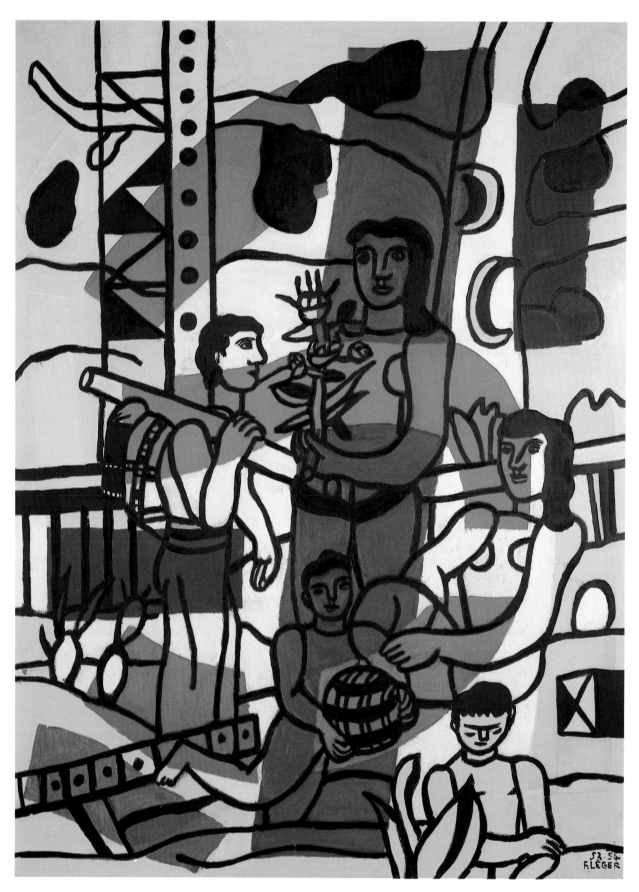

Cat. 73. *The Camper (Le Campeur [couleur en dehors]),* 1953-54
Galerie Beyeler, Basel, Switzerland

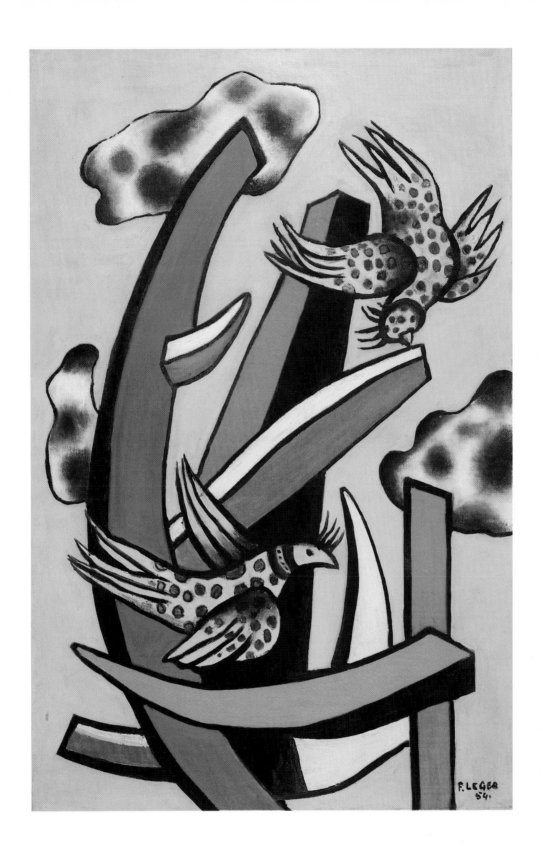

Cat. 74. *Composition With Two Birds (Composition aux deux oiseaux)*, 1954
Galerie Louise Leiris, Paris

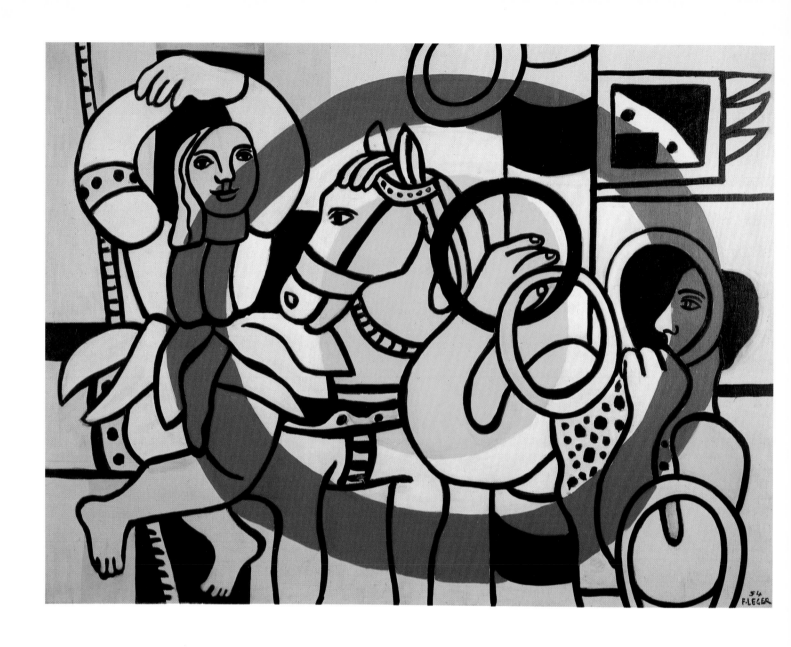

Cat. 75. *The Juggler and the Dancer (Le Jongleur et la danseuse),* 1954
Sidney Janis Gallery, New York, New York

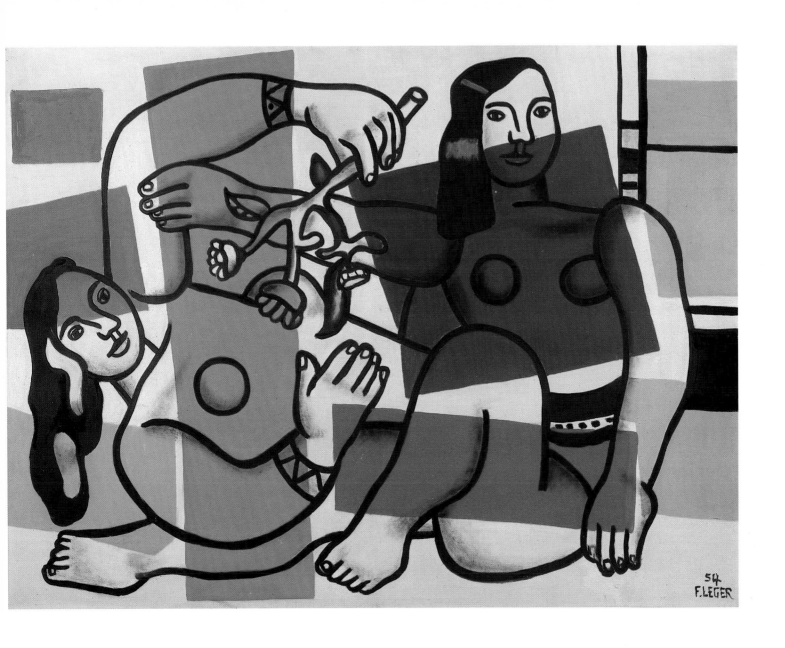

Cat. 76. *Two Women With Flowers (Deux Femmes tenant des fleurs),* 1954
The Trustees of the Tate Gallery, London, England

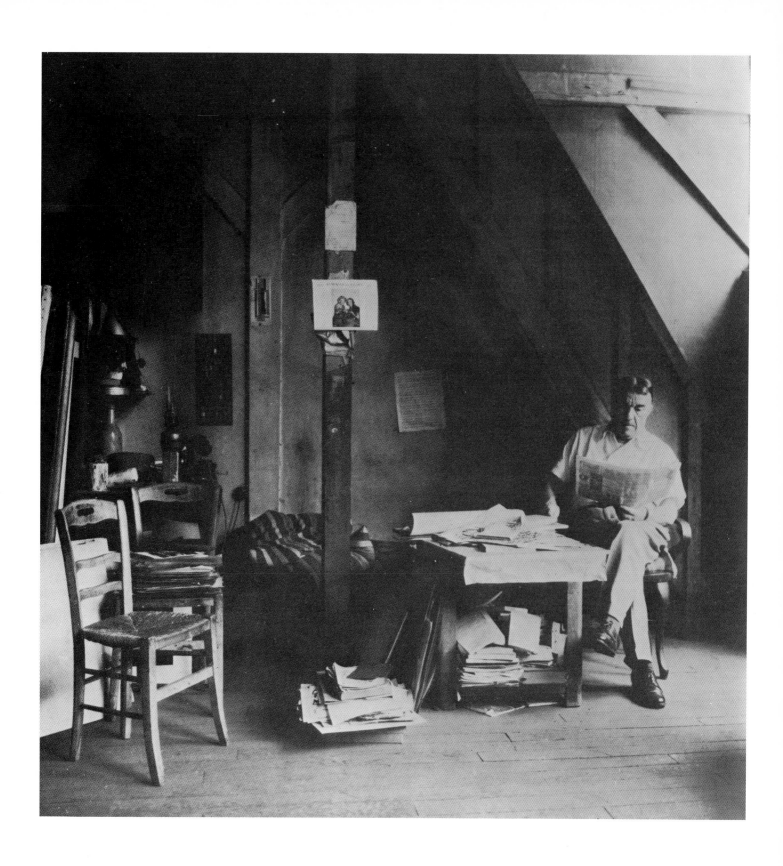

Léger in his Paris studio, c. 1935.

1881 Joseph Fernand Henri Léger born August 4 to Henri-Armand Léger, cattle breeder, and Marie-Adèle Daunou in Argentan (Orne), France.

1884 Death of father.

1890-96 Studied at schools in Argentan and Tinchebray.

1897-99 Apprentice to an architect in Caen.

1900-02 Draftsman with architect in Paris.

1902-03 Military service in Versailles.

1903 Rejected at the Ecole des Beaux-Arts, enrolled instead at Ecole des Arts Décoratifs. Attended classes, nonetheless, at the Beaux-Arts, taught by Jean-Léon Gérôme and Gabriel Ferrier. Also attended the Académie Julian.

1904 Worked for architect and also as a photographic retoucher. Shared studio with André Mare.

Winter 1905-06 Illness forced Léger to travel to Corsica to recuperate. Was to return there several times. Many paintings done during this time were destroyed by the artist; however, *My Mother's Garden* (Musée National Fernand Léger, Biot), one of the few extant works from this period, shows the influence of the Impressionists.

1907 Affected deeply by the Paul Cézanne retrospective at the Salon d'Automne.

1908 Moved to La Ruche, artists' colony, in Paris and there met artists Alexander Archipenko, Marc Chagall, Robert Delaunay, Henri Laurens, Jacques Lipchitz, Chaim Soutine and writers Guillaume Apollinaire, Blaise Cendrars, Max Jacob and Pierre Reverdy.

1909 Moved to Montparnasse and met Henri Rousseau (Le Douanier), whose "Sundays" he frequented. *Table and Fruit* (The Minneapolis Institute of Arts), painted this year, shows his interest in Analytic Cubism.

1910 Exhibited *Nudes in the Forest* (Rijksmuseum Kröller-Müller, Otterlo) at the Salon des Indépendants with Robert Delaunay, Albert Gleizes, Marie Laurencin, Henri Le Fauconnier, Jean Metzinger. Critics called him a "Tubist." Met Daniel Henry Kahnweiler who would give him exclusive contract in 1913. Frequented Kahnweiler's gallery at 28, rue Vignon where he met Georges Braque and Pablo Picasso. Participated in meetings at Jacques Villon's home in Puteaux — with Delaunay, Marcel Duchamp, Gleizes, Frantisek Kupka, Le Fauconnier, Metzinger, Francis Picabia — which resulted in the formation of the "Section d'or" group.

LÉGER CHRONOLOGY

1912 Exhibited with "Section d'or" at Galerie la Boétie. Exhibition of Italian futurists at Galerie Bernheim-Jeune influenced Léger. Exhibition at Galerie Kahnweiler.

1913-14 *Contrast of Forms* series done during these years.

1914-17 August 2, drafted into French Army as a medic. Also served as a sapper. Continued to draw during the war. Gassed at Verdun, September 1916. Convalesced at Villepinte, 1917. *The Card Party* (Rijksmuseum Kröller-Müller, Otterlo), painted in 1917, marked the beginning of Léger's incorporation of mechanical forms into his work.

1918 *Disk* series started. The Mechanical Period would continue into the twenties. Illustrated anti-war book, *J'ai tué*, by Cendrars.

1919 *The City* (Philadelphia Museum of Art) painted this year. Exhibited at Léonce Rosenberg's Galerie de l'Effort Moderne and contributed, through the twenties, to *Bulletin de l'Effort Moderne*. Illustrated *La Fin du Monde, Filmée par l'Ange de Notre-Dame* by Cendrars. Married Jeanne-Augustine Lohy in December.

Léger as a young man.

1920	Met Le Corbusier with whom he would have a lifelong friendship. *Animated Landscapes*, with nature and human figures as new subjects, begun at this time.
1921	Collaborated with Cendrars on Abel Gance's film *La Roue*. Set and costume designs for Ballet Suédois, Rolf de Maré's *Skating Rink* (music by Arthur Honegger). Friendship with de Stijl artists Théo van Doesburg and Piet Mondrian.
1922	Death of his mother.
1924	Produced first experimental film without scenario, *Ballet Mécanique;* photography by Man Ray and Dudley Murphy, music by George Antheil. Established studio on rue Notre-Dame-des-Champs with Amedée Ozenfant. There, taught classes with Laurencin and Alexandra Exter.
1925	With Robert Delaunay, decorated entrance of Ambassade Française, pavilion at Exposition Internationale des Arts Décoratifs. Studies for mural paintings, including *The Baluster* (The Museum of Modern Art, New York), exhibited at Le Corbusier's Pavillon Esprit Nouveau. First exhibition in the United States at Anderson Galleries, New York.
1928	Traveled to Berlin for opening of exhibition at Galerie Flechtheim. Began *Objects in Space* series; major painting of this series is *Mona Lisa With Keys* of 1930 (Musée National Fernand Léger, Biot).

1929	Taught at Académie Moderne with Ozenfant.
1931	First trip to the United States, visiting Chicago and New York. Exhibitions at Durand Ruel Galleries and John Becker Gallery in New York.
1932	Taught at Académie de la Grande Chaumière. Traveled to Sweden and Norway.
1933	Retrospective at Kunsthaus Zürich. To Greece with Le Corbusier.
1934	Traveled to London and Stockholm. Produced sets for Alexander Korda's film, *The Shape of Things to Come* (based on the book by H. G. Wells).
1935	Second trip to the United States, this time with Le Corbusier. Exhibitions at The Museum of Modern Art in New York and at the Art Institute of Chicago. Mural project for Brussels World's Fair. This was first of a series of projects for fair pavilions which would continue through 1939: Palais de la Découverte, Paris, 1937 and New York World's Fair, 1939.
1937	First of many one-man exhibitions at Pierre Matisse Gallery in New York. Designed sets for Serge Lifar's ballet, *David Triomphant,* at the Paris Opera.
1938	Third visit to United States. Lectured at Yale University. Exhibition at Palais des Beaux-Arts, Brussels.
1940	November, to United States where he remained for duration of war. Taught at Yale University. *The Divers*

and *The Cyclists* series begun during his stay in America.

1941	Taught at Mills College, Oakland, California. Returned to New York where he joined other artists-in-exile: André Breton, Chagall, Max Ernst, André Masson, Matta, Mondrian, Ozenfant, Yves Tanguy and Ossip Zadkine.
1942	Exhibitions at Buchholz Gallery and Paul Rosenberg Gallery in New York.
1943	Exhibition at Dominion Gallery in Montreal.
1944	Collaborated with Alexander Calder, Duchamp and Ernst on Hans Richter film *Dreams That Money Can Buy.*
1945	Returned to Paris. Joined Communist Party.
1946	Subject of Thomas Bouchard film *Fernand Léger in America, His New Realism. Adieu New York* (Musée National d'Art Moderne, Centre de Culture Georges Pompidou, Paris) painted this year. Exhibition of nineteen paintings done during his stay in America (1940-45) at Galerie Louis Carré, Paris. Began mosaic facade, which was completed in 1949, for church at Assy, Haute-Savoie. First of several public works to follow: Bastogne Memorial, 1950; church windows, Audincourt, 1951; United Nations, 1952; Courfaivre, 1954; University of Caracas, 1954; Gaz de France, 1955.
1948	Exhibitions at Sidney Janis Gallery, New York and at Galerie Louis Carré, Paris. Set designs for Ballet des Champs-Elysées, *Le Pas d'Acier* (music by Prokofiev).
1949	Illustrations for Rimbaud, *Les Illuminations* and illustrations and text for Tériade, *Le Cirque.* Sets and costumes for *Bolivar* (music by Darius Milhaud) at Paris Opera. First ceramics produced in Biot. Retrospective exhibition at the Musée National d'Art Moderne, Paris. *The Constructors* series begun during the late 1940s.
1950	Wife, Jeanne Lohy Léger, died. Retrospective at Tate Gallery, London.
1951	Exhibitions at Galerie Louise Leiris and at Galerie Louis Carré, Paris.
1952	Married Nadia Khodossievitch, his student (since 1924) and assistant. Moved to Gif-sur-Yvette. Exhibitions at Kunsthalle Berne, Art Institute of Chicago, Sidney Janis Gallery and Perls Galleries in New York and Galerie Louis Carré in Paris.
1953	Illustrations for Paul Eluard's poem, *Liberté.*
1954	*The Great Parade* (The Solomon R. Guggenheim Museum, New York) completed. Exhibitions at Sidney Janis Gallery, New York; Galerie Louis Carré, Paris; Galerie Maeght, Paris; Marlborough Fine Art, London.
1955	To Prague for "The Spartakiades." Died, August 17, in Gif-sur-Yvette.

(Left) Fig. 34. Léger and students, 1930

(Top) Fig. 35. Léger (on left) with comrades, 1914-18

(Center) Fig. 36. Léger and Dos Passos in Provincetown, Massachusetts, January 1939

(Bottom) Fig. 37. Léger and students at Montparnasse, 1939

SELECTED BIBLIOGRAPHY

BY THE ARTIST

WRITINGS

1913 "Les Origines de la peinture et sa valeur representative." *Montjoie* (Paris), vol. 1, no. 8, May 29, 1913, p. 7; *Montjoie* (Paris), vol. 1, no. 9-10, June 14-29, 1913, pp. 9-10. Reprinted in English in Fernand Léger. *Functions of Painting.* New York: The Documents of 20th Century Art, The Viking Press, 1973, pp. 3-10 (hereafter referred to as *Functions of Painting,* New York, 1973).

1914 "Les Révélations picturales actuelles." *Soirées de Paris* (Paris), no. 25, June 15, 1914, pp. 349-56.

1919 "Pensées." *Valori Plastici* (Rome), vol. 1, no. 2-3, Feb.-Mar. 1919, p. 2. Reprinted in *Sélection* (Brussels/Antwerp), no. 2, Sept. 15, 1920, p. 4.

1921 "La Couleur dans la vie." *Promenoir* (Lyon), no. 5, 1921, pp. 66-67.

1923 "L'Esthétique de la machine: l'objet fabriqué, l'artisan et l'artiste." *Der Querschnitt* (Berlin), vol. 3, 1923, pp. 122-29. Reprinted in *Bulletin de l'Effort Moderne* (Paris), no. 1, Jan. 1924, pp. 5-7; *Bulletin de l'Effort Moderne* (Paris), no. 2, Feb. 1924, pp. 8-12; in English in *Little Review* (New York), vol. 9, no. 3, Spring 1923, pp. 45-49; *Little Review* (New York), vol. 9, no. 4, 1923-24, pp. 55-58; *Functions of Painting,* New York, 1973, pp. 52-61.

"Kurzgefasste Auseinandersetzung uber das Aktuell Kunstlerische Sein." *Das Kunstblatt* (Berlin), vol. 7, 1923, pp. 1-4.

1924 "Réponse à une enquête: où va la peinture moderne?" *Bulletin de l'Effort Moderne* (Paris), no. 2, Feb. 1924, p. 5.

"Correspondance" [dated 1922]. *Bulletin de l'Effort Moderne* (Paris), no. 4, Apr. 1924. Reprinted in English in Tate Gallery, London. *Léger and Purist Paris,* 1970, pp. 85-86.

"Le Spectacle." *Bulletin de l'Effort Moderne* (Paris), no. 7, July 1924, pp. 4-7; *Bulletin de l'Effort Moderne* (Paris), no. 8, Oct. 1924, pp. 5-9; *Bulletin de l'Effort Moderne* (Paris), no. 9, Nov. 1924, pp. 7-9. Reprinted in English in *Functions of Painting,* New York, 1973, pp. 35-47.

"Architecture polychrome." *L'Architecture Vivante* (Paris), vol. 2, no. 4, Autumn-Winter 1924, pp. 21-22. Reprinted in English in Tate Gallery, London. *Léger and Purist Paris,* 1970, pp. 95-96.

"Mechanical Ballet." *Little Review* (New York), vol. 10, no. 2, Autumn-Winter 1924-25, pp. 42-44.

"Réponse à une enquête sur le Cubisme." *Bulletin de la Vie Artistique* (Paris), vol. 5, no. 21, Nov. 1924, p. 486.

"Le Ballet-Spectacle: l'objet spectacle." *La Vie des Lettres et des Arts* (Paris), no. 15, 1924. Reprinted in *Bulletin de l'Effort Moderne* (Paris), no. 12, Feb. 1925, pp. 7-9 and in English in *Functions of Painting,* New York, 1973, pp. 71-73.

1925 "Les Bals populaires." *Bulletin de l'Effort Moderne* (Paris), no. 12, Feb. 1925; *Bulletin de l'Effort Moderne* (Paris), no. 13, Mar. 1925. Reprinted in English in *Functions of Painting,* New York, 1973, pp. 74-77.

"Vive 'Relâche'." *Bulletin de l'Effort Moderne* (Paris), no. 13, Mar. 1925, pp. 5-7.

"Conference sur l'esthétique de la machine, au Collège de France." in Florent Fels. *Propos d'Artistes.* Paris: La Renaissance du Livre, 1925, pp. 98-106.

"Sehr Aktuell Sein." in *Europa Almanach.* Potsdam: Kiepenheuer, 1925, pp. 13-16.

"Peinture et cinéma." in *Cinéma.* Paris: Emile Paul, 1925.

1926 "A New Realism — the object (its cinematographic value.)" *Little Review* (New York), vol. 11, no. 2, Winter 1926, pp. 7-8.

1928 "Meine Berliner Ausstellung." *Der Querschnitt* (Berlin), vol. 8, no. 1, Jan. 1928, pp. 35-37.

"La Rue: objets, spectacles." *Cahiers de la République des Lettres, des Sciences et des Arts* (Paris), vol. XII, 1928, pp. 102-04.

1929 "Actualités." *Variétés* (Brussels), vol. 1, no. 9, Jan. 15, 1929, pp. 522-25.

"Si Tu n'aimes pas les vacances." *L'Intransigeant* (Paris), Oct. 21, 1929.

"Pensée sur l'art." in Waldemar George. *Fernand Léger.* Paris: Gallimard, 1929, p. 14.

1931 "A propos du cinéma." *Plans* (Paris), no. 1, Jan. 1931, pp. 80-84.

"Notre Paysage." *L'Intransigeant* (Paris), May 18, 1931.

"De l'Art abstrait." *Cahiers d'Art* (Paris), 6e année, no. 3, 1931, pp. 151-52.

"New York vu par Fernand Léger." *Cahiers d'Art* (Paris), 6e année, no. 9-10, 1931, pp. 437-39. Reprinted in English in *Artforum* (New York), vol. 7, no. 9, May 1969, pp. 52-55 and in *Functions of Painting,* New York, 1973, pp. 84-90.

1932 "Chicago." *Plans* (Paris), vol. 2, no. 11, Jan. 1932, pp. 63-68.

1933 "L'Art est entré en cambrioleur." *Mouvement* (Paris), no. 1, June 1933, pp. 17-18.

"Discours aux architectes." *Quadrante* (Milan), no. 5, Sept. 1933, pp. 44, 47.

1934 "Le Beau et le vrai." *Beaux-Arts* (Paris), no. 58, Feb. 9, 1934, p. 2.

"Avènement de l'objet." *Le Mois* (Paris), no. 41, June 1934.

1935 "Réponse à une enquête: que feriez-vous, si vous aviez à organiser l'Exposition de 1937?" *Vu* (Paris), no. 387, Aug. 1935, p. 1102.

"La Couleur et le sentiment." *Pour Vous* (Paris), Sept. 26, 1935.

"The New Realism." [Lecture delivered at The Museum of Modern Art, New York]. *Art Front* (New York), vol. 2, no. 8, Dec. 1935, pp. 10-11. Reprinted in *Functions of Painting,* New York, 1973, pp. 109-13 and in Robert Goldwater. *Artists on Art.* New York: Pantheon Books, 1945 and London: Kegan Paul, 1947, pp. 423-26.

1936 *La Querelle du Réalisme.* [Extracts of lectures by Aragon, Le Corbusier and Léger at the Maison de la Culture.] Paris: Editions Sociales Internationales, 1936. Reprinted in English in *Transition* (New York), no. 25, Winter 1936, pp. 104-08 and in Myfanwy Evans, ed. *The Painter's Object.* London:

(Right) Léger at Gif-sur-Yvette.

Gerald Howe, 1937, pp. 15-16, 18-20; reprint edition, New York: Arno Press, 1970.

1937 "The New Realism Goes On." *Art Front* (New York), vol. 3, no. 1, Feb. 1937, pp. 7-8. Reprinted in *Functions of Painting,* New York, 1973, pp. 114-18.

"L'Art mural de Victor Sevranckx." *Clarté* (Brussels), 10e année, no. 7, July 1937, pp. 20-22.

"Revival of mural art." *The Listener* (London), vol. 18, no. 450, Aug. 25, 1937, pp. 403, 409.

"Apropos of colour." *Transition* (New York), no. 26, 1937, p. 81.

1938 "Beauty in Machine Art." *Design* (Columbus, Ohio), vol. 39, no. 9, Mar. 1938, pp. 6-7.

"Couleur dans le monde." *Europe: revue mensuelle* (Paris), vol. 47, no. 4-7, 1938, pp. 99-113. Reprinted in *Functions of Painting,* New York, 1973, pp. 119-31.

1939 "The Question of 'truth'." *Architectural Forum* (New York), vol. 70, no. 2, Feb. 1939, supp. *Plus,* pp. 18-21.

"Réponse à une enquête: l'acte créateur se ressent-il de l'influence des événements environnants..." *Cahiers d'Art* (Paris), 14e année, no. 14, 1939, pp. 70-72.

1941 "New York-Paris, Paris-New York." *La Voix de France* (New York), Sept. 15, 1941, p. 10.

"Un Art nouveau sous le ciel californien." *La Voix de France* (New York), Nov. 1, 1941, p. 8.

1942 "Découvrir l'Amérique." *La Voix de France* (New York), May 15, 1942, p. 9.

1944 "Byzantine Mosaics and Modern Art." *Magazine of Art* (Washington, D.C.), vol. 37, no. 4, Apr. 1944, pp. 144-45.

1945 "Relationship Between Modern Art and Contemporary Industry." in *Modern Art in Advertising: An Exhibition of Designs for Container Corporation of America.* Chicago: Art Institute of Chicago, 1945, pp. 4-5.

"A propos du Corps humain considéré comme un objet." in *Fernand Léger: La Forme Humaine dans l'Espace.* Montreal: Editions de l'Arbre, 1945. Reprinted in English in *Functions of Painting,* New York, 1973, pp. 132-36.

1946 "Le Peuple et les arts." *Bulletin de Travail et Culture,* June-July 1946, pp. 35-36.

"L'Oeil de peintre." *Variétés* (Paris), no. 3, July 1946, pp. 44-45. Reprinted in English in *Functions of Painting,* New York, 1973, pp. 141-42.

"Causerie sur l'art." *Arts de France* (Paris), no. 6, 1946, pp. 36-42.

"Modern Architecture and Color." in Charmion von Wiegand and Fritz Glarner. *American Abstract Artists.* New York: Ram Press, 1946, pp. 31, 34-35, 37-38. Reprinted in *Functions of Painting,* New York, 1973, pp. 149-54.

1948 "L'Aventure au pays de merveilles." *Ciné-Club* (Paris), 2e année, no. 1, Oct. 1948, p. 1.

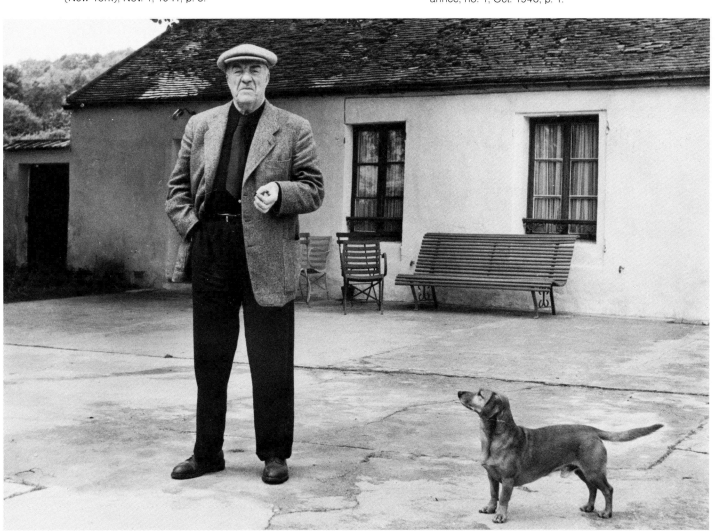

"Color in Architecture." in Stamo Papadaki. *Le Corbusier.* New York: Macmillan, 1948, pp. 78-80.

1949 "L'Art abstrait." *Derrière le Miroir* (Paris), no. 20-21, May 1949, p. 9.

"Un nouvel espace en architecture." *Art d'Aujourd'hui* (Boulogne-sur-Seine), no. 3, Oct. 1949, p. 19. Reprinted in English in *Functions of Painting,* New York, 1973, pp. 157-59.

1951 "Situation de la peinture dans le temps actuel." *La Biennale di Venezia* (Venice), no. 5, Aug. 1951, p. 19.

Architecture moderne et la couleur." *Formes et Vie* (Paris), no. 1, 1951, pp. 24-26.

1952 "Témoignage: espace." *XXᵉ Siècle* (Paris), n.s., no. 2, Jan. 1952, pp. 67-68.

"La Peinture moderne devant le monde actuel." *Lettres Françaises* (Paris), vol. 11, no. 405, Mar. 13, 1952, pp. 1, 9.

1955 "Discorso agli architetti." *Casabella* (Milan), no. 207, Oct. 1955, pp. 69-70.

1956 [Letter to a friend, 1955]. *Quadrum* (Brussels), no. 2, Nov. 1956, pp. 79-80.

"The New Landscape." in Gyorgy Kepes. *The New Landscape in Art and Science.* Chicago: Theobald, 1956, p. 90.

1957 *Bekenntnisse, Gespräche.* Zurich: Die Arche, 1957.

1958 "De la Peinture murale." *Derrière le Miroir* (Paris), no. 107/108/109, 1958, pp. 3-6. Reprinted in English in *Functions of Painting,* New York, 1973, pp. 178-80.

"On Monumentality and Color [1943]." in Siegfried Giedion. *Architecture, You and Me.* Cambridge, Massachusetts: Harvard University Press, 1958.

with J. L. Sert and S. Giedion. "Nine Points on Monumentality." in Siegfried Giedion. *Architecture, You and Me.* Cambridge, Massachusetts: Harvard University Press, 1958, pp. 48-51.

1959 *Propos et Présence.* Paris: Gonthier-Seghers, 1959.

1960 "Au temps ou F. Léger découvrait les Etats-Unis." *Arts* (Paris), no. 799, Dec. 7-13, 1960.

Mes Voyages. Paris: Editeurs Français Réunis, 1960.

1965 *Fonctions de la Peinture* (Preface by Roger Garaudy). Paris: Bibliothèque médiations, Gonthier, 1965.

1973 *Functions of Painting* (Preface by George L. K. Morris; intro. by Edward F. Fry). New York: The Documents of 20th Century Art, The Viking Press, 1973.

1974 "Le Décor domine la vie." *Galerie-Jardin des Arts* (Paris), no. 139, July-Aug. 1975, pp. 98-99.

INTERVIEWS

1930 Wilms, Rosemonde R. "Une Femme chez les peintres." *L'Intransigeant* (Paris), July 7, 1930. Reprinted in Cabinet d'Art Graphique, Musée National d'Art Moderne, Paris. *Fernand Léger: La Poésie de l'Objet, 1928-1934,* p. 17.

1932 *Seuphor, Michel. "Conversation, réelle et imaginaire, avec Léger."

1933 Cogniat, Raymond. "Chez Fernand Léger." *Beaux-Arts* (Paris), n.s., vol. 72, no. 16, Apr. 21, 1933, pp. 1-2.

Cogniat, Raymond. "Fernand Léger précise." *Beaux-Arts* (Paris), n.s., vol. 72, no. 18, May 5, 1933.

1935 "Où va la peinture: interview." *Commune* (Paris), 2ᵉ année, no. 21-22, May 1935, pp. 944-46.

"Pity Us! Interview." *Art Digest* (New York), vol. X, no. 1, Oct. 15, 1935, p. 26.

1939 I., P. "Fernand Léger pendant son séjour en Amérique a fait de conférences à l'université de Yale." *Beaux-Arts* (Paris), n.s., vol. 76, no. 326, Mar. 31, 1939, p. 1.

1946 Warnod, André. "L'Amérique, ce n'est pas un pays, c'est un monde, dit Fernand Léger." *Arts* (Paris), no. 49, Jan. 4, 1946, pp. 1-2. Reprinted in English [summary of an interview] in *Architectural Forum* (New York), vol. 84, no. 4, Apr. 1946, pp. 50+.

Gromaire, François. "'L'Avenir est à la couleur', nous dit Fernand Léger, peintre et cinéaste." *Ecran Francais* (Paris), vol. 4, no. 40, Apr. 3, 1946, p. 11.

1948 Descargues, Pierre. "F. Léger, interview." *Arts* (Paris), no. 147, Jan. 2, 1948, pp. 1, 5.

"Doit-on réformer l'enseignement des beaux-arts?" *Traits* (Paris), no. 4, 1948, pp. 1, 8.

1949 Howe, Russell. "Chalk and Cheese: Puy and Léger." *Apollo* (London), vol. 50, no. 294, Aug. 1949, pp. 31-38.

1952 Favre, L. P. "Quel paysage avez-vous choisi? Fernand Léger: 'Jamais de la vie n'irai dans le Midi'." *Arts* (Paris), no. 367, July 10, 1952, p. 10.

*Taillandier, Yvon. "Un Enquête: l'art et le climat visuel contemporain." *Salon de Mai,* p. 1.

1954 *Marceau, Marcel. "Interview mit Léger." *Magnum* (Frankfurt am Main), 1954.

Vallier, Dora. "La Vie fait l'oeuvre de Fernand Léger." *Cahiers d'Art* (Paris), no. 11, 1954, pp. 133-39.

1955 Bordier, Roger. "Polychromie architecturale." *Aujourd'hui, Art et Architecture* (Boulogne-sur-Seine), 1ᵉ année, no. 2, Mar.-Apr. 1955, pp. 34-35.

ILLUSTRATIONS

1918 Cendrars, Blaise. *J'ai Tué.* Paris: La Belle Edition, 1918.

1919 Cendrars, Blaise. *J'ai Tué.* Paris: Georges Crès, 1919.

Cendrars, Blaise. *J'ai Tué.* New York: The Plowshare, Woodstock, 1919.

Cendrars, Blaise. *La Fin du Monde, Filmée par l'Ange Notre-Dame.* Paris: Editions de la Sirène, 1919.

1920 Goll, Ivan. *Die Chapliniade, Eine Kinodichtung.* Dresden and Berlin: Rudolf Kaemmerer Verlag, 1920.

1921 Malraux, André. *Lunes en Papier.* Paris: Editions de la Galerie Simon, 1921.

1923 Goll, Ivan. *Le Nouvel Orphée.* Paris: Editions de la Sirène, 1923.

1937 Ganzo, Robert. *Orénoque.* Paris, 1937.

1948 Guillevic. *Coordonées.* Geneva and Paris: Editions des Trois Collines, 1948.

Masson, Loys. *L'Illustre Thomas Wilson.* Paris: Bordas, 1948.

1949 Rimbaud, Arthur. *Les Illuminations.* Lausanne: Louis Grosclaude, 1949.

Cirque. Paris: Tériade, 1949.

1950 Jakovsky, Anatole. *La Petite Reine.* Paris: Louise, 1950.

1951 Goll, Ivan. *Les Cercles Magiques.* Paris: Falaize, 1951.

ON THE ARTIST

MONOGRAPHS

1920 Raynal, Maurice. *Fernand Léger: Vingt Tableaux.* Paris: L'Effort Moderne, 1920.

*unverified secondary source

1928 Tériade, E. *Fernand Léger.* Paris: Editions Cahiers d'Art, 1928.

1929 George, Waldemar. *Fernand Léger.* Paris: Gallimard, 1929.

Fernand Léger. [Special issue of periodical *Sélection* devoted to Léger]. Cahier 5, February. Antwerp: Editions Séléction, 1929.

1948 Elgar, Frank. *Léger: Peintures 1911-1948.* Paris: Editions du Chêne, 1948.

1949 Cooper, Douglas. *Fernand Léger et le Nouvel Espace.* London: Lund Humphries and Geneva-Paris: Trois Collines, 1949.

1952 Zervos, Christian. *Fernand Léger: Oeuvres de 1905 à 1952.* Paris: Cahiers d'Art, 1952.

1953 Jardot, Maurice. *Léger, Dessins.* Paris: Editions des Deux Mondes, 1953.

Kuh, Katharine. *Léger.* Urbana: University of Illinois Press, 1953.

1954 Elgar, Frank. *Picasso et Léger: Deux Hommes, Deux Mondes.* Paris: Les Amis de l'Art, 1954.

1955 Descargues, Pierre. *Fernand Léger.* Paris: Editions Cercle d'Art, 1955.

Verdet, André. *Fernand Léger: Le Dynamisme Pictural.* Geneva: Cailler, 1955.

Hommage à Fernand Léger. [Special issue of periodical devoted to Léger]. *Les Lettres Françaises* (Paris), no. 582, Aug. 25-31, 1955.

1956 Cooper, Douglas. *Fernand Léger: Dessins de Guerre, 1915-1916.* Paris: Berggruen, 1956.

Jardot, Maurice. *Léger.* Paris: Hazan, 1956.

Verdet, André. *Fernand Léger.* Geneva: Editions Kister, 1956.

1962 Delevoy, Robert L. *Léger: Biographical and Critical Study.* Geneva: Skira, 1962.

1964 Tadini, Emilio. *Fernand Léger.* Milan: Fratelli Fabbri, 1964.

1965 Petrová, Eva. *Fernand Léger.* Prague, 1965.

1966 Nickels, Bradley J. *Fernand Léger: Paintings and Drawings 1905 to 1930.* [Ph.D. dissertation, Indiana University, Department of Fine Arts, June 1966]. Ann Arbor, Michigan: University Microfilms, 1971.

1968 Deroudille, René. *Léger.* Paris: Bordas, 1968.

Garaudy, Roger. *Pour un Réalisme du XXᵉ Siècle. Dialogue Posthume avec Fernand Léger.* Paris: Grasset, 1968.

1969 Francia, Peter de. *On Léger's "The Great Parade."* London: Cassell, 1969.

Verdet, André. *Fernand Léger.* Florence: Sansoni, 1969.

1970 Cendrars, Blaise; Jullian, René; Léger, Fernand and Maurois, André. *Fernand Léger.* Basel: Editions Beyeler Basle, 1970.

Johnson, Charles William. *A Comparative Study of the Views of Present Reality Manifested in the Art Works of Fernand Léger and Edgard Varèse.* [Ph.D. dissertation, Ohio University, 1970]. Athens, Ohio: Dissertation Abstracts International, 1971.

Zadova, L. *Fernand Léger.* Moscow: Isskusstvo Publishers, 1970.

1971 San Lazzaro, Gualtieri di, ed. *Homage to Fernand Léger.* [Special issue of the *XXᵉ Siècle Review*]. New York: Tudor, 1971.

Léger. [Special issue of periodical *Europe* devoted to Léger]. *Europe* (Paris), 49ᵉ année, no. 508-09, Aug.-Sept. 1971.

Fernand Léger, Sa Vie, Son Oeuvre, Son Rêve. Milan: Edizioni Apollinaire, 1971.

1972 Cassou, Jean and Leymarie, Jean. *Fernand Léger: Dessins et Gouaches.* Paris: Editions du Chêne, 1972. English translation, *Fernand Léger: Drawings and Gouaches.* Greenwich, Conn.: New York Graphic Society, 1973.

Deac, Mircea. *Léger.* Bucharest: Editura Meridiane, 1972.

1976 Golding, John. *Fernand Léger: 'The Mechanic.'* Ottawa: National Gallery of Canada, 1976.

Green, Christopher. *Léger and the Avant-Garde.* New Haven: Yale University Press, 1976.

Schmalenbach, Werner. *Fernand Léger.* New York: Abrams, 1976.

Wakakuwa, Midori. *Léger.* Tokyo: Shinchosha, c. 1976.

1977 Danoff, I. Michael. *Fernand Léger.* Milwaukee: Milwaukee Art Center, 1977.

Verdet, André. *Songes de Fernand Léger.* Cannes: Editions du Musée Fernand Léger, 1977.

1978 Saphire, Lawrence. *Fernand Léger: The Complete Graphic Work.* New York: Blue Moon Press, 1978.

1981 Laugier, Claude and Richet, Michele. *Léger: Oeuvres de Fernand Léger (1881-1955).* Paris: Collections du Musée National d'Art Moderne, 1981.

ARTICLES

1913 Boccioni, Umberto. "Il Dinamismo futurista e la pittura francese." *Lacerba* (Florence), vol. 1, no. 15, Aug. 1913, pp. 169-71.

Allard, Roger. [Fernand Léger]. *Soirées de Paris* (Paris), 1913.

1914 Walden, Herwarth. "Les Origines de la peinture contemporaine et sa valeur représentative." *Der Sturm* (Berlin), vol. 4, no. 256-57, 1914, p. 76.

1919 Ely, C. B. "Monsieur Léger." *Sewanee Review* (Sewanee, Tenn.), vol. XXVII, no. 1, Jan. 1919, pp. 43-47.

1920 Kahnweiler, Daniel Henry. "Fernand Léger." *Der Cicerone* (Leipzig), vol. 12, no. 19, Oct. 1920, pp. 699-702. Reprinted in *Jahrbuch der Jungen Kunst* (Leipzig), vol. 1, 1920, pp. 301-04.

Goll, Ivan. "Über Kubismus." *Das Kunstblatt* (Potsdam), vol. 4, 1920, pp. 215-22.

1922 Goll, Ivan. "Fernand Léger." *Das Kunstblatt* (Potsdam), vol. 6, 1922, pp. 73-77.

1923 Epstein, Jean. "Fernand Léger." *Feuilles Libres* (Paris), 5ᵉ année, no. 31, Mar.-Apr. 1923, pp. 26-31.

Cendrars, Blaise. "La Création du monde, ballet de MM. Borlin, Cendrars, Léger, Milhaud." *L'Esprit Nouveau* (Paris), 2ᵉ année, 1923, pp. [2113-20]. Reprint ed. of *Esprit Nouveau*, no. 18, n.p. New York: Da Capo Press, 1968-69.

Raynal, Maurice. "Skating-Rink, ballet de Fernand Léger." *Esprit Nouveau* (Paris), 2ᵉ année, 1923, pp. [2020-24]. Reprint ed. of *Esprit Nouveau*, no. 17, n.p. New York: Da Capo Press, 1968-69.

1924 Badovici, Jean. "Projet décoratif et fresques par F. Léger." *Architecture Vivante* (Paris), Fall/Winter 1924, pp. 10-11.

1925 Lozowick, Louis. "Fernand Léger." *Nation* (New York), vol. 121, no. 3154, Dec. 16, 1925, p. 712.

1926 Raynal, Maurice. "Fernand Léger." *Cahiers d'Art* (Paris), 1ᵉ année, no. 4, May 1926, pp. 61-65.

George, Waldemar. "Fernand Léger." *L'Amour de l'Art* (Paris), vol. 7, no. 8, Aug. 1926, pp. 259-63.

1927 Gasch, Sebastià. "Fernand Léger." *L'Amie de les Arts* (Sitges, Spain), vol. 2, no. 10, Jan. 31, 1927.

Mauny, Jacques. "Paris Letter." *The Arts* (New York), vol. XI, no. 6, June 1927, pp. 320-21,323.

George, Waldemar. "Lettre de Berlin." *Art Vivant* (Berlin), 3e année, Oct. 15, 1927, pp. 835-36.

Zervos, Christian. "Nouvelles peintures de F. Léger." *Cahiers d'Art* (Paris), 2e année, no. 3, 1927, pp. 96-100.

1928 Grohmann, Will. "Fernand Léger." in Thieme, Ulrich and Becker, Felix. *Allgemeines Lexikon der Bildenden Künstler.* Leipzig: Seemann, 1928, pp. 566-67.

Tériade, E. "Oeuvres récentes de Léger. Les Objets dans l'espace." *Cahiers d'Art* (Paris), 3e année, no. 4, 1928, pp. 145-52.

1929 George, Waldemar. "Fernand Léger." *The Arts* (New York), vol. XV, no. 5, May 1929, pp. 303-13.

Zervos, Christian. "Fernand Léger et le développement de sa conception des objets dans l'espace." *Cahiers d'Art* (Paris), 4e année, no. 4, May 1929, pp. 149-58.

Fierens, Paul. "Fernand Léger." *Renaissance* (Paris), 12e année, no. 8, Aug. 1929, pp. 380-87.

Cogniat, Raymond. "Décors de Fernand Léger." *Chroniques du Jour* (Paris), no. 3, Sept. 1929, pp. 19-21.

1930 George, Waldemar. "Fernand Léger — Triumphs and Miseries of a Victory." *Formes* (Paris), no. 7, July 1930, pp. 4-5, 7.

Goodrich, Lloyd. "November exhibitions: Contemporary Parisians." *The Arts* (New York), vol. XVII, no. 2, Nov. 1930, pp. 117-19.

Berthelot, Pierre. "L'Atelier de Fernand Léger." *Beaux-Arts* (Paris), 8e année, no. 12, Dec. 14, 1930, p. 14.

Einstein, Carl. "Léger: oeuvres récentes." *Documents* (Paris), vol. 2, no. 4, 1930, pp. 190-95.

Zervos, Christian. "De l'importance de l'objet dans la peinture d'aujourd'hui." *Cahiers d'Art* (Paris), 5e année, no. 7, 1930, pp. 342-54.

1931 Raynal, Maurice. "De La Fresnaye à Fernand Léger." *Plans* (Paris), no. 1, Jan. 1931, pp. 94-96.

Morris, George L. K. "On Fernand Léger and Others." *The Miscellany* (New York), vol. 1, no. 6, Mar. 1931, pp. 1-16.

Sweeney, James Johnson. "Léger and the Cult of the Close-Up." *The Arts* (New York), vol. XVII, no. 8, May 1931, pp. 561-68.

Bazin, Germain. "Fernand Léger ou l'effort moderne." *Amour de l'Art* (Paris), 12e année, no. 6, June 1931, pp. 245-47.

Sweeney, James Johnson. [A Picture by Léger: 'Contraste de Formes']. *Creative Art* (New York), vol. IX, no. 1, July 1931, pp. 63-64.

Kormendi, André. "Fernand Léger." *Creative Art* (New York), vol. IX, no. 3, Sept. 1931, pp. 218-22.

Hoppe, Ragnar. "Fransk genombrottskonst under nittonhundratalet." *Ord och Bild* (Stockholm), vol. 40, 1931, pp. 527-43.

1932 Sweeney, James Johnson. "Léger and Cinesthetic." *Creative Art* (New York), vol. X, June 1932, pp. 440-45.

Bond, Kirk. "Léger, Dreyer and Montage." *Creative Art* (New York), vol. XI, no. 2, Oct. 1932, pp. 135-38.

Zervos, Christian. "Une Nouvelle étape dans l'oeuvre de Fernand Léger (gouaches et dessins colorés)." *Cahiers d'Art* (Paris), 7e année, no. 6-7, 1932, pp. 264-69.

1933 Cogniat, Raymond. "Le Cubisme méthodique; Léger et 'l'effort moderne'." *Amour de l'Art* (Paris), vol. 14-15, 1933-34, pp. 234-38. Reprinted in René Huyghe, *Histoire de l'Art Contemporain; la Peinture.* Paris: Alcan, 1935, pp. 234-36.

Zervos, Christian. "Fernand Léger, est-il cubist?" *Cahiers d'Art* (Paris), 8e année, no. 3-4, 1933.

1934 Raynal, Maurice. "Fernand Léger et l'objet." *L'Intransigeant* (Paris), Apr. 19, 1934.

Zervos, Christian. "Fernand Léger et la poésie de l'objet." *Cahiers d'Art* (Paris), 9e année, no. 1-4, 1934, pp. 99-108.

1936 Greene, Balcomb. "The Function of Léger." *Art Front* (New York), vol. 2, no. 9, Jan. 1936, pp. 8-9.

1937 "New York University Acquires Outstanding Painting by Léger: *The City.*" *Art News* (New York), vol. 35, no. 24, Mar. 13, 1937, p. 17.

Nelson, Paul. "Peinture spatiale et architecturale, a propos des dernières oeuvres de Léger." *Cahiers d'Art* (Paris), 12e année, no. 1-3, 1937, pp. 84-88.

1939 Martienssen, Rex. "Architecture in Modern Painting." *South African Architectural Record* (Johannesburg), vol. 24, no. 3, Mar. 1939, pp. 76-91.

Chéronnet, Louis. "L'Expression murale chez Fernand Léger." *Art et Décoration* (Paris), n.s., vol. 68, no. 2, Dec. 1939.

Barry, Iris. "Ballet mécanique." in *The Film in Germany and in France.* Series III, Program 5. New York: The Museum of Modern Art Film Library [1939?]. Reprinted in "Film Notes." *Bulletin of The Museum of Modern Art* (New York), vol. 16, no. 2-3, 1949, p. 47.

1940 Follain, Jean. "Fernand Léger." *Cahiers d'Art* (Paris), 15e année, no. 1-2, 1940, pp. 22-32.

Painlevé, Jean. "A propos d'un 'nouveau realisme' chez Fernand Léger." *Cahiers d'Art* (Paris), 15e année, no. 3-4, 1940, pp. 71-74.

1941 "Muralist." *New Yorker* (New York), vol. 16, no. 47, Jan. 4, 1941, p. 10.

Sweeney, James Johnson. "Léger: classicista." *Norte* (New York), vol. 1, no. 9, June 1941, pp. 14-15.

Janis, Sidney. "School of Paris Comes to U.S." *Decision* (New York), vol. II, no. 5-6, Nov.-Dec. 1941, pp. 85-95.

"Twelve Artists in U.S. Exile." *Fortune* (New York), vol. XXIV, no. 6, Dec. 1941, p. 104.

1942 Martienssen, Rex. "Fernand Léger in Paris — 1938." *South African Architectural Record* (Johannesburg), Aug. 1942, pp. 237-39.

Sweeney, James Johnson. "Today's Léger — Demain." *Art News* (New York), vol. XLI, no. 11, Oct. 15, 1942, pp. 18-19, 30.

Farber, Manny. "Two European Painters." *New Republic* (New York), vol. 107, no. 19, Nov. 9, 1942, p. 610.

1944 Sweeney, James Johnson. "Léger and the Search for Order." *View* (New York), vol. 4, no. 3, Oct. 1944, pp. 84-87.

1945 Giedion, Siegfried. "Léger in America." *Magazine of Art* (Washington, D.C.), vol. 38, no. 8, Dec. 1945, pp. 295-99.

1945-46 "Fernand Léger — oeuvres executées aux Etats-Unis." *Cahiers d'Art* (Paris), 20-21e années, 1945-46, pp. 372-83.

1946 Clayeux, Louis-Gabriel. "Le Retour de Fernand Léger." *Les Arts et Les Lettres* (Paris), vol. 2, no. 6, Jan. 9, 1946.

Moussinac, Léon. "Fernand Léger retrouve la France." *Arts de France* (Paris), no. 6, 1946, pp. 33-36.

1948 Couturier, M.A. "L'Eglise d'Assy." *Arts* (Paris), no. 162, Apr. 16, 1948, pp. 1,3.

Kraus, Piet. "Constructie der Schoonheid." *Kroniek van Kunst en Kultuur* (Amsterdam), vol. 9, no. 4, Apr. 1948, pp. 107-09.

"Fernand Léger et ses élèves vont décorer l'Exposition Internationale des Femmes." *Arts* (Paris), no. 168, May 28, 1948, p. 1.

Alfons, Sven. "Léger vid skiljovägen." *Konstrevy* (Stockholm), vol. 24, no. 4-5, 1948, pp. 189-97.

Haftmann, Werner. "Neues von Fernand Léger." *Tagebuch* (Dusseldorf), no. 3-4, 1948, pp. 34-36.

1949 Baumeister, Willi and Greenberg, Clement. "Fernand Léger." *L'Age Nouveau* (Paris), no. 42, Oct. 1949.

Degand, Léon. "Fernand Léger." *Art d'Aujourd'hui* (Boulogne-sur-Seine), ser. 1-2, Oct. 1949, pp. 15-18.

Audiberti. "Fernand Léger est un phénomène historique." *Arts* (Paris), no. 231, Oct. 7, 1949, pp. 1,4.

Cassou, Jean. "Fernand Léger: Inventor of Tubism." *Art News* (New York), vol. XLVII, no. 7, Nov. 1949, pp. 27, 58-59.

Guillevec. "Sur des figures de Fernand Léger." *Cahiers d'Art* (Paris), 24e année, no. 1, 1949, pp. 81-87.

Hilaire, Georges. "Visite à Fernand Léger." *Pour l'Art* (Lausanne), no. 6, 1949, p. 6.

1950 Heron, Patrick. "Fernand Léger." *New Statesman and Nation* (London), vol. 39, Feb. 25, 1950, p. 215.

Sylvester, David. "Portrait of the Artist: Fernand Léger." *Art News and Review* (London), vol. 2, no. 2, Feb. 25, 1950, pp. 1,7.

Kahnweiler, Daniel Henry. "Fernand Léger." *Burlington Magazine* (London), vol. 92, no. 564, Mar. 1950, pp. 63-69.

Raynal, Maurice. "Fernand Léger." *Carreau* (Lausanne), no. 4, Mar. 1950, pp. 1,3.

Agay, Cécile. "L'Artiste et son modèle." *Art d'Aujourd'hui* (Boulogne-sur-Seine), ser. 1-2, no. 10-12, May-June 1950, pp. 15-17.

"Londra: una personale di Fernand Léger." *Emporium* (Bergamo), vol. 112, no. 667, July 1950, pp. 36-39.

Denvir, Bernard. "Painter of Modern Industrial Forms." *Studio* (London), vol. 140, no. 693, Dec. 1950, pp. 170-73.

Pierre, Jean. "Fernand Léger: aquarelles de Deauville." *Arts de France* (Paris), no. 33, Dec. 1950, pp. 52-53.

1951 Cogniat, Raymond. "Un Independiente del Cubismo." *Saber Vivir* (Buenos Aires), ano 9, no. 94, Jan.-Feb. 1951, pp. 20-23.

McBride, Henry. "Léger." *Art News* (New York), vol. 50, no. 3, Mar. 1951, pp. 23,54,56,57.

Hildebrandt, Hans. "Der Maler Fernand Léger." *Die Kunst und Das Schöne Heim* (Munich), vol. 49, no. 7, Apr. 1951, p. 257.

Marcenac, Jean. "Fernand Léger et les ouvriers de la beauté." *Les Lettres Françaises* (Paris), 11e année, no. 365, May 31, 1951, pp. 1,7.

Elgar, Frank. "Les Constructeurs de F. Léger." *Carrefour* (Paris), June 12, 1951.

Estienne, Charles. "Léger ou l'espace des hommes." *Arts* (Paris), no. 315, June 15, 1951, p. 4.

[Audincourt]. *Art Sacré* (Paris), no. 3-4, Nov.-Dec. 1951, pp. 1,32.

Gindertael, R.V.F. "F. Léger." *Art d'Aujourd'hui* (Boulogne-sur-Seine), ser. 3, no. 1, Dec. 1951, p. 15.

Veronesi, Giulia. "Fernand Léger." *Emporium* (Bergamo), vol. 114, no. 681, 1951, pp. 107-09.

Zervos, Christian. "A propos des 'Constructeurs' de Fernand Léger." *Cahiers d'Art* (Paris), 26e année, 1951, pp. 190-202.

1952 Dégand, Léon. "Capire Fernand Léger." *La Biennale di Venezia* (Venice), no. 8, Apr. 1952, pp. 13-18.

B.[azaine], J.[ean]. "Une nouvelle interpretation de l'homme." *Arts* (Paris), no. 363, June 12, 1952, p. 9.

Gindertael, R.V.F. "La Figure dans l'oeuvre de Fernand Léger." *Art d'Aujourd'hui* (Boulogne-sur-Seine), ser. 3, no. 6, Aug. 1952, p. 30.

Gindertael, R.V.F. "Sculptures polychromes." *Art d'Aujourd'hui* (Boulogne-sur-Seine), ser. 3, no. 2, 1952.

Grand, P. M. "Céramiques de peintres." *Art et Décoration* (Paris), vol. 30, 1952, pp. 4-7.

1953 Elgar, Frank. "Les Sculptures polychromes de Léger." *Arts* (Paris), Jan. 21, 1953, p. 14.

Milhaud, Darius. "Divertissements variés." *Magazine of Art* (New York), vol. 46, no. 2, Feb. 1953, pp. 59-67.

Cassou, Jean. "Développement de l'art de Léger." *Revue des Arts* (Paris), vol. 3, no. 1, Mar. 1953, pp. 40-45.

Rexroth, Kenneth. "Fernand Léger: Master Machine." *Art News* (New York), vol. 52, no. 6, Oct. 1953, pp. 20-23.

Stahly, François. "Fernand Léger: Polychromatic Ceramic Sculptures." *Graphis* (Zurich), vol. 9, no. 49, Oct. 1953, pp. 398-99.

Raynal, Maurice. "Léger." *Vogue* (New York), Oct. 1, 1953, pp. 144-45, 193.

Sweeney, James Johnson. "Léger's Art is the Man." *New York Times Magazine* (New York), Oct. 18, 1953, pp. 28-29, 42.

Fitzsimmons, James. "Notes on Léger's Works." *Arts & Architecture* (Los Angeles), vol. 70, no. 12, Dec. 1953, pp. 6-7, 30.

Schmalenbach, Werner. "Zur Funktion der Modernen Kunst; Aus Anlass der Kirchenfenster in Audincourt und Les Bréseux." *Werk* (Zurich), vol. 40, Dec. 1953, pp. 422-28.

Imbourg, Pierre. "Fernand Léger." *L'Amateur d'Art* (Paris), no. 118, 1953, pp. 8-9.

1954 Courthion, Pierre. "Léger, peintre de la figure humaine." *XXe Siècle* (Paris), n.s., no. 4, Jan. 1954, p. 67.

Greenberg, Clement. "Master Léger." *Partisan Review* (New York), vol. XXI, no. 1, Jan.-Feb. 1954, pp. 90-97. Reprinted in Clement Greenberg. *Art and Culture.* London: Thames and Hudson, 1973.

Bordier, Roger. "Les Oeuvres de Caracas." *Art d'Aujourd'hui* (Boulogne-sur-Seine), ser. 5, no. 6, Sept. 1954, pp. 2-6.

Maunoury, Richard. "Peut-On miser sur un peintre moderne?" *Nouveau Femina* (Paris), Oct. 1954, p. 79.

Sylvester, David. "The Realism of Léger." *Art* (London), vol. 1, no. 1, Nov. 1954, p. 4.

Gindertael, R.V.F. "Fernand Léger propose l'art populaire de notre époque." *Les Beaux-Arts* (Brussels), Nov. 19, 1954.

Verdet, André. "Léger ou la joie de vivre." *Défense de la Paix* (Paris), no. 42, 1954, pp. 81-91.

Zervos, Christian. "Fernand Léger, 'La Grande Parade'." *Cahiers d'Art* (Paris), 29e année, II, 1954, pp. 131-32.

1955 Cooper, Douglas. "La Grande Parade de Fernand Léger." *L'Oeil* (Paris), no. 1, Jan. 1955, pp. 21-25.

Gage, Otis. "Fernand Léger: Ceramist." *Craft Horizons* (New York), vol. XV, no. 1, Jan.-Feb. 1955, pp. 10-15.

Gindertael, R.V.F. "Fernand Léger." *Cimaise* (Paris), ser. 2, no. 3, Jan.-Feb. 1955, p. 7.

Mellquist, Jerome. "I Paesaggi di Léger." *Communita* (Milan), Feb. 1955.

Divonne, Pierre. "L'Eglise et la politique artistique de l'état." *L'Art Sacré* (Paris), no. 7-8, Mar.-Apr. 1955, pp. 9-15.

Géo, Charles. "Fernand Léger." *Le Courrier Graphique* (Paris), 20e année, no. 79, May 1955, pp. 21-29.

Ferrier, J.-L. "Léger et la civilisation technicienne." *Clartés* (Lausanne), May 9, 1955.

Favre, Louis-Paul. "Léger sera toujours vivant." *Combat* (Paris), Aug. 9, 1955.

Chastel, André. "Fernand Léger, la manière forte en peinture." *Le Monde* (Paris), no. 3287, Aug. 19, 1955, p. 1.

Gueguen, Pierre. "Fernand Léger." *Aujourd'hui, Art et Architecture* (Boulogne-sur-Seine), 1e année, no. 4, Sept. 1955, pp. 4-5.

Berger, Max. "Fernand Léger ou le mythe de la machine." *Preuves* (Paris), vol. 5, no. 56, Oct. 1955, pp. 56-62.

Cartier, J.-A. "Fernand Léger, ouvrier de la vie moderne." *Le Jardin des Arts* (Paris), no. 12, Oct. 1955.

Sweeney, James Johnson. "Fernand Léger: Simple and Solid." *Art News* (New York), vol. 5, no. 6, Oct. 1955, pp. 29-31.

"La Vie d'un peintre: Fernand Léger." *L'Oeil* (Paris), no. 10, Oct. 1955, pp. 40-44.

Chonez, Claudine. "Dernière journée avec Fernand Léger." *Nouvelles Litteraires* (Paris), no. 1460, Aug. 25, 1955, pp. 1-2.

Gindertael, R.V.F. "Fernand Léger, 1881-1955." *Les Beaux-Arts* (Brussels), Sept. 30, 1955.

Bauquier, Georges. "Fernand Léger, peintre." *La Nouvelle Critique* (Paris), vol. 7, no. 68, 1955, pp. 129-38.

Delot, Jean. "Fernand Léger, un primitif d'un age nouveau." *Quatrième Internationale* (Paris), vol. 13, no. 11-12, 1955, pp. 45-47.

Reverdy, Pierre. "Pour tenir tête à son époque." *Derrière le Miroir* (Paris), no. 79/80/81, 1955, pp. 1-13.

"Hommage à Fernand Léger." *Pour l'Art* (Lausanne), no. 44, 1955, pp. 13-29.

1955-56 Trier, Eduard. "Der Späte Léger." *Das Kunstwerk* (Baden-Baden), vol. 9, no. 2, 1955-56, pp. 48-49.

1956 Cendrars, Blaise. "Cendrars devant ces images nous a raconté trois histoires." *Arts* (Paris), no. 559, Mar. 1956, pp. 9, 14-20.

Berger, John. "Léger. Artist and Man." *Nation* (New York), vol. 182, no. 20, May 19, 1956, pp. 431-32.

Degand, Léon. "L'Heritage de Fernand Léger." *Aujourd'hui, Art et Architecture* (Boulogne-sur-Seine), 2e année, no. 9, Sept. 1956, pp. 4-13.

Lassaigne, Jacques. "Fernand Léger, maître d'oeuvre et peintre du bonheur." *Prisme des Arts* (Paris), no. 4, 1956.

Mathey, François. "Léger et l'art dit 'décoratif'." *Jardin des Arts* (Paris), no. 20, 1956.

Richter, Hans. "In Memory of Two Friends." *College Art Journal* (New York), vol. 15, no. 4, 1956, pp. 340-43.

1956-57 Vallier, Dora. "Carnet inédit de Fernand Léger. Esquisses pour un Portrait." *Cahiers d'Art* (Paris), 31-32e années, 1956-57, pp. 97-175. Reprinted as a book: Vallier, Dora. *Carnet Inédit de Fernand Léger. Esquisses pour un Portrait.* Paris: Cahiers d'Art, n.d.

1957 Gállego, Julian. "Fernand Léger, creador de 'nechos plasticos'." *Goya* (Madrid), no. 17, Mar.-Apr. 1957, pp. 295-302.

Usami, E. "Picasso and Léger." *Mizue* (Tokyo), no. 621, Apr. 1957, pp. 5-27.

Heilmaier, Hans. "Fernand Léger." *Die Kunst und das Schöne Heim* (Munich), vol. 55, no. 11, Aug. 1957, pp. 404-07.

Combet, G. "La dernière oeuvre de Fernand Léger." *Aujourd'hui, Art et Architecture* (Boulogne-sur-Seine), 3e année, no. 15, Dec. 1957, p. 33.

1958 Prévert, Jacques. "Le Monde en vaut la peine." *Aujourd'hui, Art et Architecture* (Boulogne-sur-Seine), 4e année, no. 18, July 1958, pp. 4-11.

Bauquier, Georges. "Fernand Léger, peintre." *Nouvelle Critique* (Paris), 7e année, no. 68, 1958, pp. 129-36.

1959 "Fernand Léger at the Musée Léger at Biot." *Apollo* (London), vol. 70, no. 416, Oct. 1959, p. 103.

"Präsentation des Léger-Museums von Biot in der Maison de la Pensée Française." *Werk* (Winterthur), 1959.

Cingria, H. "Le Musée Fernand Léger. Un monument aux dimensions cyclopéens." *Art & Décoration* (Paris), no. 74, 1959.

1960 Verdet, André. "Le Temple solaire de Fernand Léger à Biot." *XXe Siècle* (Paris), n.s., XXII année, no. 14, June 1960, supp. [38].

"Museum for an Anti-Museum Man." *Life* (New York), Oct. 17, 1960, p. 57.

Hansing, E. G. and Meyer-Bothe, W. "Das Léger-Museum in Biot." *Bau und Werk* (Vienna), vol. 13, 1960.

Picon, Gaëtan. "Le Musée Léger à Biot." *Cahiers d'Art* (Paris), 33-35 années, 1960, pp. 197-200.

Picon, Gaëtan. "Hommage à Léger." *Cahiers d'Art* (Paris), 33-35 années, 1960, pp. 201-02.

Sovák, P. "Fernand Léger." *Vytvarné Umení* (Prague), vol. X, 1960, pp. 77-83.

1961 Ashton, Dore. "Exhibitions at the Janis Gallery and the Museum of Modern Art." *Arts & Architecture* (Los Angeles), vol. 78, no. 2, Feb. 1961, pp. 5,30.

Wraight, Robert. "The Musée Fernand Léger." *Studio* (London), vol. 162, no. 824, Dec. 1961, pp. 206-09.

1962 Geldzahler, Henry. "The Late Léger: Parade of Variations." *Art News* (New York), vol. 61, no. 1, Mar. 1962, pp. 32-34.

Ashton, Dore. "Léger, the Monumental." *Studio* (London), vol. 163, no. 829, May 1962, pp. 180-83.

Kozloff, Max. "Fernand Léger: Five Themes and Variations." *Art International* (Zurich), vol. VI, no. 4, May 1962, pp. 73-75.

Tillim, Sidney. "Five Themes and Variations at the Guggenheim Museum." *Arts* (New York), vol. 36, no. 9, May-June 1962, p. 84.

Descargues, Pierre. "Fernand Léger et le monde moderne." *XXe Siècle* (Paris), n.s., XXIV année, no. 19, June 1962, pp. 33-36.

Gregory, Bruce. "Léger's Atelier." *Art Journal* (New York), vol. XXII, no. 1, Fall 1962, pp. 40-42.

"Mostre di Léger e Il Muséo a Biot." *Domus* (Milan), no. 397, Dec. 1962, p. 29.

1963 Berger, John. "Fernand Léger: A Modern Artist, Part I." *Marxism Today* (London), vol. 7, no. 4, Apr. 1963, pp. 112-17. "Fernand Léger: A Modern Artist, Part II." *Marxism Today* (London), vol. 7, no. 5, May 1963, pp. 143-47.

Gregory, Bruce. "Léger's United Nations Murals." *Art Journal* (New York), vol. 23, no. 1, Fall 1963, pp. 35-36.

1964 Roditi, Edouard. "Geometry and After." *Arts Magazine* (New York), vol. 38, no. 10, Sept. 1964, pp. 42-47.

"O Dilema profundo e metafisico de Fernand Léger." *Habitat* (Sao Paulo), vol. XIV, no. 79, Sept.-Oct. 1964, pp. 94-97.

1965 Vanci, Marina. "Fernand Léger." *Arta Plastica* (Bucharest), vol. 12, no. 1, 1965, pp. 84-90, 122-23.

1966 Robinson, Duncan. "Fernand Léger and the International Style." *Form* (Cambridge, England), Summer 1966, pp. 16-18.

1967 Pleynet, Marcelin. "Léger Legacy." *Art News* (New York), vol. 65, no. 10, Feb. 1967, pp. 42-43.

Mathey, François. "Léger e altre personalità cubiste." *L' Arte Moderna* (Milan), vol. IV, no. 33, 1967, p. 106.

1968 Goldin, Amy. "Léger Now." *Art News* (New York), vol. 67, no. 8, Dec. 1968, pp. 24-27, 65-66.

1969 Grieve, Alastair. "Art and the Machine Age." *Art and Artists* (London), vol. 4, no. 4, Apr. 1969, pp. 32-37.

Descargues, Pierre. "Fernand Léger et la règle des contrastes." *XXe Siècle* (Paris), n.s., XXXI année, no. 33, 1969, pp. 38-46.

Johansson, Hans. "Fernand Léger: Konsten och Arbetarna." *Konstrevy* (Stockholm), vol. 45, no. 3, 1969, pp. 109-10.

1970 Golding, John. "London Commentary: Fernand Léger at Waddington Galleries." *Studio International* (London), vol. 179, no. 922, May 1970, pp. 226-27.

Sacks, Lois. "Fernand Léger and the Ballet Suédois." *Apollo* (London), vol. XCI, no. 100, June 1970, pp. 463-68.

Banham, Rayner. "Nature Morte Lives." *New Society* (London), Nov. 26, 1970, pp. 958-59.

Cabanne, Pierre. "Le Purisme, ou la recherche de l'absolu." *Jardin des Arts* (Paris), Dec. 1970, pp. 44-51.

Green, Christopher. "Léger, Purism and the Paris Machines." *Art News* (New York), vol. 69, no. 8, Dec. 1970, pp. 54-56, 67.

Blunt, Anthony. "Léger at the Tate." *Listener* (London), Dec. 3, 1970, pp. 792-93.

Benthall, Jonathan. "Léger's City and Atget's." *Studio International* (London), vol. 181, no. 929, Jan. 1971, pp. 7-8.

1971 Forge, Andrew. "Forces Against Object-Based Art." *Studio International* (London), vol. 181, no. 929, Jan. 1971, pp. 32-37.

Bazaine, Jean. "Fernand Léger raconté par Jean Bazaine." *Jardin des Arts* (Paris), no. 203, Oct. 1971.

Descargues, Pierre. "En Hommage à Fernand Léger: la 'ferme du souvenir' en pays d'Auge." *Plaisir de France* (Paris), vol. 38, no. 393, Oct. 1971, pp. 32-35.

De Beauvais, P. "Léger." *Paris Match* (Paris), Oct. 23, 1971, pp. 50-59.

"Fernand Léger." *Chroniques de l'Art Vivant* (Paris), no. 24, Oct. 1971, pp. 14-15.

"Mondrian et Léger: leurs destins ont suivis d'étonnantes parallèles." *Connaissance des Arts* (Paris), no. 236, Oct. 1971, p. 23.

Comte, P. "Fernand Léger." *Opus International* (Paris), no. 29-30, Dec. 1971, pp. 99-100.

Lévêque, Jean-Jacques. "Hommage de Nadia Léger à son premier maître." *XXe Siècle* (Paris), XXXIII année, no. 37, Dec. 1971, pp. 53-64.

Denvir, Bernard. "The Poussin of Pigalle." *Art and Artists* (London), vol. 5, no. 10, 1971, pp. 16-19.

Clair, J. "L'Etrangeté de Léger." *La Nouvelle Revue Française* (Paris), vol. 20, no. 229, Jan. 1972, pp. 28-37.

1972 Clay, J. "Léger: the Strong Man of French Art." *Réalités* (Paris), no. 256, Mar. 1972, pp. 52-59.

Elderfield, John. "Epic Cubism and the Manufactured Object: Notes on a Léger Retrospective." *Artforum* (New York), vol. X, no. 8, Apr. 1972, pp. 54-63.

Krauss, Rosalind. "Léger, Le Corbusier and Purism." *Artforum* (New York), vol. X, no. 8, Apr. 1972, pp. 50-53.

"Fernand Léger (1881-1955): le peuple du monde mécanique." *Jardin des Arts* (Paris), no. 209, Apr. 1972, pp. 60-64.

Visser, M. "Fernand Léger." *Museumjournaal* (Otterlo), vol. 17, pt. 2, May 1972, pp. 59-64.

Weelen, G. "Fernand Léger: The Industrial Age and the City." *Vie des Arts* (Montreal), no. 66, Spring 1972, pp. 32-35, 84-86.

Russell, John. "Léger: The Master of the Machine." *Horizon* (New York), vol. XIV, no. 4, Autumn 1972, pp. 86-95.

1973 Kramer, Hilton. "Léger, Easel Painting and Utopian Politics." *New York Times* (New York), Jan. 28, 1973, sect. D, p. 23.

Rondolino, G. "Pittori e uomini di cinema: Francis Picabia e Fernand Léger." *D'Ars* (Milan), vol. 14, no. 66-67, Nov.-Dec. 1973, pp. 68-81.

1975 De Micheli, M. "Il 'maestro dei costruttori.'" *Le Arti* (Milan), vol. 25, no. 8-9, Sept.-Oct. 1975, pp. 27-32.

Green, Christopher. "Painting for the Corbusian Home: Fernand Léger's Architectural Paintings, 1924-26." *Studio International* (London), vol. 190, no. 977, Sept.-Oct. 1975, pp. 103-07.

Lascault, G. "Léger: l'anti-récit." *XXe Siècle* (Paris), XXXVII année, no. 45, Dec. 1975, pp. 54-62.

1976 Smith, R. "Léger: A Dilemma Unresolved." *Art and Australia* (Sydney), vol. 14, pt. 1, July-Sept. 1976, pp. 42-43.

"La Rêve de Léger conquérit la terre." *Galerie-Jardin des Arts* (Paris), no. 185, Oct. 1976, pp. 95-98.

Tarlton, J. "A Twentieth Century Master in Auckland: the 'object' in the Art of Fernand Léger." *Art New Zealand* (Auckland), no. 2, Oct.-Nov. 1976, pp. 11-12.

1978 Guillaumin, J. "Cours: relance de Léger." *Connaissance des Arts* (Paris), no. 322, Dec. 1978, p. 151.

Franzke, Andreas. "Fernand Léger: 'fumées sur les toits'." *Jahrbuch der Staatlichen Kunstsammlung in Baden-Württemberg* (Baden-Württemberg), vol. 15, 1978, pp. 75-93.

Messer, Thomas. "Léger's Final Masterpiece." *Art News* (New York), vol. 79, no. 8, Oct. 1980, pp. 160-61.

1980 Franzke, Andreas. "Fernand Légers Stilleben von 1925 in Ihrem Verhältnis zur Zeitgenössischen Architektur und zum Avangardistichem Film." *Jahrbuch der Staatlichen Kunstsammlung in Baden-Württemberg* (Baden-Württemberg), 1980.

Fig. 39. Léger and Blaize Cendrars at Deauville, c. 1950

1981 Ohff, Heinz. "Fernand Léger." *Das Kunstwerk* (Stuttgart), vol. XXXIV, no. 1, 1981, pp. 61-62.

GENERAL BOOKS

1912 Gleizes, Albert and Metzinger, Jean. *Du Cubisme.* Paris: Figuière, 1912.

1913 Apollinaire, Guillaume. *Les Peintres Cubistes.* Paris: Figuière, 1913. English translation, *The Cubist Painters.* New York: Wittenborn, Schultz, 1944; revised edition, 1949.

1915 Wright, Willard Huntington. *Modern Painting, Its Tendency and Meaning.* New York and London: John Lane, 1915.

1920 Kahnweiler, Daniel Henry. *Der Weg zum Kubismus.* Munich: Delphin Verlag, 1920. English translation, *The Rise of Cubism.* New York: Wittenborn, Schultz, 1949.

Salmon, André. *L'Art Vivant.* Paris: Crès, 1920.

1922 Kassak, Ludwig and Moholy-Nagy, László. *Buch Neuer Kunstler.* Vienna: MA, 1922.

1923 Gordon, Jan. *Modern French Painters.* New York: Dodd, Mead, 1923.

1924 Hildebrandt, Hans. *Die Kunst des 19. und 20. Jahrhunderts.* Wildpark-Potsdam: Akademische Verlagsgesellschaft Athenaion, 1924.

Walden, Herwarth. *Einblick in Kunst.* Berlin: Verlag der Sturm, 1924.

1926 Einstein, Carl. *Die Kunst des 20. Jahrhunderts.* Berlin: Propylaen Verlag, 1926.

Kurtz, Rudolf. *Expressionismus und Film.* Berlin: Verlag der Lichtbühne, 1926.

1927 Raynal, Maurice. *Anthologie de la Peinture en France.* Paris: Editions Montaigne, 1927.

1928 Raynal, Maurice. *Modern French Painters.* New York: Brentano's, 1928 and London: Duckworth, 1929.

Uhde, Wilhelm. *Picasso et la Tradition Française: Notes sur la Peinture Actuelle.* Paris: Editions des Quatre Chemins, 1928. English translation, *Picasso and the French Tradition.* Paris: Editions des Quatre Chemins and New York: E. Weyhe, 1929.

1929 Janneau, Guillaume. *L'Art Cubiste.* Paris: Charles Moreau, 1929.

Ozenfant, Amedée. *Art.* Paris: J. Budry, 1929. Reprinted in English as *Foundations of Modern Art.* New York: Dover Publications, 1952.

1933 Read, Herbert. *Art Now.* New York: Harcourt, Brace, 1933 and London: Faber and Faber, 1948.

1934 Sweeney, James Johnson. *Plastic Redirections in 20th Century Painting.* Chicago: University of Chicago Press, 1934.

1935 Huyghe, René. *Histoire de l'Art Contemporain; La Peinture.* Paris: Alcan, 1935.

1936 Barr, Alfred H., Jr. *Cubism and Abstract Art.* New York: The Museum of Modern Art, 1936. Reprint edition, New York: Arno Press, 1966.

1937 Escholier, Raymond. *La Peinture Française, XXme Siècle.* Paris: Floury, 1937.

1938 Zervos, Christian. *Histoire de l'Art Contemporain.* Paris: Editions Cahiers d'Art, 1938.

1939 Madsen, Herman. *Fran Symbolism till Surrealism.* Stockholm: Ahlén oon Söners, 1939.

1940 *Museum of Living Art, A. E. Gallatin Collection.* New York: New York University Press, 1940.

Wilenski, Reginald Howard. *Modern French Painters.* New York: Reynal & Hitchcock, 1940.

1942 Georges-Michel, Michel. *Peintres et Sculpteurs Que J'ai Connus.* New York: Brentano's, 1942.

1943 *Current Biography.* New York: H. W. Wilson, 1943.

1944 Dorival, Bernard. *Les Étapes de la Peinture Française Contemporaine.* Paris: Gallimard, 1944.

1945 Billie, Ejler. *Picasso, Surrealisme Abstrakt Kunst.* Copenhagen: Helios, 1945.

Bonfante, Egidio and Ravenna, Juti. *Arte Cubista.* Venice: Ateneo, 1945.

1946 Amberg, George. *Art in Modern Ballet.* New York: Pantheon, 1946.

Kahnweiler, Daniel Henry. *Juan Gris.* Paris: Gallimard, 1946. English translations, London: Lund Humphries and New York: Curt Valentin, 1947 and New York: Abrams, 1969.

Moholy-Nagy, László. *Vision in Motion.* Chicago: Paul Theobald, 1946.

1948 Biederman, Charles. *Art as the Evolution of Visual Knowledge.* Red Wing, Minnesota: Charles Biederman, 1948.

Davidson, Morris. *An Approach to Modern Painting.* New York: Coward McCann, 1948.

Dorival, Bernard, ed. *Les Peintres Célèbres.* Geneva –Paris: Lucien Mazenod, 1948.

Eluard, Paul. *Voir; Poèmes, Peintures, Dessins.* Geneva: Editions des Trois Collines [1948].

Hitchcock, Henry Russell. *Painting Toward Architecture.* [Miller Company Collection]. New York: Duell, Sloan and Pearce, 1948.

Kootz, Samuel M. *Women.* New York: Samuel M. Kootz Editions, 1948.

1949 Arland, Marcel. *Chronique de la Peinture Moderne.* Paris: Corrêa, 1949.

Jardot, Maurice and Martin, Kurt. *Les Maîtres de la Peinture Française Contemporaine.* Baden-Baden: Editions Waldemar Klein, 1949.

Manvell, Roger, ed. *Experiment in the Film.* London: Grey Walls, 1949.

1950 Cassou, Jean. *Situation de l'Art Moderne.* Paris: Editions de Minuit, 1950.

Raynal, Maurice. *History of Modern Painting from Picasso to Surrealism.* Geneva: Skira, 1950.

Marchiori, Giuseppe. *Pittura Moderna in Europa.* Venice: Neri Pozzi, 1950.

Collection of the Société Anonyme: Museum of Modern Art. New Haven: Yale University Art Gallery, 1950.

1952 Sterling, Charles. *La Nature Morte de l'Antiquité à Nos Jours.* Paris: P. Tisné, 1952.

1953 Gray, Christopher. *Cubist Aesthetic Theory.* Baltimore: Johns Hopkins Press, 1953.

1954 Barr, Alfred H., Jr. *Masters of Modern Art.* New York: The Museum of Modern Art, 1954.

Georges-Michel, Michel. *De Renoir à Picasso, les Peintres Que J'ai Connus.* Paris: A. Fayard, 1954.

Haftmann, Werner. *Malerei in 20. Jahrhunderts.* Munich: Prestel-Verlag, 1954.

1955 Barr, Alfred H., Jr. and Lieberman, William S. *Les Maîtres de l'Art Moderne.* Paris-Brussels-Amsterdam: Elsevier, 1955.

Heron, Patrick. *Changing Forms of Art.* London: Routledge and Kegan Paul, 1955.

1956 Francastel, Pierre. *Histoire de la Peinture Française, du Classicisme au Cubisme.* Paris-Brussels: Elsevier, 1956.

Lake, Carlton and Maillard, Robert, eds. *A Dictionary of Modern Painting.* New York: Tudor [1956?].

Parmelin, Hélène. *Cinq Peintres et le Théâtre; Léger, Coutaud, Gischia, Labisse, Pignon.* Paris: Cercle d'Art, 1956.

Schmeller, Alfred. *Cubism.* New York: Crown, n.d. and London: Methuen, 1956.

1957 David, C. W., ed. *Moderne Kirchen.* Zurich: Die Arche, 1957.

Delaunay, Robert. *Du Cubisme à l'Art Abstrait.* Paris: S.E.V.P.E.N., 1957.

Gleizes, Albert. *Cahiers.* New York: Wittenborn, 1957.

1958 Giedion, S. *Architecture: You and Me.* Cambridge, Massachusetts: Harvard University Press, 1958.

1959 Apollonio, U. *Fauves and Cubists.* New York: Crown, 1959.

Habasque, Guy. *Cubism.* Geneva: Skira, 1959.

Myers, Bernard, ed. *Encyclopedia of World Art.* New York: McGraw-Hill, 1959-68.

Read, Herbert. *A Concise History of Modern Painting.* London: Thames and Hudson, 1959.

1960 Haftmann, Werner. *Painting in the Twentieth Century.* New York: Praeger, 1960.

Jacobs, Lewis, ed. *Introduction to the Art of Movies: an Anthology.* New York: Noonday Press, 1960.

Liberman, Alexander. *The Artist in His Studio.* New York: The Viking Press, 1960.

Maillard, Robert, ed. *Dictionary of Modern Sculpture.* New York: Tudor [1960?] and London: Methuen, 1962.

Rosenblum, Robert. *Cubism and Twentieth Century Art.* New York: Abrams, 1960.

1963 Wilenski, Reginald. *Modern French Painters.* New York: Harcourt, Brace, 1963.

1965 Jardot, Maurice. *Mélanges Kahnweiler.* Stuttgart: Verlag Gerd Hatje, 1965.

Sylvester, David, ed. *Modern Art From Fauvism to Abstract Expressionism.* London: Rainbird and New York: Watts, 1965.

1966 Fry, Edward. *Cubism.* New York-Toronto: McGraw-Hill, 1966.

1967 Banham, Reyner. *Theory and Design in the First Machine Age.* 2nd ed. New York: Praeger, 1967.

Hamilton, George Heard. *Painting and Sculpture in Europe.* Baltimore: Penguin, 1967.

1968 Chipp, Herschel B. *Theories of Modern Art.* Berkeley and Los Angeles: University of California Press, 1968.

Golding, John. *Cubism, a History and Analysis, 1907-1914.* 2nd ed. London: Faber and Faber, 1968.

1969 *Encyclopédie de la Pléiade* [Histoire de l'Art]. Paris: Gallimard, 1969.

Rischbieter, Henning, ed. *Art and the Stage in the 20th Century.* Greenwich, Conn.: New York Graphic Society [1969].

1970 Egbert, Donald Drew. *Social Radicalism and the Arts — Western Europe.* New York: Knopf, 1970.

Selections from the Guggenheim Museum Collection 1900-1970. New York: The Solomon R. Guggenheim Museum, 1970.

1971 Cooper, Douglas. *The Cubist Epoch.* London: Phaidon Press, 1971.

Kahnweiler, Daniel Henry with Crémieux, Francis. *My Galleries and Painters.* New York: Documents of 20th Century Art, The Viking Press, 1971.

Malevich, Kasimir Severinovich. Troels Andersen, ed. *Essays on Art, 1915-1933.* New York: Wittenborn, 1971.

1972 Apollinaire, Guillaume. *Apollinaire on Art: Essays and Reviews 1902-1918.* LeRoy C. Breunig, ed. New York: Documents of 20th Century Art, The Viking Press and London: Thames and Hudson, 1972.

1973 Kozloff, Max. *Cubism / Futurism.* New York: Charterhouse, 1973.

1975 Standish, D. Lawder. *The Cubist Cinema.* New York: New York University Press, 1975.

1976 Rudenstine, Angelica Zander. *The Guggenheim Museum Collection: Paintings 1880-1945,* Vols. I and II. New York: The Solomon R. Guggenheim Museum, 1976.

Fig. 40. Léger in the studio of Roland Brice, his ceramist, c. 1952

SELECTED
EXHIBITIONS

1919 Galerie de l'Effort Moderne, Paris. Feb.

 Galerie Sélection, Antwerp, Belgium.

1924 Galerie de l'Effort Moderne, Paris.

1925 Anderson Galleries, New York, New York. *Fernand Léger* (organized by the Société Anonyme). Nov. 16-28. Cat., texts by Katherine S. Dreier, Carl Einstein and the artist.

1926 Galerie des Quatre Chemins, Paris. May.

1928 Galerie Alfred Flechtheim, Berlin, Germany. *Fernand Léger.* Feb. 6-Mar. 2. Cat., intro. by Alfred Flechtheim.

 Galerie de l'Effort Moderne, Paris. Mar.

 Leicester Galleries, London, England.

1930 Galerie Paul Rosenberg, Paris.

1931 Durand-Ruel Galleries, New York, New York. *Exhibition of Paintings by Fernand Léger.* Feb. 3-21. Cat.

 John Becker Gallery, New York, New York. *Fernand Léger.* Oct. 1-23. Cat.

1933 Kunsthaus Zürich, Zurich, Switzerland. *Fernand Léger.* Apr. 30-May 25. Special issue *Exposition Fernand Léger au Kunsthaus Zürich* published in conjunction with the exhibition by *Cahiers d'Art* (Paris), 8ᵉ année, no. 3-4, 1933. Texts by Guillaume Apollinaire, Germain Bazin, C.-J. Bulliet, Blaise Cendrars, Pierre Courthion, Carl Einstein, Ilya Ehrenburg, Paul Fierens, Waldemar George, Giedion, Hans Heilmaier, Ragnar Hoppe, H. Laugier, Le Corbusier, Jacques-Henri Lévesque, Darius Milhaud, Oskar Moll, Amedée Ozenfant, Maurice Raynal, André Salmon, James Johnson Sweeney, Théo van Doesburg, Christian Zervos and the artist.

1934 Galerie Vignon, Paris. *Objets par Fernand Léger: Gouaches-Dessins 1933-34.* Apr. 16-28.

 Galerie Moderne, Stockholm, Sweden.

1935 The Museum of Modern Art, New York, New York. *Fernand Léger.* Sept. 30-Oct. 24. Traveled to the Art Institute of Chicago, Chicago, Illinois, Dec. 19, 1935-Jan. 19, 1936. Cat., text by George L. K. Morris, published in *The Bulletin of The Museum of Modern Art* (New York), vol. 1, no. 3, Oct. 1935.

1937 Galerie Paul Rosenberg, Paris. Feb. 5-27.

 London Gallery, London, England. *Léger.* Oct. 14-Nov. 13. Cat.

 Galerie Artek, Helsinki, Finland.

1938 Rosenberg and Helft Gallery, London, England. *Exhibition of Works by Léger.* Jan. 17-Feb. 16. Cat.

 Pierre Matisse Gallery, New York, New York. *Léger 1937: Paintings and Gouaches.* Feb. 23-Mar. 19. Cat., text by James Johnson Sweeney.

 Palais des Beaux-Arts, Brussels, Belgium. *Fernand Léger.* May 14-June 5. Cat., preface by the artist.

 Mayor Gallery, London, England. *Fernand Léger 1912-1916.* June 8-July 2. Cat. in *London Bulletin* (London), no. 3, June 1938, pp. 25-26.

 Pierre Matisse Gallery, New York, New York. *Léger: Recent Gouaches.* Oct. 25-Nov. 12.

1940 Nierendorf Galleries, New York, New York. *Fernand Léger.* Feb. 20-Mar. 2.

 Galerie MAI, Paris. *Oeuvres Récentes de Fernand Léger.* Mar. 1-30.

 Katharine Kuh Gallery, Chicago, Illinois. *Exhibition of New Work: Léger.* May.

 The Museum of Modern Art, New York, New York. *Composition with Two Parrots by Fernand Léger.* Dec. 27, 1940-Jan. 12, 1941.

1941 Marie Harriman Gallery, New York, New York. *Fernand Léger: Gouaches and Drawings.* Mar. 4-15. Checklist.

 The Arts Club of Chicago, Chicago, Illinois. *Fernand Léger.* May 23-June 14. Cat., intro. by James Johnson Sweeney.

 Mills College Art Gallery, Oakland, California. *Fernand Léger.* June 29-July 31. Cat., intro. by Alfred Neumeyer. Traveled to San Francisco Museum of Art, San Francisco, California. Aug.-Sept.

1942 Buchholz Gallery, New York, New York. *Fernand Léger: Gouaches and Drawings.* Oct. 12-31. Checklist.

 Paul Rosenberg Gallery, New York, New York. *Recent Works by Fernand Léger.* Oct. 12-31.

1943 Jacques Seligmann & Co., Inc., New York, New York. *Fernand Léger.* Apr. 19-May 6. Checklist.

 Dominion Gallery, Montreal, Quebec, Canada. *Exhibition of Paintings by Fernand Léger.* May 29-June 9.

1944 Valentine Gallery, New York, New York. *Léger: New Paintings.* Mar. 13-Apr. 8. Checklist.

 Jacques Seligmann & Co., Inc., New York, New York. *Fernand Léger: "Les Plongeurs."* Apr. 19-May 6. Cat., text by Germain Seligmann.

 Institute of Design, Chicago, Illinois. *Exhibition of Painting by Fernand Léger.* Oct. 14-Nov. 8. Cat., texts by Siegfried Giedion and the artist published by the Cincinnati Modern Art Society, Cincinnati Art Museum, for *Exhibition of Painting by Fernand Léger* in Cincinnati, Nov. 14-Dec. 17, 1944.

 Cincinnati Modern Art Society, Cincinnati Art Museum, Cincinnati, Ohio. *Exhibition of Painting by Fernand Léger.* Nov. 14-Dec. 17. Cat., texts by Siegfried Giedion and the artist.

1945 Fogg Art Museum, Harvard University, Cambridge, Massachusetts. [*Fernand Léger: Paintings*]. Jan. 3-15.

 Galerie Louis Carré, Paris. *Fernand Léger: Peintures Antérieures à 1940.* Jan. 16-Feb. 5. Cat., text by Jean Bazaine.

 Samuel M. Kootz Gallery, New York, New York. *Léger: Oils, Gouaches, Drawings.* Apr. 9-28.

 Valentine Gallery, New York, New York. *Léger: New Paintings.* Apr. 9-May 5. Checklist.

1946 Galerie Louis Carré, Paris. *F. Léger, Oeuvres d'Amérique, 1940-1945.* Apr. 12-May 11. Cat.

1947 Nierendorf Galleries, New York, New York. *Fernand Léger.* Apr. 29-May 12.

Léger in his studio with *Mona Lisa With Keys,* c. 1931.

948 Svensk-Franska Konstgalleriet, Stockholm, Sweden. *Retrospectiv Utställning Fernand Léger.* May 21-June 30. Cat., intro. by Folke Holmèr.

Galerie Louis Carré, Paris. *Fernand Léger 1912-1939, 1946-1948.* June 11-July 11.

Sidney Janis Gallery, New York, New York. *F. Léger 1912-1948.* Sept. 21-Oct. 16. Checklist.

949 Musée National d'Art Moderne, Paris. *Fernand Léger, Exposition Retrospective, 1905-1949.* Oct. 6-Nov. 13. Cat., preface by Jean Cassou; text by Guillaume Apollinaire.

Landesamt für Museen, Freiburg, West Germany. *Fernand Léger.* Cat., text by Willi Baumeister, published in conjunction with the exhibition by Verlags Gerd Hatje, Stuttgart und Calw, 1949.

950 Tate Gallery, London, England. *Fernand Léger.* Feb. 17-Mar. 19. Cat., intro. by Douglas Cooper.

Galerie 16, Zurich, Switzerland. *Léger's Lithographs for "Le Cirque."* July 1-28.

Buchholz Gallery, New York, New York. *Léger: Recent Paintings and Le Cirque.* Nov. 6-Dec. 2. Cat., excerpts of writings by Guillaume Apollinaire and Douglas Cooper.

Galerie Louis Carré, Paris. *Deauville Vu par Fernand Léger.* Nov. 8-Dec. 9.

951 Kunstnerforbundet, Oslo, Norway. *Fernand Léger.* Mar. Cat.

Sidney Janis Gallery, New York, New York. *Early Léger: Oil Paintings 1911-25.* Mar. 19-Apr. 17. Checklist.

Louis Carré Gallery, New York, New York. *70th Anniversary Exhibition: Fernand Léger.* Mar. 28-Apr. 21. Cat., texts by M. A. Couterier, Jerome Mellquist and the artist.

Maison de la Pensée Française, Paris. *Fernand Léger: Les Constructeurs.* June 12-Oct. 7. Cat., text by Claude Roy, published in conjunction with the exhibition by Editions Falaize, Paris, 1951.

Galerie Louise Leiris, Paris. *Sculptures, Polychromes et Lithographies: Fernand Léger.* Nov. 27-Dec. 15.

1952 Museum Fodor, Amsterdam, The Netherlands. *Léger: de Bouwers.* Jan. Cat., statement by the artist.

Art Institute of Chicago, Chicago, Illinois. *Léger.* Apr. 2-May 17. Cat., text by Katharine Kuh (also published separately as a book by University of Illinois Press, Urbana, 1953). Traveled to the San Francisco Museum of Art, San Francisco, California, June 12-Aug. 30, 1953 and The Museum of Modern Art, New York, New York, Oct. 21, 1953-Jan. 3, 1954.

Kunsthalle Berne, Bern, Switzerland. *Fernand Léger.* Apr. 10-May 28. Cat., preface by Maurice Raynal.

Galerie de Berri, Paris. [Fernand Léger: peintures, gouaches, dessings]. June-July.

*Musée, Antibes, France. June-Sept.

Galerie Louis Carré, Paris. *La Figure dans l'Oeuvre de Fernand Léger.* June 6-July 12. Cat., texts by André Maurois and the artist.

Sidney Janis Gallery, New York, New York. *Paintings by Fernand Léger.* Sept. 15-Oct. 11. Checklist.

Perls Galleries, New York, New York. *Fernand Léger.* Oct. 27-Nov. 29. Cat.

Riksförbundet för Bildande Konst, Stockholm, Sweden. *Léger och Nordisk Postkubism.* Cat., texts by Hans Eklund and Oscar Reutersvard.

1953 Galerie Louis Carré, Paris. *Léger: Peintures.* May 29-June 27. Cat., text by the artist.

Saidenberg Gallery, New York, New York. *Fernand Léger.* Sept. 28-Nov. 15.

Maison de la Pensée Française, Paris. *Fernand Léger: Oeuvres Récentes 1953-1954.* Nov. Cat., intro. by Georges Huisman.

Galerie Louis Carré, Paris. *Le Paysage dans l'Oeuvre de F. Léger.* Nov. 19-Dec. 31. Cat., text by Blaise Cendrars; interview with the artist by Cendrars and Louis Carré.

1954 Sidney Janis Gallery, New York, New York. *Ceramics by Léger.* Dec.

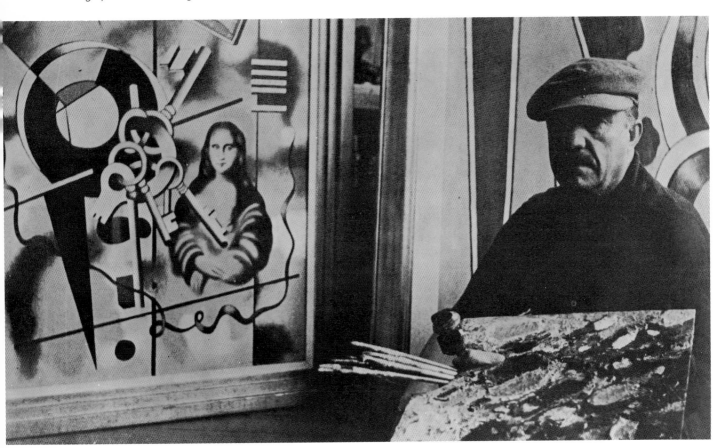

Galerie d'Art Moderne, Basel, Switzerland. *Fernand Léger.* Dec. 1954-Jan. 20, 1955.

Marlborough Fine Art Ltd., London, England. *Fernand Léger.* Dec. 1954-Jan. 1955. Cat., preface by Maurice Jardot.

1955 Galerie Gerald Cramer, Geneva, Switzerland. *Fernand Léger: Lithographies en Couleurs.* Feb.-Mar. Checklist.

Städtisches Museum, Leverkusen, Germany. *F. Léger.* Feb. Cat., preface by Curt Schweicher.

Galerie Blanche, Stockholm, Sweden. *Fernand Léger, 1881-1955.* Aug.-Sept. Cat.

The Museum of Modern Art, New York, New York. *Léger Memorial.* Aug. 19-Sept. 30.

Galerie Maeght, Paris. *Hommage à F. Léger. Peintures de 1920 à 1930.* Oct. Cat., text by Pierre Reverdy.

Perls Galleries, New York, New York. *Fernand Léger.* Oct. 3-Nov. 12. Cat.

Institut Français, Athens, Greece. *F. Léger, Dessins et Lithographies.* Cat., preface by G. Huisman.

Musée de Lyon, Lyon, France. *Fernand Léger.* Cat., preface by René Jullian.

1956 Musée des Arts Décoratifs, Palais du Louvre, Pavillon de Maison, Paris. *Fernand Léger, 1881-1955.* June-Oct. Cat., texts by Jean Cassou, Georges Bauquier, and the artist.

Stedelijk Museum, Amsterdam, The Netherlands. *Léger: Wegbereider.* Dec. 11, 1956-Jan. 28, 1957. Cat.

1957 Sidney Janis Gallery, New York, New York. *Léger: Major Themes.* Jan. 2-Feb. 2. Cat.

Haus der Kunst, Munich, West Germany. *Fernand Léger 1881-1955.* Mar.-May. Cat., preface by Jean Cassou; text by Georges Bauquier.

Kunsthalle Basle, Basel, Switzerland. *Fernand Léger.* May 22-June 23. Cat.

Kunsthaus Zürich, Zurich, Switzerland. *Fernand Léger.* July 6-Aug. 17. Cat., texts by André Maurois, Werner Weber and the artist.

Museum am Ostwall, Dortmund, West Germany. *Fernand Léger, 1881-1955.* Sept. 29-Oct. 27. Cat.

1958 Galerie Louise Leiris, Paris. *F. Léger: Dessins et Gouaches 1909-1955.* Feb. 19-Mar. 22. Cat., intro. by Maurice Jardot.

1959 Albertina, Vienna, Austria. *Fernand Léger.* Feb.-Mar. Cat., text by Otto Benesch.

Maison de la Pensée Française, Paris. *Tapisseries F. Léger.* Mar.

1960 La Porte Latine, Caen, France. *Fernand Léger.* Jan. 22-Feb. 5. Cat., text by Daniel Wallard.

Galerie Europe, Paris. *F. Léger.* Mar. Cat.

Otto Gerson Gallery, New York, New York. *Fernand Léger: Sculpture-Ceramics.* Sept. Checklist.

The Museum of Modern Art, New York, New York. *Fernand Léger in the Museum Collection.* Nov. 16, 1960-Jan. 2, 1961.

Sidney Janis Gallery, New York, New York. *Sidney Janis Presents His 6th Exhibition of Paintings by Fernand Léger, Selected From the Years 1918-1954.* Dec. 5, 1960-Jan. 7, 1961. Cat.

1961 Pierre Berès, Inc., New York, New York. *Fernand Léger: "Mes Voyages."* May 8-June 9.

1962 The Solomon R. Guggenheim Museum, New York, New York. *Fernand Léger: Five Themes and Variations.* Feb. 28-Apr. 29. Cat., preface by Thomas M. Messer; text by Daniel Robbins.

Galerie Renée Ziegler, Zurich, Switzerland. *Fernand Léger.* Apr. 6-May 26. Checklist.

Galerie Berggruen, Paris. *Fernand Léger: Contrastes de Formes 1912-1915.* May-June 30. Cat., preface by Douglas Cooper.

Palais de la Méditerranée, Nice, France. *Fernand Léger: Tapisseries, Céramiques, Bronzes, Lithographies.* July 21-Sept. 30. Cat., preface by Jean Cocteau; text by Jacques Thirion.

1963 Galerija Suvremene Umjetnosti, Zagreb, Yugoslavia. *Fernand Léger.* Oct. 10-Nov. 10. Cat., text by Grgo Gamulin.

La Nuova Pesa, Rome, Italy. Oct. 15-Nov. 10. Cat., texts by D. H. Kahnweiler and R. Guttuso.

1964 Galerie Madoura, Cannes, France. *Léger: Céramiques et Bronzes.* Mar.

Galerie Beyeler, Basel, Switzerland. *Fernand Léger.* Apr.-June. Cat., text by the artist.

Moderna Museet, Stockholm, Sweden. *Fernand Léger.* Oct. 23-Nov. 29. Cat., texts by K. G. Hultén, Ragnar Hoppe, Otto G. Carlsund, Ulf Linde, Carl Fredrik and the artist.

Galerie d'Art Moderne, Basel, Switzerland. *F. Léger: Gouaches et Dessins de 1921 à 1938.* Nov. 28, 1964-Jan. 25, 1965. Cat., preface by Jean Cassou.

1965 Galerie Chalette, New York, New York. *Fernand Léger: The Figure.* Apr. Cat., text by the artist.

Galerie Günther Franke, Munich, West Germany. *Fernand Léger.* Apr. 10-May 10. Cat., text by the artist.

Gimpel Fils, London, England. *Fernand Léger.* June 22-Aug. 14. Cat.

James Goodman Gallery, Buffalo, New York. *Fernand Léger: Drawings.* Oct. 18-Nov. 6. Cat., text by Merle Goodman.

1966 Richard Gray Gallery, Chicago, Illinois. *Léger: Drawings.* Jan. 4-29.

Michael Hertz, Bremen, West Germany. *Fernand Léger: Werke aus den Jahren 1909 bis 1955.* Feb.-Apr. 30. Cat., text by Werner Haftmann.

Galerie Georges Bongers, Paris. *Fernand Léger: Gouaches, Aquarelles et Dessins (1938-1950).* Feb. 17-Mar. 19. Checklist.

Musée Cantini, Marseille, France. *Fernand Léger.* June-Aug. Cat., preface by Douglas Cooper; texts by Marie-Louise Latour and Simone Bourlard-Collier.

International Galleries, Chicago, Illinois. *Fernand Léger, 1881-1955. Retrospective Exhibition.* Nov.-Dec. Cat., text by the artist.

Fig. 42. Poster for Léger exhibition at Dominion Gallery, Montreal, Canada, 1943.

67 Tel Aviv Museum, Tel Aviv, Israel. *Fernand Léger.* Apr.-May. Cat., texts by Jean Cassou, Haim Gamzer, Blaise Cendrars and the artist.

Staatliche Kunsthalle, Baden-Baden, Switzerland. *Fernand Léger: Gemälde, Gouachen, Zeichnungen.* June 19-Sept. Cat., texts by K. Gallwitz, D. H. Kahnweiler and the artist.

Fernand Léger (traveling exhibition organized by The Museum of Modern Art, New York, New York). Traveled to Washington University, St. Louis, Missouri; Cornell University, Ithaca, New York; University of Akron, Akron, Ohio; Telfair Academy of Arts and Sciences, Savannah, Georgia; Dartmouth College, Hanover, New Hampshire; Vassar College, Poughkeepsie, New York; Des Moines Art Center, Des Moines, Iowa.

68 Museum des 20. Jahrhunderts, Vienna, Austria. *Léger.* Apr. 26-June 9. Cat., texts by Werner Haftmann, D. H. Kahnweiler and Ina Steegen.

Svensk-Franska Konstgalleriet, Stockholm, Sweden. *Fernand Léger.* Sept. 21-Oct. 19. Cat.

Musée du Havre, Le Havre, France. *Fernand Léger.* Oct. 12-Dec. 2. Cat., texts by Patrice Hugues and the artist.

Perls Galleries, New York, New York. *Fernand Léger: Oil Paintings.* Nov. 12-Dec. 12. Cat.

Saidenberg Gallery, New York, New York. *Fernand Léger: Gouaches, Watercolors and Drawings From 1910 to 1953.* Nov. 12-Dec. 7. Cat.

69 Musée Galliera, Paris. *Fernand Léger.* Feb.-Mar. Cat., preface by Marie-Claude Dane.

Galerie Günther Franke, Munich, West Germany. *Fernand Léger.* May 6-June. Checklist.

Galerie Beyeler, Basel, Switzerland. *F. Léger.* Aug.-Oct. Cat., texts by Blaise Cendrars, René Jullian, André Maurois and the artist.

Maison de la Culture, Nanterre, France. *Fernand Léger, Les Constructeurs.* Sept. 5-20.

Academy of Arts, Honolulu, Hawaii. *Léger and The Machine.* Sept. 11-Oct. 26.

Galleria Il Milione, Milan, Italy. *Fernand Léger.* Dec. 1969-Jan. 1970. Cat., text by Mario di Michele.

Städtische Kunsthalle, Dusseldorf, West Germany. *Léger.* Dec. 16, 1969-Feb. 8, 1970. Cat., texts by Karl Ruhrberg, Werner Schmalenbach, Daniel Henry Kahnweiler, Pierre Reverdy, Hans Holz, Rolf-Gunter Dienst and Yvonne Friedrichs.

970 Centre d'Art International, Paris. *Oeuvres Monumentales de Fernand Léger.* Feb. 18-closing date unknown.

Musée d'Art Contemporain, Montreal, Quebec, Canada. *Fernand Léger — Témoin de Son Temps.* Feb. 27-Mar. 29.

Albert White Gallery, Toronto, Ontario, Canada. *Fernand Léger, 1881-1955.* Mar. 2-Apr. 3. Cat., text by André Verdet.

Waddington Galleries, London, England. *Fernand Léger.* Apr. 8-May 9. Cat.

Galerie Claude Bernard, Paris. *Fernand Léger: Dessins.* Dec. Cat., text by Maurice Jardot.

971 Grand Palais, Paris. *Fernand Léger* (organized by Musée National d'Art Moderne, Paris). Oct. 16, 1971-Jan. 10, 1972. Cat., texts by Jean Leymarie and Jean Cassou.

972 Pace Gallery, New York, New York. *Léger: The Late Works.* Feb. 5-Mar. 8. Checklist.

Fuji Television Gallery, Tokyo, Japan. *Fernand Léger.* Mar. 10-30. Cat.

Blue Moon Gallery, New York, New York. *Fernand Léger: Drawings and Gouaches 1916-1953.* Oct. Cat.

Michel Couterier et Cie, Paris. *Fernand Léger: Gouaches et Dessins.* Nov. 10-Dec. 16.

1974 Blue Moon Gallery and Lerner-Heller Gallery, New York, New York. *An Intimate View of F. Léger.* Oct. 8-Nov. 9.

Galerie Bonnier, Geneva, Switzerland. *F. Léger.*

1975 Galerie Berggruen, Paris. *F. Léger: Huiles, Aquarelles & Dessins.* Cat., poem by Blaise Cendrars.

1976 *Fernand Léger* (traveling exhibition organized under the auspices of the International Council of The Museum of Modern Art, New York, New York). Cat., text by Alicia Legg. Traveled to Art Gallery of South Australia, Adelaide, Australia; Art Gallery of New South Wales, Sydney, Australia and National Gallery of Victoria, Melbourne, Australia.

Galerie Jan Krugier, Geneva, Switzerland. *Fernand Léger: Gouaches et Dessins.* Cat., text by Maurice Besset.

1977 Galerie Schmela, Dusseldorf, West Germany. *Fernand Léger.* Mar.

1978 J. P. L. Fine Arts, London, England. *Fernand Léger: Drawings and Gouaches 1910-1953.* Mar. 7-Apr. 28. Checklist.

Kunsthalle Köln, Cologne, West Germany. *Fernand Léger: Das Figurliche Werk.* Apr. 12-June 4. Cat., texts by Siegfried Gohr and Christopher Green.

1979 Galerie Berggruen, Paris. *F. Léger: Gouaches, Aquarelles et Dessins.* May. Cat., text by the artist.

Château de Vascoeul, Eure, France. *Fernand Léger.* June 2-Sept. 30. Cat., text by Georges Bauquier.

Cultureel Centrum, Mechelen, Belgium. *Fernand Léger.* Oct. 14-Dec. 2.

Maxwell Davidson Gallery, New York, New York. *Léger: Works on Paper.* Oct. 23-Nov. 24.

1980 The Minneapolis Institute of Arts, Minneapolis, Minnesota. *Léger's Grand Déjeuner.* Apr. 9-June 1. Cat., text by Robert L. Herbert. Traveled to the Detroit Institute of Arts, Detroit, Michigan, July 10-Aug. 24.

Staatliche Kunsthalle, Berlin, West Germany. *Fernand Léger, 1881-1955.* Oct. 24, 1980-Jan. 7, 1981. Cat., texts by Georges Bauquier, Dieter Ruckhaberle, Christopher Green and the artist.

1981 Cabinet d'Art Graphique, Musée National d'Art Moderne, Paris. *Fernand Léger: La Poésie de l'Objet, 1928-1934.* May 13-July 13. Cat., intro. by Maurice Jardot; text by Christian Derouet; reprints of articles by the artist and interviews with the artist.

Musée National Fernand Léger, Biot, France. *Fernand Léger: L'Exposition du Centenaire.* May 30-Sept. 31.

SELECTED GROUP EXHIBITIONS

1907 Grand Palais, Paris. *Salon d'Automne, 5e Exposition.* Oct. 1-22.

1908 Grand Palais, Paris. *Salon d'Automne, 6e Exposition.* Oct. 1-Nov. 8.

1909 Grand Palais, Paris. *Salon d'Automne, 7e Exposition.* Oct. 1-Nov. 8.

1910 Grand Palais, Paris. *Salon d'Automne, 8e Exposition.* Oct. 1-Nov. 8.

Cours-la-Reine, Paris. *Artistes Indépendants, 26e Exposition.* Mar. 18-May 1.

1911 Quai d'Orsay, Paris. *Artistes Indépendants, 27e Exposition.* Apr. 21-June 13.

7, Place A. Steurs, Brussels, Belgium. *Les Indépendants, VIIIe Salon Annuel.* June 10-July 3.

Grand Palais, Paris. *Salon d'Automne, 9e Exposition.* Oct. 1-Nov. 8.

Galerie d'Art Ancien & d'Art Contemporain, Paris. *Société Normande de Peinture Moderne (1re Exposition).* Nov. 20-Dec. 16.

1912 Tretyakov Gallery, Moscow. [Second Jack of Diamonds Exhibition]. Jan.

Quai d'Orsay, Paris. *Artistes Indépendants, 28e Exposition.* Mar. 20-May 16.

Galeries J. Dalmau, Barcelona, Spain. *Exposició d'Art Cubista.* Apr. 20-May 10.

Société Normande de Peinture Moderne, Rouen, France. *1912 Salon.* June 15-July 15.

Grand Palais, Paris. *Salon d'Automne, 10e Exposition.* Oct. 1-Nov. 8.

Stedelijk Museum, Amsterdam, The Netherlands. *Moderne Kunst Kring.* Oct. 6-Nov. 7.

Galerie la Boétie, Paris. *Salon de la "Section d'Or."* Oct. 10-30.

Kunsthaus Lepke, Berlin, Germany. *III. Juryfreie Kunstschau.* Nov. 26-Dec. 31.

Galerie Kahnweiler, Paris.

1913 Galerie Miethke, Vienna, Austria. *Die Neue Kunst.* Jan.-Feb.

Galerie B. Weill, Paris. *Gleizes, Léger, Metzinger.* Jan. 17-Feb. 1.

Armory of the Sixty-Ninth Regiment, New York, New York. *Armory Show.* Feb. 17-Mar. 15.

Art Institute of Chicago, Chicago, Illinois. *Armory Show.* Mar. 24-Apr. 15.

Copley Hall, Copley Society of Boston, Boston, Massachusetts. *Armory Show.* Apr. 28-May 18.

Der Sturm, Berlin, Germany. *Erster Deutscher Herbstsalon.* Sept. 20-Dec. 1.

1916 Der Sturm, Berlin, Germany. *XXXXIII Ausstellung: Expressionisten/Futuristen/Kubisten.* July.

1920 Grand Palais, Paris. *Artistes Indépendants, 31e Exposition.*

1921 Galerie de l'Effort Moderne, Paris. *Les Maîtres du Cubisme.*

Grand Palais, Paris. *Artistes Indépendants, 32e Exposition.*

1926 Brooklyn Museum, Brooklyn, New York. *Modern Art* (organized by the Société Anonyme, The Museum of Modern Art, New York, New York). Nov. 1926-Jan. 1927.

1930 Leicester Galleries, London, England. June.

Reinhardt Galleries, New York, New York. *Paintings by Modern French Artists.* Oct.-Nov. 6.

1931 Museum of French Art, New York, New York. *Picasso, Braque, Léger.* Feb. Cat.

1932 Valentine Gallery, New York, New York. [Léger, Masson, Roux]. Feb. 1-20.

1936 The Museum of Modern Art, New York, New York. *Cubism and Abstract Art.* Mar. 2-Apr. 8. Cat., text by Alfred H. Barr, Jr.

1937 Petit Palais, Paris. *Les Maîtres de l'Art Indépendant.* June-Oct. Cat.

1938 Pierre Matisse Gallery, New York, New York. *Léger: Gouaches/ Paul Nelson: Painting.* Oct. 25-Nov. 12.

1940 Steuben Glass, Inc., New York, New York. *The Collection of Designs in Glass by Twenty-Seven Contemporary Artists.* Cat.

1941 Virginia Museum of Fine Arts, Richmond, Virginia. [Chrysler Collection]. Jan. 6-Mar. 4.

Arts and Crafts Club, New Orleans, Louisiana. *Alexander Calder, Mobiles, Jewelry; Fernand Léger, Gouaches, Drawings.* Mar. 28-Apr. 11. Cat.

1942 Pierre Matisse Gallery, New York, New York. *Artists in Exile.* Mar. 3-28.

1945 The Philadelphia Museum of Art, Philadelphia, Pennsylvania. *The Gallery Collection: Picasso, Léger.* Jan. 10-Feb. 20. Cat.

Art Institute of Chicago, Chicago, Illinois. *Modern Art in Advertising: An Exhibition of Designs for Container Corporation of America.* Apr. 28-June 24. Cat., text by the artist.

Galerie de France, Paris. *Le Cubisme, 1911-1918.* May 25-June 30. Cat.

Whitney Museum of American Art, New York, New York. *European Artists in America.* Mar. 13-Apr. 11.

1947 The London Gallery, Ltd., London, England. *The Cubist Spirit in its Time.* Mar. 18-May 3. Cat., texts by Robert Melville and E. L. T. Mesens.

Galerie Louis Carré, Paris. *F. Léger, Gromaire.* Apr. 17-May 3.

Kunsthalle Berne, Bern, Switzerland. *Calder, Léger, Bodmer, Leuppi.* May 4-26. Cat., intro. by Arnold Rüdlinger.

Palais des Papes, Avignon, France. *Exposition de Peintures et Sculptures Contemporaines.* June 27-Sept. 30. Cat., intro. by Christian Zervos; statement by the artist.

Stedelijk Museum, Amsterdam, The Netherlands. *Alexander Calder, Fernand Léger.* July-Aug. Cat., intro. by Louis Carré.

Galerie Nina Dansset, Paris. [Léger, Hélion, Masson]. Dec. 3-23.

1949 Buchholz Gallery, New York, New York. *Léger, Matisse, Miró, Moore: Panels and Sculpture/Recent Lithographs by Matisse.* May 4-28. Cat.

Kestner Gesellschaft, Hanover, West Germany. *Fernand Léger, André Masson, Woty Werner.* July 3-31.

1951 Saidenberg Gallery, New York, New York. *Léger and Picasso.* Sept. 25-Nov.

1952 Kootz Gallery, New York, New York. *Vlaminck, Léger, Miró.* Jan. 28-Feb. 16.

Biennale, Venice, Italy. Cat.

1956 Sidney Janis Gallery, New York, New York. *Cubism 1910-1912.* Jan. 3-Feb. 4. Cat.

Biennale, Venice, Italy. Cat.

1958 Sidney Janis Gallery, New York, New York. *Modern French Tapestries by Braque, Léger, Matisse, Miró, Picasso, Rouault.* Apr. 21-May 17. Cat.

Musée des Arts Decoratifs, Paris. *Collection S. Guggenheim in New York.* Apr. 23-June 1. Cat., text by James Johnson Sweeney.

Musée de l'Art Wallon, Liège, Belgium. *Léger-Matisse, Picasso-Miró-Laurens, Magnelli-Arp, Hartung-Jacobsen.* July-Sept.

1962 Galerie Beyeler, Basel, Switzerland. *Le Cubisme: Braque, Gris, Léger, Picasso.* May-July. Cat., intro. by George Schmidt. Traveled to M. Knoedler & Co., Inc., New York, New York.

Wallraf-Richartz Museum, Cologne, West Germany. *Europaische Kunst 1912.* Sept. 12-Dec. 9. Cat., text by G. von der Osten.

Museum des 20. Jahrhunderts, Vienna, Austria. *Kunst vor 1900 bis Heute.* Sept. 21-Nov. 4. Cat., texts by W. J. B. Sandberg, Hans Arp, F. Wotruba, W. Hoffmann.

1963 Ministerstvo Kul'tury, Moscow, U.S.S.R. *Fernan Lezhe, Zhorzh Bok'e.* Cat., texts by Maurice Thonez and Georges Bauquier.

1964 Sidney Janis Gallery, New York, New York. *The Classic Spirit in 20th Century Art.* Feb. 4-29.

Leonard Hutton Galleries, New York, New York. *Albert Gleizes and the Section d'Or.* Oct. 28-Dec. 5. Cat., texts by William A. Camfield and Daniel Robbins.

1965 Staatliche Kunsthalle, Baden-Baden, West Germany. *Bild und Bühne.* Jan. 30-May 9.

Galerie Louis Carré, Paris. *La Peinture sous le Signe de Blaise Cendrars: Robert Delaunay, Fernand Léger.* June 17-July 31. Cat., texts by Blaise Cendrars.

Museum of Art, Houston, Texas. *The Heroic Years: Paris 1908-1914.* Oct. 21-Dec. 12.

1966 Fondation Maeght, St. Paul-de-Vence, France. *Dix Ans d'Art Vivant.* Apr. 9-May 31.

Museum of Art, Rhode Island School of Design and Brown University, Providence, Rhode Island. *Herbert and Nanette Rothschild Collection.* Oct. 7-Nov. 6. Cat.

1967 Albright-Knox Art Gallery, Buffalo, New York. *Painters of the Section d'Or: The Alternatives to Cubism.* Sept. 27-Oct. 22. Cat., text by Richard V. West.

1968 University of St. Thomas, Houston, Texas. *Look Back: An Exhibition of Cubist Paintings and Sculptures from the Menil Family Collection.* Mar. 13-Sept. 13. Cat. Traveled throughout the United States.

1970 Tate Gallery, London, England. *Léger and Purist Paris.* Nov. 18, 1970-Jan. 24, 1971. Cat., preface by John Golding; texts by John Golding, Christopher Green and the artist.

Los Angeles County Museum of Art, Los Angeles, California and the Metropolitan Museum of Art, New York, New York. *The Cubist Epoch.* Los Angeles: Dec. 17, 1970-Feb. 21, 1971; New York: Apr. 7-June 7, 1971. Cat., *The Cubist Epoch* by Douglas Cooper published in conjunction with the exhibition by Phaidon Press, London, 1970.

1972 Baukunst, Cologne, West Germany. *Fernand Léger: Ölbilder, Gouachen, Wandteppiche; Pablo Picasso: Ölbilder, Zeichnungen, Plastiken, Wandteppiche.* Mar. 23-June 10. Cat.

Kunstsammlung Nordrhein-Westfalen, Dusseldorf, West Germany. *Kubismus: Kunstrevolution 1907-1914.* Oct. 31-Dec. 3. Cat., foreword by Joachim Büchner.

1975 The Museum of Modern Art, New York, New York. *Modern Masters: Monet to Matisse.* Aug. 4-Sept. 1. Cat. Traveled to Art Gallery of New South Wales, Sydney, Australia and National Gallery of Victoria, Melbourne, Australia.

Minneapolis Institute of Art, Minneapolis, Minnesota. *Picasso, Braque, Léger: Masterpieces from Swiss Collections.* Oct. 30, 1975-Jan. 4, 1976. Cat., intro. by Samuel Sachs II; note by Ernst Beyeler. Traveled to Sarah Campbell Bloffer Gallery, University of Houston, Houston, Texas and San Francisco Museum of Modern Art, San Francisco, California.

1976 National Museum of Modern Art, Tokyo, Japan. *Cubism.* Oct. 2-Nov. 14, Cat., texts by Tamon Miki. Traveled to The National Museum of Modern Art, Tokyo, Japan.

1977 Musée National d'Art Moderne, Centre Georges Pompidou, Paris. *Paris-New York.* June 1-Sept. 19. Cat.

1979 Musée National d'Art Moderne, Centre Georges Pompidou, Paris. *Paris-Moscou, 1900-1930.* May 31-Nov. 5. Cat.

M. Knoedler & Co., Inc., New York, New York. *Alexander Calder/Fernand Léger.* Oct. 4-27. Cat., preface by Lawrence Rubin.

Léger in Paris, c. 1950.

LENDERS TO THE EXHIBITION

Mr. and Mrs. Gordon Bunshaft, New York, New York
James H. and Lillian Clark Foundation, Dallas, Texas
N. Léger, Biot, France
McCrory Corporation, New York, New York
Thyssen-Bornemisza Collection, Lugano, Switzerland
Private collection, courtesy Richard L. Feigen & Co., Inc.,
 New York, New York
Private collections

Albright-Knox Art Gallery, Buffalo, New York
Art Institute of Chicago, Chicago, Illinois
Gallery of Art, Washington University, St. Louis, Missouri
The Solomon R. Guggenheim Museum, New York,
 New York
Hirshhorn Museum and Sculpture Garden, Smithsonian
 Institution, Washington, D.C.
Indiana University Art Museum, Bloomington, Indiana
Los Angeles County Museum of Art, Los Angeles,
 California
Milwaukee Art Museum, Milwaukee, Wisconsin
Musée d'Art Moderne de la Ville de Paris, Paris
Musée National d'Art Moderne, Paris

Musée National Fernand Léger, Biot, France
The Museum of Modern Art, New York, New York
Norton Gallery and School of Fine Art, West Palm
 Beach, Florida
Philadelphia Museum of Art, Philadelphia, Pennsylvania
Staatliche Museen Preussischer Kulturbesitz,
 Nationalgalerie, Berlin, West Germany
Stedelijk Museum, Amsterdam, The Netherlands
Stedelijk Van Abbemuseum, Eindhoven,
 The Netherlands
Tate Gallery, London, England

Galerie Beyeler, Basel, Switzerland
Sidney Janis Gallery, New York, New York
Galerie Louise Leiris, Paris
Galerie Adrien Maeght, Paris
Galerie Maeght, Paris
Perls Galleries, New York, New York
E. J. Van Wisselingh & Co., Amsterdam,
 The Netherlands

CREDITS

7,500 paperback and 2,500 hardcover copies of this catalogue, edited by Josephine Novak and designed by Sandra T. Ticen, have been published by Abbeville Press, Inc., New York, New York. Typeset in Helvetica Light by Thorner-Sidney Type Services, Buffalo, New York. Separations by Spectralith, Inc., Chicago, Illinois. Printed by American Printers & Lithographers, Chicago, Illinois. Paper: 100 lb. Wedgwood Coated Offset. Printed on the occasion of the exhibition, *Fernand Léger,* January 1982.

The organizers of the exhibition wish to thank the museums, galleries and private collections for permitting the reproduction of works in their collections. Photographs were supplied by owners or custodians of the works of art except for the following:

COLOR

Jörg P. Anders: Cat. no. 49
Robert T. Buck: Cat. no. 3
Bulloz, Paris: Cat. no. 17
Bob Kolbrenner: Cat. no. 67
Robert E. Mates: Cat. nos. 4, 32, 34
Robert E. Mates and Mary Donlon: Cat. no. 71
Eric E. Mitchell: Cat. no. 26
Jacques Mer: Cat. nos. 9, 13, 16, 19, 35, 40, 42, 47, 48, 50, 51, 53, 55, 63
Otto E. Nelson: Cat. nos. 11, 22, 23, 73, 75

Eric Pollitzer: Cat. no. 36
John Tennant: Cat. no. 41
Malcolm Varon: Cat. no. 21
John Webb: Cat. no. 76

BLACK AND WHITE

Dominion Gallery, Montreal, Canada: Fig. no. 42
Sidney Janis Gallery, New York, New York: Fig. no. 24
Robert E. Mates: Fig. no. 13
Jacques Mer: Fig. no. 22
Peter T. Muscato: Fig. nos. 19, 28
Musée National Fernand Léger, Biot, France: Fig. nos. 15, 20, 29, 30, 31, 34, 36, 37, 38, 39, 40
Runco Photo Studios, Tonawanda, New York: Fig. nos. 4, 5, 6, 8, 10, 32, 33, 35, 41, 43